BY ROBERT LONG

POETRY

Blue (1999)

What Happens (1988)

What It Is (1981)

Getting Out of Town (1978)

EDITOR

For David Ignatow: An Anthology (1994)

Long Island Poets: An Anthology (1986)

DE KOONING'S BICYCLE

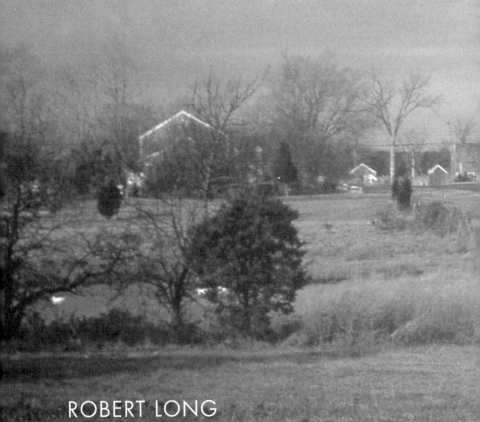

ROBERT LONG

FARRAR, STRAUS AND GIROUX NEW YORK

DE KOONING'S BICYCLE

ARTISTS AND WRITERS IN

THE HAMPTONS

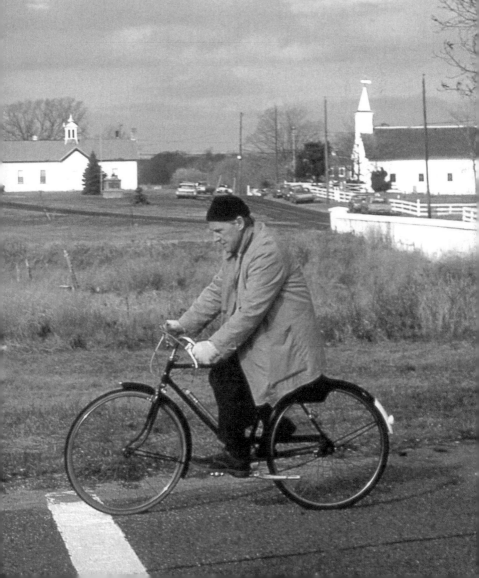

Farrar, Straus and Giroux
19 Union Square West, New York 10003

Grateful acknowledgment is made to the following for permission to reprint previously published material: "A cardinal/in the branches of," excerpt from "In earliest morning/an orange devours," and excerpt from "The sky eats up the trees" from *Collected Poems* by James Schuyler, copyright © 1993 by the Estate of James Schuyler. Reprinted by permission of Farrar, Straus and Giroux, LLC.

Library of Congress Cataloging-in-Publication Data
Long, Robert, 1954 –
 De Kooning's bicycle : artists and writers in the Hamptons / Robert Long.—
1st ed.
 p. cm.
 Includes bibliographical references.
 ISBN-13: 978-0-374-16538-3
 ISBN-10: 0-374-16538-6 (hardcover : alk. paper)
 1. Artist Colonies—New York (State)—Hamptons. 2. Arts, American—
New York (State)—Hamptons—19th century. 3. Arts, American—New York
(State)—Hamptons—20th century. 4. Hamptons (N.Y.)—Description and
travel. I. Title.

NX510.N462H366 2005
709'.747'25—dc22

 2004030212

Designed by Jonathan D. Lippincott

www.fsgbooks.com

1 3 5 7 9 10 8 6 4 2

Frontispiece: Willem de Kooning in East Hampton, 1980 (© Dan Budnik)

For Danny and for Nick

Everything is already in art. It's like a big bowl of soup. You stick your head in and you find something there for you.

—Willem de Kooning

DE KOONING'S BICYCLE

ONE

On maps, Long Island resembles a whale that's swum across the Atlantic Ocean southwest from Ireland, grazing Nantucket Island and Martha's Vineyard and slamming its big blunt head against the island of Manhattan, nudging it that much closer to the mainland at Jersey City.

This whale stretches northeast for 120 miles. Its corroded flukes, known as the East End, split into North and South Forks and trail off into the ocean, the former running parallel with the south shore of Connecticut, which lies across Long Island Sound, the latter with a series of bays to the north and the ocean to the south.

No matter where you go on the South Fork, water is nearby. It plays tricks with the light, which seems both clear and soft. It permeates the woods and the potato fields, and you sense it as you walk the streets of the villages. More successfully than most painters, William Merritt Chase and Willem de Kooning caught something of its pastel evanescence; it is the primary subject of everything that came from de Kooning's brush from the mid-1960s on, informing figures as well as landscape.

The light may be the South Fork's principal aesthetic asset, but it is not the reason the area was settled in the mid-seventeenth century. People went there because they felt crowded, in any num-

ber of ways, at home. And there was real estate to be had, and money to be made. They go there for the same reasons today, and because it is close to New York City, and because rich and famous people go there, as they did in the nineteenth century.

The men and women who sailed to Southampton and East Hampton were part of the Puritan migration that had been making its way to the Eastern Seaboard since the settlement of Plymouth in 1620 and the signing of the Massachusetts Bay Colony charter in 1629. In 1640, the Long Parliament promised tolerance of Puritans in their homeland, but by then it was too late, for over twenty-one thousand people had fled the Old World for New England.

The separation of church and state that had been lacking in England was lacking on the East End, too, but no one minded, because it was the Presbyterian Church, not the Church of England, that collected taxes from the townspeople for the next two centuries: "Everyone into the melting pot, just come out Presbyterian," as the urban historian and architect Robert A. M. Stern put it.

Upon arriving in the colonies of Massachusetts and Connecticut, many of these immigrants found that the place didn't exactly live up to its advance billing. Land was not as plentiful as advertised, and the soil was hardscrabble. So they made their way south, where the land was for the taking and the soil not as rocky.

With the Indians out of the way (they had been further quieted with liquor and laudanum), the East Enders set up shop. Most had come from the English countryside, and so reestablished themselves in agriculture. The men raised sheep and geese, planted, hunted, and fished. The women sewed, knit, quilted, gardened, spun, and churned. They cooked wild birds, venison, fish, and samp, a cornmeal porridge whose recipe the Indians

taught them. They built cedar- and cypress-shingled houses whose roofs sloped from two stories at the back to one at the front, a configuration that allowed them to avoid a tax on two-story structures imposed by the King.

The settlement was begun in a communal spirit, but a pecking order was soon established. Lion Gardiner came to America in the service of the King, who hoped to prevent the Dutch from claiming the territory, but he was a businessman, the seventeenth century's equivalent of a real estate speculator. Walt Whitman admired him, or the idea of him. "Tradition relates that Wyandance, the great chief of eastern Long Island, loved and obeyed Mr. Gardiner in a remarkable manner," he wrote. Having once sailed past it, Whitman conjured Gardiners Island as a kind of colonial Santa's Workshop:

> Imagine the Arcadian simplicity and plenty of the situation, and of those times. Doubtless, among his workpeople, Mr. Gardiner had Indians, both men and women. Imagine the picturesqueness of the groups, at night in the large hall, or the kitchen—the mighty fire, the supper, the dignity and yet good humor of the heads of family, and the stalwart health of the brown-faced crowd around them. Imagine their simple pleasures, their interests, their occupations—how different from ours!

Well, yes and no.

Wealth came to the settlers in a way that must have seemed like a biblical plague. One day, someone noticed that the fifty-foot-long, seventy-five-ton, glistening, reeking black carcass of a whale had washed up on the shore from the ocean. The creature

may have been sick; it may have been disoriented or driven inland by an offshore storm. Such landings were common throughout the 1720s.

The story of whaling on the East End is in outline the same as that found everywhere they have been hunted. At first, whales were abundant, washing up onshore or spotted close to land. A handful of men in a small boat set out in pursuit, and when the carcass was dragged ashore, it was divided among the townspeople. As the creatures decreased in number, it became necessary to sail farther from land to capture them. Eventually, they were sought on voyages of months or even years. Finally the expense of the ventures exceeded the revenue they yielded, and the industry collapsed.

The Indians had been observed pursuing and killing whales as early as 1620. They cut up and cooked the blubber, using the rendered oil to preserve animal hides. The settlers realized that whales were valuable in manifold ways. Their oil was the most efficient fuel for illumination available, and everything from buggy whips and candles to corsets and collar stays could be fashioned from their bones and baleen. The economies of Southampton and East Hampton thereby flourished in a way no one had anticipated.

The disposal of whales was at first a communal effort. Because time was of the essence—whales rot quickly—everyone was expected to lend a hand in the unpleasant business of hacking up the smelly carcasses and cooking down the blubber. Children were even let out of school. Anyone who did not participate could be fined.

The East Enders made the process as efficient as they could. Whaleboats patrolled the coast for weeks at a time. Onshore, a paid whale watcher alerted the town when he spotted a glossy black back breaking the ocean's skin. A crew of six—four row-

ers, a tiller, and a harpooner—piled into a twenty-foot cedar whaleboat, patterned after the Indians' dugout canoe. They chased down the creature, hoping to puncture its heart or lung. If the wound was made accurately, the whale could be towed to shore; if not, the whale dragged the men behind it for hours, until it tired, all the while snapping the boat in its wake like the tail of a kite.

By the mid-1660s whaling had evolved into the private enterprise of a few fortunate families. It took capital to purchase a whaleboat, harpoons, the expensive iron kettle used to boil blubber, and special barrels for whale oil, and it was an investment most families could not afford to make. The Montaukett Indians, whose bartering arrangements with the settlers left them permanently in debt, entered into contracts in which they agreed to work for the whaling companies to settle those debts; in this way, they were bound to the English from year to year with little hope of paying all that they owed. The early whaling companies paid their employees with small amounts of cash and with whale bounty: the Indians were given fins, and the English received three-foot hunks of meat.

The industry thus hastened the stratification of white society on the East End. And in a community that numbered about five hundred, resentments flourished, and were often played out in court, for the settlers and their early descendants were a litigious lot. Complaints were routinely filed over trivial matters, the most popular being slander and defamation of character.

By 1700 Amagansett had become the main source for whale oil and whalebone on the Eastern Seaboard. A thriving market economy was now in place on the East End; social classes had been established. It was almost impossible to buy land unless you were descended from one of the settling families or extremely wealthy.

And then the whales simply stopped coming. It would be years before the hunt for them resumed, this time in three-masted ships out of Sag Harbor. In the meantime, the East End lost its position on the front line of the economy, a victim of what later centuries would call overfishing. There was little reason for East Enders to maintain more than a tenuous connection with the rest of the world, and they reverted to obscurity.

The families who had managed to get in on the whaling boom retained an aura of importance; they owned the most valuable land, in the hearts of the villages and along the ocean. Those who hadn't claimed a stake constituted the servant class and lived in outlying areas. The Long Island Rail Road tracks would come to mark the dividing line between the classes, then the Montauk Highway, when it became the more popular travel route; "south of the highway" still means class on the East End.

As late as 1878, a visitor would describe East Hampton thus: "It is 5 miles from Sag Harbor, 15 from Greenport, and about 100 miles from New York. But from the way they are behind the times, should think they were about 5,000." Sag Harbor, however, had vitality; it was one of the most important whaling ports on the East Coast from the time of the Revolutionary War until 1857, when a financial crash killed off the industry for the second time. In any case, the discovery of petroleum a few years earlier meant that whale oil and spermaceti would soon be replaced by kerosene and paraffin.

The most notable cultural presence on the East End until the end of the nineteenth century was that of a woodworking family, the Dominys. They were East Hampton farmers who in the off-seasons made about one thousand pieces of furniture over sixty-five years, handing down the craft through several generations. Nathaniel Dominy IV and his son and grandson ignored changing fashions and technological advances, but each added a

specialty to the family's arsenal, and they had a wide range of clients among the wealthier citizens of the East End. By the mid-nineteenth century the demand for their custom-made chairs, tables, desks, and bureaus had fallen as large companies began providing cheap, well-made furniture. But the Dominys had something else to offer, though it didn't fatten their purses. When hordes of painters descended upon East Hampton in the 1880s, the Dominy farmhouse, sagging with age, and its adjoining workshop became a popular subject. Nathaniel Dominy VII sometimes stepped outside to watch the artists work at their easels. "You fellows get a thousand dollars in York for a picture of my back door," he'd say, "and I get nothing."

Lange Eylandt, as the Dutch labeled it on maps, is sediment left by a glacier that plowed south as it melted for thousands of years, part of its detritus the South Fork, a hilly, scrubby ridge that slopes off to bays on the north, the ocean on the south. Like bubbles in pancake batter, pockets formed in the glacial sediment, kettle holes that held meltwater in the form of bays, ponds, harbors, and creeks.

Because the Dutch wanted eastern Long Island, Lion Gardiner was sent there in the early 1630s to keep them from having it. He did so by building and commanding a fort at the mouth of the Connecticut River, north of Long Island. The fort also was meant to subdue the Pequot Indians, who had their own plans for the East End. In 1637, the nation was all but wiped out when Gardiner's men set fire to the Indian fort. Those who fled the inferno were shot or hacked up with swords.

The Montaukett Indians, who had been paying protection money to the Pequots, began paying off the English instead. In a deal struck with Gardiner by Wyandance, the Montaukett chief,

the English were granted exclusive trading rights with the tribe. With a continuous source of wampum, Gardiner could trade shells for whatever his heart desired, including beaver skins, which London merchants coveted. In this manner he acquired Gardiners Island, which he named the Isle of Wight on taking ownership of it in 1639. About a decade later, the English governors of the Connecticut and New Haven Colonies bought what is now East Hampton Town for a pile of looking glasses, hatchets, and knives, twenty coats, and a hundred muxes—the small metal drills used to string wampum on leather strips. Two years later they resold East Hampton to Gardiner for $30,000.

At about the same time, the English acquired Southampton from the Shinnecocks in return for protecting them from the Narragansetts, and promptly segregated the Indians in Shinnecock Hills, where the golf club bearing their name, and designed by Stanford White, would be erected 250 years later.

The Indians who sold the East End to the British thought they retained the right to hunt and fish where they liked, which was all they cared about. But the agreement was restrictive in a way that they could not have anticipated. Although an Indian was allowed to hunt "up and downe in the woods without Molestation," if he killed a deer, for example, he could keep the skin but was required to turn the body over to the English. The settlers shunted the Indians from one place to another, making it clear that they were not welcome in the village center unless on official business; those who did venture there were closely watched.

By the mid-nineteenth century the Montauketts, whose population had been drastically reduced by smallpox and tuberculosis, were planted in an area just north of East Hampton Village called Freetown; the name can still be seen on maps. They sued to regain title to their former property in Montauk, but the suit

was dismissed in 1910, and an appeal was thrown out in 1918, when the court found that the Montauketts, by then even further diminished in number, no longer existed. A movement to reclaim the land in recent years has thus far failed to cohere.

At the time Thomas Moran arrived in the late 1870s, East Hampton was a sleepy backwater whose charms were all but unknown to most New Yorkers; his presence there would help to draw attention to the area. Coinciding with his arrival was a vogue for plein-air painting, and the East End offered a limitless choice of subjects for painters who found inspiration in direct observation of nature.

Moran was the first significant artist to call the East End home and to memorably translate its late-nineteenth-century landscape into oil paint and scratches on a copper plate. An English-born traditionalist who was admired and encouraged by a fellow Lancashireman, John Ruskin, he rejected Impressionism as a distortion of God's handiwork. At his best, Moran was a relaxed literalist, and his pictures of East Hampton are his plainest and most affecting; they do not suffer, as his more famous paintings of Yellowstone and the Grand Canyon sometimes do, from the tendency to overstatement that Ruskin chided him for.

Moran's friends who had sailed the south coast of Long Island told him that it was a paradise for painters, as full of subjects as any place he'd been, including Europe. So why look to the West, or to the Continent, when such material was close at hand? European artists saw plenty to paint in their own backyards; why couldn't Americans?

One day Moran and his wife, Mary, and their children left Newark at dawn, on a ferry that pitched in the wake of a dozen other vessels as it traced the southern tip of Manhattan, plowing

gray water to Long Island City, where a gray train waited under a wooden shed.

The train lurched, then slid forward, the window filling with field and sky. Five hours later the family descended metal steps onto a wooden platform, then climbed into a carriage with hard springs. The road east was a pair of ruts and a blanket of dust. The air smelled of hay. When, after an hour, they turned sharply left for the first time, there suddenly appeared a big green pond set in a thick bright green lawn blotched here and there with white geese, copper beeches rustling overhead. A shingled two-story boardinghouse with a smoking chimney faced the pond, and they got out there, on East Hampton's Main Street.

Night was falling. They were served bluefish in crisp corn-meal coats, crumbly biscuits. A chocolate layer cake rested on the sideboard. There were no other lodgers. They were led up to rooms where they looked out at the pond's dim glow beyond massed clouds of beech leaves. Something like a tree frog sounded. The smell of the sea carried faintly.

As he sat in the mornings at the pond or set out with sketchbook, pencils, and a knife, Moran thought that this could be his Fontainebleau. There was a different subject everywhere he looked; he felt he could spend his life circumnavigating the pond. At Hook Pond, a five-minute walk from Main Street, he could hear the surf pound on the other side of the dunes. There were patches of heather along the pond's marshy rim, and nervous quail burst from stands of reeds. An egret stood on straw legs.

In the stillness it felt like the countryside beyond the mill town in Lancashire where he was born and the forest at Wissahickon, along the banks of the Schuylkill, in Philadelphia, where he had grown up.

Trips to Yellowstone had given him pictures that made him famous, but he came to like the softer beauties of this place. This

was a quieter world. There was forest and seashore. He rode to Montauk and caught sea bass from the surf, off the rock jetties at the ocean.

There he came to understand Ruskin's counsel. "Please in some degree attend to what I wrote of the necessity of giving up the flare and splash," Ruskin had written. "Force yourself to show leaves and stones—such as God means us all to be shaded by, and to walk on—and be buried under—till you can see the daily beauty of them and make others see it."

Moran set out very early each summer day so as to be back home before the blanket of mid-afternoon heat settled. The night's rain evaporated quickly, but the air would still be damp. He rode along Main Street past the sheep pound with its white fence, upon which sat a boy in a hat, past the soundlessly turning sails

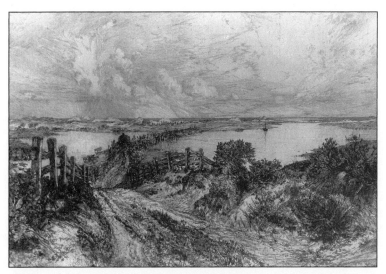

Thomas Moran, *Hook Pond, Easthampton*, 1884 (Guild Hall Museum Permanent Collection)

of Hook Mill, north toward Springs, where the fishermen and farmers collected scallops and salt hay and the Indians camped, the road narrower and the ruts deeper now, a forest of skinny scrub oak to either side, trees with scaly bark that crumbled to sawdust in his hand.

He pulled off into a clearing at Soak Hides, a mile and a half north of the village, and tied the horse to a birch tree. He shoved through a fence of reeds whose stems broke like kindling snapping in a fire. The sandy path was studded with shards of scallop shells, and here and there it turned gray with the ashes of centuries of banked fires, a summer camp for the Montauketts. There were trees with red berries called shadblow—they flowered when the shad were running.

He plowed through the last of the reeds onto a path to the shore at the head of Three Mile Harbor, which opened in the distance as it made its lazy way north toward Gardiners Bay. Two boats were moored on the far shore, and storm clouds, slowly breaking apart, were piled like fists above them in the gray blue sky. He sat on a large, flattish rock, took out his book, and began to draw. There was a small breeze in the oaks. He listened to the tide.

Two years before, in the fall of 1877, a half-dozen painters and one journalist gathered to chat in a studio above a grocery store at Fourteenth Street and Broadway in New York. The group, which grew to include about forty painters, writers, musicians, and architects, socialized on Wednesday evenings, at first at a different member's studio each week, and later at a place they rented on West Tenth Street. The painters, inspired by William Morris and the English decorative arts movement, amused themselves by painting designs on clay tiles; the tiles were fired, and

then presented to that week's host for his trouble. William Merritt Chase was an early member, but Moran, though he dropped in now and then, never officially joined.

The men talked, wrote, drew, painted, sang, played music and cards, and went on excursions together. Because the membership was remarkable (Stanford White, John Henry Twachtman, Winslow Homer), publicity, much of it self-generated, soon attached to their activities.

In the late spring of 1878, the Tile Club spent a fortnight touring the south coast of Long Island on a sloop paid for by Charles Scribner. In return they were to send him a story about the adventure, illustrated by club artists. Long Island was fresh territory; New York artists until then preferred to escape to the Adirondacks or the coast of Maine. Scribner liked the story and spread it over two issues of his magazine.

"The Tile Club at Work," published in January 1879, led to an unprecedented invasion of the East End, particularly East Hampton, by people who wanted to draw its windmills, saltbox houses, wandering flocks of geese, and rustic inhabitants. Not least among the invaders was Moran. Chase, too, would return, though not for another decade.

According to the story, East Hampton "consisted of a single street, and the street was a lawn. An immense *tapis vert* of rich grass, green with June, and set with tapering poplar trees, was bordered on either side of its broad expanse with ancestral cottages, shingled to the ground with mossy squares of old gray 'shakes'—the primitive split shingles of antiquity."

The club members stayed at boardinghouses in the vicinity of Main Street and made a sport of scandalizing the locals. One group of artists, wrote the East Hampton historian Jeannette Edwards Rattray, "indulged in the reprehensible habit of painting nudes out of doors." The artists were easy to spot in their vel-

vet suits and berets. In the 1880s, farmers "could hardly get out to their own barnyards to milk the cows, the easels and mushroom-like umbrellas were so thick," Rattray reported. But they were admired and imitated by some of the younger members of the community who were fascinated by their sophisticated chatter and bohemian aura; young women, caught up in the spirit of things, "covered the parlor wall with watercolors."

The Morans helped organize a tennis club, whose members first played in an apple orchard. In 1884 the family made East Hampton their permanent summer home when Moran designed and oversaw the construction of a two-story house and studio near the entrance to the village, not far from the house where they had stayed on their first visit. The front door opened onto Moran's big studio, which he furnished with Persian and Afghan rugs and "fragrant, moth-eaten robes from old Rome." The young people of the village came there and "nearly danced it down" to Moran's fiddling, according to the Moran biographer Thurman Wilkins.

Moran's residence on the East End coincided with the beginning of a cultural revolution that would pay dividends to some of the artists who followed in his wake. At the end of the nineteenth century the United States was turning from agriculture to industry, and a wealthy class of industrialists had become patrons of the arts. They liked to have their portraits painted, and they liked to buy pictures of the French countryside. American artists learned to satisfy them, not only by acting as middlemen between collectors and European artists, but also by painting the kinds of pictures rich people wanted. The wealthier and further from their rural roots the ruling class grew, the more they were afflicted by *nostalgie de la boue*.

Before the summer people came there were cattle. Around Memorial Day each year, from the mid-nineteenth century to the

1920s, East Hamptoners drove about ten thousand cows, horses, and sheep from the town's outlying reaches to the main drag—what is now Montauk Highway—and released them to graze in the pastures that stretched from the east end of Amagansett Village to windy Montauk Point. Come Labor Day, the animals were funneled back through the villages to their winter homes. The highway was a ribbon of dirt that froze in the winter and turned to a river of almost impassable mud each spring. When the last of the late-winter frost had evaporated and spring's perfume tinged the air, hundreds of geese resumed their daily morning waddle down East Hampton's Main Street to bathe in Town Pond, like tourists making their way to the ocean.

In the 1820s, a trip from East Hampton to New York by stagecoach took two days. Travelers departed the Union Hotel in Sag Harbor at 6:00 a.m., breakfasted in Westhampton, stayed the night in Patchogue, paused for nourishment in Babylon, and climbed from the coach that evening in Brooklyn. The cost was $5.

By the early 1960s, the drive from the city to East Hampton took about three and a half hours, in a pale green 1958 Ford station wagon my parents had bought for that purpose. It took us on warm Friday afternoons to a small unheated cottage in Springs, the working-class hamlet outside of East Hampton Village, several miles north of the Montauk Highway, in a marshy neighborhood near Gardiners Bay called Maidstone Park, one of the Montauketts' fishing grounds. It was just down the road from the places where Jackson Pollock died, Frank O'Hara drank gimlets, Jean Stafford stared out her study window, and Willem de Kooning rode his Royce Union three-speed, white hair and work shirt flapping. Most people there had heard of

de Kooning and Pollock, but their celebrity was minor. The art world was largely irrelevant to anyone but artists; the idea of investing in art at any level was unheard of. Those who did keep an eye on the art world said that de Kooning, who by then was over sixty, was past his prime; the pastel landscapes he was making lacked the aggressive psychodrama of the paintings of women that had made him famous. Lee Krasner, Pollock's widow, was guarding the work her husband had left behind, doing what she could to help its value increase. Hardly anyone even knew she was a painter, nor would they have cared.

Dan Miller, who had taken Pollock for scary rides in his Cessna, still ran the general store where Jackson had chatted away hours, but the small painting he'd accepted in trade for groceries had been sold. Miller sat at his desk in the little office off the one-room grocery where the Pollock had hung, tall, barrel-chested, in white shirtsleeves and brown slacks, with a big expressionless face and a shock of white hair. Children who dropped their bikes in his gravel lot and banged through the screen door for root beer and candy on hot afternoons grew respectful and quiet when he rose slowly from his chair, eyeing them silently, and made his way behind the waist-high, varnished wooden counter. His wife, a slight woman with lank gray hair, smiled at the children behind his back as she darted in and out of sight in a flowered shift.

There were still working farms in Springs; Jean Stafford lived across the road from one. She liked seeing the horses, which reminded her of her Colorado childhood, and the small flock of sheep that gathered each morning at the fence.

There's a startlingly truthful moment in the movie *Pollock*, when Ed Harris and Marcia Gay Harden, playing Jackson and Lee, step into the Pollocks' actual backyard, a field facing Accabonac Harbor, and the whir of cicadas fills the air. It's the

sound that the Pollocks heard every warm night from their little upstairs bedrooms, the thin white curtains hanging straight in the still air. De Kooning heard it, too, a half mile away, in the trees around his house, when he'd climb onto his bike for a ride to Louse Point. Even Thomas Moran had once heard it, three miles south, in the village. Pollock called one of his synesthetic masterpieces *Sounds in the Grass*.

By the time Jackson and Lee made their way to the East End in the mid-1940s, it was no longer uncharted wilderness, but it was still cheap—even they could afford to buy a small, rundown farmhouse. The East End was being rediscovered then, and it would again begin to assume a glamorous aspect in the public imagination. It had already passed through such a period, fifty years earlier; this time, it would stick.

That first wave of artists and writers was unleashed in earnest when a well-dressed, bearded, very short man, sometimes trailed by a tall black manservant, took up residence in a shingled house in Shinnecock Hills. Chase's outsize personality and talent for self-promotion made him an influential figure on the art scene, as a teacher and as a promoter of American art and artists. The trajectory of his career coincided with the Gilded Age and with the beginnings of an identifiably American movement in art.

TWO

White shirt, oxblood half boots, snowy linen suit, maroon sus-
penders, maroon cravat, red carnation, Academy pin. Pince-nez
with black satin ribbon, pocket watch on gold fob, ebony cane.
Straw hat with black satin ribbon.

It was time to go to the beach.

Tuesday was Chase day, and the students waited for him on
the shore of Shinnecock Bay, where he had dispatched them to
sketch or paint whatever struck them first—a stretch of busted
fence, a wooden pail at a well, gulls on pilings, the silver scales of
the bay, hard little berries and wildflowers, peeling rowboats in
the weeds.

A few students stood by rickety easels on either side of the
sandy path that snaked from the road to the shore, knowing he
would pause as he passed. Some he recognized from other teach-
ing engagements. Some were new. Many were returning stu-
dents; this was the school's seventh year. He would spend the
whole morning with them, stopping at their easels and pads,
where they stood or sat on folding stools, sometimes taking a
brush to make a mark himself.

In the boom years of the 1870s it was possible for a painter
to earn a living by painting portraits, and Chase's charisma and
his vast range of acquaintance helped him to become second

only to John Singer Sargent in securing commissions. He painted portraits throughout his career that are often so unlike his impressionistic landscapes that they might as well have been made by another artist. It is a tribute to the breadth of Chase's talent that he was able to work successfully in several distinct and overlapping styles. Although he arrived at them successively, he did not hesitate to switch from one to the other when necessary.

Chase managed to have his cake and eat it. He worked hard to maintain a public face; his manner and clothing and those of his wife and children, the decoration of his house and studio, were all contrived for artistic effect. Like Albert Pinkham Ryder, whose father sold coal, and Winslow Homer, whose father ran a hardware store, Chase was determined to transcend his origin as a boy who sold shoes in his father's general store in Indiana. Like many people who came from the sticks and succeeded in New York City, he found comfort in the East End's rural atmosphere, a place where small-town attitudes and big-city money were found side by side. And this was a good job. His duties were fairly limited; he could paint outdoors when he wasn't teaching or tending to administrative matters.

He had six children to feed and private-school tuition to pay, as well as rent on the Tenth Street studio and his assistant's salary, and so the routine trips he'd once taken to Europe were out of the question; even summers at the shore in Brooklyn had become too expensive. The family's wardrobe was especially costly. He had sometimes bartered small works with sympathetic tailors and haberdashers. For some time he had taught at three schools simultaneously while taking portrait commissions and giving private lessons as well. If he had a call to teach a class in Chicago, he was on the first train, with three cases of clothes and a paint box.

His pictures sold, but because he specialized in living beyond his means, they could never sell well enough. Chase and his

friends relied on private sales, commissions, and public auctions. And Chase's auctions, always well attended and praised, were commercial disasters. He had once held a banquet to celebrate the opening night of his biggest sale, of two thousand items he'd acquired over the years, from a group of six hundred rings to over sixty works of art by him and others. The first night, the crowd was huge, but by the auction's end, five days later, interest had evaporated, and many paintings sold for less than the cost of their frames. He later bought many of them back, at a loss.

The public still would not acknowledge that American art could have a value approaching that of European art, though Chase had spoken on its behalf for decades, not only educating thousands of younger artists but also founding or helping to found

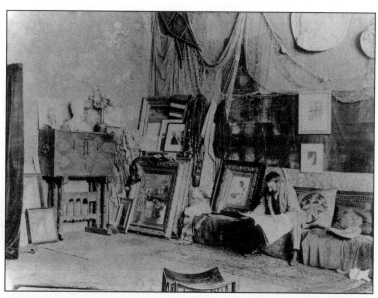

William Merritt Chase in his studio, Shinnecock Hills, ca. 1896. Albumen print, 4⅝ x 6⅛ inches (William Merritt Chase Archives, The Parrish Art Museum, Southampton, N.Y. Gift of Jackson Chase Storm)

clubs, institutes, and schools; organizing exhibits at the leading venues; writing articles; cultivating publishers and editors of the most widely read magazines; and inviting one and all into his studios.

It was an uphill battle. On his return from Europe twenty years earlier, he was thought to be a radical, an overly impetuous painter; people wanted to see close resemblances and highly finished surfaces, not bravura brushwork. On the one hand, they thought American painting second-rate; on the other, they didn't approve of Americans who openly acknowledged their debt to Continental painters celebrated for assertive brushwork. Now that he had made a career and even become famous, people complained that Chase wasn't adventurous enough, that he viewed art through the eyes of the past. His success was the result of personal charisma rather than artistic achievement, they said. He was too eclectic, too glib; he was a painting machine, not an artist. But he still had fans, and followers, and twenty-five years' worth of connections in the art world.

The Shinnecock School of Art was one of the fruits of his years of campaigning.

A Mrs. Hoyt and a Mrs. Porter had asked him to help create a summer art school at Southampton, a resort that by 1890 had come to rival Newport. Chase had been to the East End years earlier, on an excursion along the coast with the Tile Club. It had seemed barely inhabited in those days. Now a number of his clients, and a tantalizing number of potential clients, had built summerhouses by the sea, and when the railroad was extended, Southampton became far more accessible to visitors. There were rooming houses and an inn or two.

The women, both amateur painters and admirers of Chase, were joined by Samuel Parrish, a collector of Italian Renaissance pictures who owned thousands of acres of land, land that was

doubling and tripling in value as the East End's popularity soared. He provided sites for the school and hired architects. The three of them persuaded their friends—the wives of Belmont, Carnegie, Vanderbilt, Astor, and Whitney—to help pay for the school.

Chase's friend Stanford White had recently completed a house in the Shinnecock Hills that was close enough to the school for easy access but far enough removed for privacy. Samuel Parrish bought the house from its pleasantly surprised owner before he'd even moved in, engaged White to make renovations to Chase's specifications, and turned it over to the artist.

Chase's residence was simple by the standard set by Southampton's summer crowd. McKim, Mead, and White were the favored architects; the firm was responsible for Parrish's house and those of several of his friends who vacationed on the long leafy lanes near the ocean, in the village. They had also designed the clubhouse for the Shinnecock Hills Golf Club, a rambling mansion in the dunes a mile or so east of Chase's house that had been completed a couple of years before.

Chase had known White for decades; they'd been on Tile Club outings to the East End together and saw each other at the Century Club. They gained in fame together, and spoke highly of each other to clients. White was an artist to his fingertips, Chase wrote, after his friend was shot to death. White had been killed by the angry husband of one of his mistresses while watching a musical revue on the roof of Madison Square Garden in 1906. Subsequent revelations in the daily newspapers about White's womanizing called all of his accomplishments into question. Did such a dissolute character deserve the praise that had been lavished on his architecture? "If it be a fault to admire beautiful women, he possessed that fault. He did not seem to regard it as anything to conceal. Why should he?" Chase said.

From the dormer windows in the cozy upstairs bedrooms,

Chase could see the grand golf club riding the moraine like an ocean liner to the northeast and glimpse the Indian settlement to the southeast. The bays were rolling bands of blue and green to the north and south. On windy days the waves lost their heads, puffs of foam like flattened cotton balls scudding across the slate gray sea.

As the school opened in 1891, workmen were still renovating the house, and he slept and dined at the Canoe Place Inn, a vast and hopeful new hotel a mile to the west that faced a narrow inlet from Shinnecock Bay. From his rooms he watched fishermen pass in their dories, smoking pipes, in oilskins or high boots, the sterns of their vessels bristling with short-toothed rakes and long-handled baskets for harvesting shellfish. Sometimes he'd see a vessel return in the afternoon bearing heaps of glistening black mussels in the mouths of damp burlap sacks, and there would be tubs of silvery bluefish and fluke shaped like spearheads. He thought of Winslow Homer, who had painted haul seiners dragging their nets from the ocean at Amagansett.

As he passed the house in a buggy every morning, he noted the workmen's progress. Set on the highest point of the moraine, the building reminded him of a prairie schooner hunkered close to the horizon, the seven slender pillars that supported the gentle slope of its gambrel roof lending an elegant symmetry, the squat red chimney matter-of-fact. He imagined a satin ribbon of smoke, the smell of wood burning in the stone fireplace, the children at breakfast in the little dining room, windows opened to a salty breeze on a sunny morning in June.

He watched the men nail planks end to end atop the studio, tap silver nails through shingles layered like fish scales.

Skirts rustled and benches scraped as a breeze through the rear windows began to displace the day's accumulation of heat. A

double-sided easel stood at the far end of the room; facing it were the students, who sat in rows of folding chairs or stood along the walls. Townsfolk, whispering among themselves or staring openly at the students, were scattered in small groups. Their interest had been piqued by glimpses of young women seated beneath umbrellas in the fields and of young men in bright cravats carrying easels into thickets of marsh grass that usually served as duck blinds. They'd examined the Art Village in the off-season, a semicircle of little cottages that led to the big log house where they now waited. They knew of the artists' decadence, the drinking and sexual liberties. The students were attractive but aloof and no doubt spoiled. It was said that they had their comeuppance in these public critiques, that Chase, the famous artist, took delight in ridiculing them. It was, they'd heard, as good as a bullfight.

When Chase appeared, a hush fell. He walked in quickly, a very short man with a neat beard, a luxurious mustache, and, clipped to the bridge of his nose, small silver-rimmed glasses that trailed a long, thin ribbon. He handed his straw hat to an even shorter man wearing a baggy gray suit and went to the easel.

When Chase was a boy in Williamsburg, Indiana, his father had owned a harness shop. When business fell off, he turned the shop into a general store, then a shoe store. Chase worked there as a teenager, and discovered that his good looks and good manners translated into sales. He spent his free time drawing, and his father arranged for him to have lessons in draftsmanship and painting, for it was clear that he had talent. And although Chase loved Williamsburg, his teachers finally convinced him to move east. If he didn't, he would never have a chance at the kind of career his skill promised.

And so he got on a train and in two days found himself enrolling at a New York art school. He wasn't lonely, for there were many students just like him, Midwestern imports who had surprised their families with their ability. His father sent almost enough money for him to get by, and he supplemented it by taking portrait commissions, many of them arranged by a teacher who lived in wealthy Yonkers. His sitters liked the job he did, and they liked him. If they were disturbed by their likenesses, he flattered them or made a few changes, with a flourish. Rarely were they dissatisfied, in the end.

When his father finally went broke, Chase returned to the Midwest, this time to St. Louis, where the family had relocated, hoping for a new start. A big fish in a small pond, he was able to help his family, and he won the friendship of merchants who accepted paintings in trade for goods, especially clothes: Chase had already begun to dress for his role.

But great art was made in Europe, not in America, especially not St. Louis. He charmed a group of merchants who offered to send him abroad to study for two years if he would act as their agent, scouting out works of art for them to buy. In addition, he would send each patron one of his own paintings.

Life was quieter in Munich than in London and Paris, it was cheaper, and it was the destination of choice for young painters from Midwestern capitals with large German populations such as St. Louis, Cincinnati, and Milwaukee. Chase took to the unusually progressive teaching methods at the Munich Academy, where bravura brushwork was the object. The students painted rapidly, wet on wet, drawing in paint, bypassing the preliminary sketches that were still favored in Paris and London.

———

—To paint is to become part of nature! Rather than stand apart from it, we must become one with it, as best we can.

As the man in the gray suit retrieved the young woman's canvas from the easel and carried it to a table where many other paintings were stacked, Chase replaced his glasses and clasped his hands behind his back, facing the room. He spoke as if addressing a crowd of a thousand.

—When you are painting, whether a landscape or a figure, there must be no intermission between the hand and the head. Do not imagine that I would disregard the thing that lies beneath the mask, but when the outside is rightly seen, the thing that lies under the surface will be found on your canvas.

The children were used to dressing up and posing, and they bore it with equanimity for limited periods. Often, they would be playing or just staring out the window at a cloud, and he would startle them by shouting, "Hold that! Hold that!" Cosy, the oldest, could go for more than an hour indoors, but the others hadn't that kind of stamina. In the summers, he painted them outdoors, as they were. This day, they had come to play near him as he worked in the field east of the house, and he'd asked them to stay. Alice had dressed them in summer frocks, and they looked like angels in the dry landscape.

Dorothy sat in the grass, its long pale blades bunched beneath her, holding her cloth doll. A red sash cinched her white dress at the waist, and a big red ribbon perched like a giant butterfly on her white hat. She watched Helen, who was picking berries from the bayberry bush. Helen's sash and ribbon were yellow. Cosy stood farther away, behind the bush, most of her body hidden by it, facing him. He was painting all three of them,

the bush, and what was behind it: their house, the rolling land, a few clouds sitting in the big watery blue late-summer sky.

He poked at the canvas with a skinny brush, and then bent at the waist to look closely at what he'd done. He stepped away to look some more, head tilted back, eyes squinting, as if he'd forgotten something and was trying to remember what it was.

—Dorothy, please hold still while I paint your bonnet.

He swiped the brush across a corner of the palette he'd rested on his folding chair and stepped to the canvas, leaning into it, making tiny marks: she could see the little movements of his hand, as if he were conducting tiny musicians. The sun glinted off the silver rims of his glasses, and she felt the sun on her back. She was tired and thirsty and bored. She wanted to get up and walk around.

Now he had set down the gnarled peculiarities of the shrubs and had a good take on the girls' postures. He quickly brushed in an imagined clump of beach grass that looked like an anemone, or a porcupine, in the foreground. It sat like an anchor in an oasis of sand, holding in place the three white shapes of the girls, the house in the distance, little trees, and the half-kneaded clouds that hung in the sky. He added a black mark near the house's white porch—this might be the black kettle on the lawn that Alice had filled with wildflowers. Whalers had once used it to boil blubber.

A whir of insects rose abruptly. Katydids? Cicadas? He'd heard the sound was produced by the vibration of their wings, and tried to imagine how they moved them; were they stiff, like the brittle shells of beetles? He slid his palette into its slot in the paint box.

—All right, that's all. Let's go home. It's almost suppertime.

There were subjects for paintings everywhere. Tomorrow he would turn the easel around and, facing in the opposite direction, paint his wife and two of the girls as they sat in the grass.

He told his students to paint the first thing they saw when they left their lodgings. See what is there. Be faithful to the details. Even elements in the landscape that may seem unlikely are subjects. Find the least artistic view and make it yours.

One student was dressed as Cleopatra, another as Napoleon. They stood chatting in the big common studio at the center of the semicircle of bungalows that constituted the school, holding cups of punch, almost all in costume. At the far end of the room, movement could be seen behind black drapes. Was it Mr. Chase

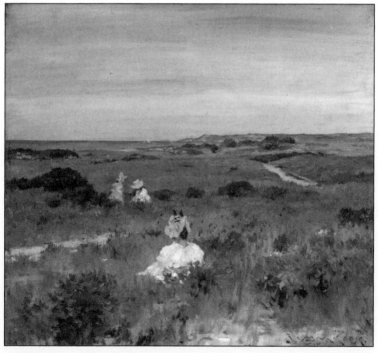

William Merritt Chase, *Landscape: Shinnecock, Long Island*, ca. 1896 (Princeton University Art Museum, Princeton, N.J. Photograph © 2004 Trustees of Princeton University)

again? He had already posed as a Dutchman in wooden shoes. It was an imitation of a painting by Frank Duveneck, a friend of his from the Munich days. He'd sat in an armchair, one leg thrust before him, his hand casually placed on his knee, pretending to smoke a three-foot-long pipe. A pewter tankard rested on a table nearby. Everyone applauded. The townspeople had heard that the wealthy held such evenings in their parlors and that Mr. Chase was much in demand for his expertise at staging them. His New York studio was said to be filled with decorative objects and unusual props that added fidelity to his creations. Other artists were constantly in and out of the place, borrowing tankards and dressing gowns and stuffed birds. When Winslow Homer was painting a shipwreck scene and wanted his model to look half-drowned, he borrowed a giant wooden tub from Mr. Chase so that the man could get good and wet.

Hills dotted with easels.

—The light of the world is strong and vivid. When you paint that world out of doors, you must make a whole new set of colors. When I go to my color merchant, I tell him to show me all the blues and greens he has. There are skies that cannot be made with a permanent blue. There is an eggshell blue that is the most difficult thing in the world to make. Magenta is a color you will find useful and difficult to make—get that.

—Set your palettes with blues and greens from lightest to darkest the same way every day. You must know where they are without having to look.

He produced an empty black frame and held it out at arm's length. He strolled among the easels, turning the frame and peering through it as he went. He stopped suddenly.

—There! The fresh glance is what you strive to reproduce.

Do not paint the grandiose. Paint the commonplace so that it will be distinguished. The world caught in a glimpse.

They gathered in their sundresses and white cotton suits to watch him paint. The sun blasted down on dozens of straw hats. He moved the brush quickly from the palette in his left hand to the canvas, speckling quarter-inch daubs of pink onto a bush, and then scuffing what was left of the pink into the blue sky.

—Try to paint the sky as if you could see through it.

He smeared a little white on the canvas with a knife, and then brushed it in quickly, as if applying a salve to the sky. The picture grew brighter, clearer, the landscape more defined. He began to sharpen the contour of a bush.

—Get the color first, and then concentrate on form.

When Chase finally gave up the Tenth Street studio, he auctioned its contents. But much remained, and the overflow found its way to Shinnecock, where he greeted visitors and sometimes entertained students. The half-dozen steps that led down to the studio helped to create the illusion that you'd entered a different world. A neoclassical bust of a Greek youth stood on a heavy, century-old German sideboard; Mexican cushions were flung onto a divan draped in yards of ocher silk.

It was early September, and only a dozen students remained for the last few weeks of classes. All but the youngest of the children were due to return to school in New York, and Alice was packing their clothes for transport by boat from Sag Harbor to the Thirty-fourth Street terminal; she and the girls would follow by rail, on a private car provided by Mr. Parrish. Alice was expecting their eighth child in a few months.

In the next days Chase would finish pictures he'd begun outdoors earlier in the summer, and then spend most of each week in

New York, taking the train to Southampton to give studio critiques and visit the plein-air painting class on Mondays and Tuesdays.

The Shinnecock school was the first of its kind, but others soon followed, in Old Lyme, on Cape Cod, sprinkled along the Atlantic coast. The turn of the century had come and gone, and enrollment dropped while expenses increased. Chase had begun to grow weary of the annual routine as he noticed with disappointment that the student body was increasingly composed of passionless hobbyists. It seemed that ambitious young artists were drawn to fads, that they cared more for theory than for execution. They lacked the hunger to paint the world as it was; light and color took a backseat to style for its own sake.

The board agreed that the following season, 1902, which was already partially subscribed, would be the school's last. Chase was relieved and excited, too, because he had found a way to resume the annual tours of Europe he missed so acutely. Each summer he would take a small group of artists on a painting tour through a different country: Italy one year, France or Germany the next. He was anxious to walk in the forest outside Paris again, to reacquaint himself with the streets of Munich, the soft light of Venice.

He folded his newspaper and crossed to the window, where a pale cloudless sky stretched over the heather toward the sea. The near-fall air smelled pleasantly of leaves.

In the kitchen the children were finishing lunch, and he took Mary and Roland by their hands and walked out onto the porch. The big red Japanese umbrella lay in the grass. It was over six feet across, decorated with the pale silhouettes of a dozen soaring birds the size of ospreys. He swung its smooth handle up onto his shoulder, and the children looked up into the canopy, where the birds, backlit by the sky, seemed to soar in a sky of red fabric.

—Are we going for a walk?

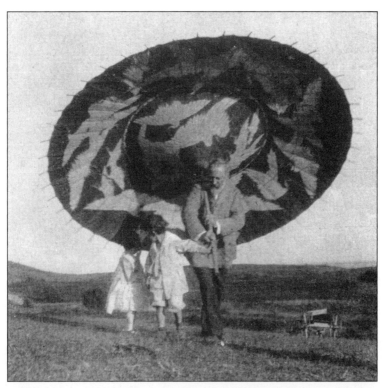

William Merritt Chase, Mary Content, and Roland, Shinnecock Hills, ca. 1905. Cyanotope, 2¼ x 1⅜ inches (William Merritt Chase Archives, The Parrish Art Museum, Southampton, N.Y. Gift of Jackson Chase Storm)

—Yes, we are.

The three of them made their way slowly across the rolling field, past the old kettle and mule cart piled high with flowers. From the porch Alice watched them grow smaller, the birds seeming to twist and dive as the umbrella turned on Merritt's shoulder. After a while it looked like a smear of red paint on the blue horizon, and then it was gone.

(1902)

THREE

The East End fell into inertia again as the twentieth century opened. Chase had left. The modernist explosion made plein-air painting seem dated and irrelevant. Young artists no longer waded through marsh grass in suits and taffeta skirts. Yet successive waves of landscape artists working in the wake of Impressionism continued to wash up on the established beachheads of Southampton and East Hampton, even as there were hints of a new order to come, just as dozens of Abstract Expressionists would land in Springs in the years after Pollock's death, when Abstract Expressionism had already lost its initial vitality.

By 1900, locals were complaining that the East End had become too expensive for common people and that its rural character was being destroyed by an influx of New Yorkers. The art community's invasion had reached its peak by 1898, the year Childe Hassam finally traveled east from Manhattan to see what all the noise was about.

Hassam, a half generation younger than Chase, had absorbed the lessons of Impressionism and was popular and successful. He made colorful pictures of both the country and the city, including some breathtakingly intricate views of Union Square and Madison Square in New York and a series of street scenes dominated by the flags of the Allied nations, particularly

the Stars and Stripes, that would bring him enormous popularity in the patriotic war years.

Largely because Chase and his friends had laid the groundwork, Hassam's career unfolded effortlessly. He was included in most of the major exhibitions of the day, and won medals and awards on a regular basis. At the height of his power, his vibrant canvases, which owe more than a little to Pissarro and Renoir, had even begun to take on something of a modernist flavor as he simplified his surface. The big red, white, and blue flags of the patriotic paintings threaten to flatten out into simple abstract shapes before your eyes.

Union Square in Spring (1896), an aerial view of the big park at Fourteenth Street in Manhattan, is a surprisingly modern picture. Spindly green-yellow trees blend with the lawns where they are planted, and grassy islands have a biomorphic look, like corpuscles on an Impressionist's microscope slide. Tiny people circulate in the white paths around the green islands. In the distance, buildings and avenues are suggested by abrupt daubs and slashes of subdued color that anticipate the Ashcan school's darker palette. The picture shows New York as Bonnard and John Sloan might have painted it on a single canvas as you read it from bottom to top, from the clearly lit, vernal park to the bland, hazy-looking stretch of pale color that is the New York sky. This picture tells us that for all the received flavor of Impressionism in much of his work, Hassam actually saw the world in front of him.

Color was Hassam's strength. His figures are awkward; the women who appear in his warmly lit interiors or sun-blasted gardens have the expressiveness of department store mannequins, and their arms often seem to have been imported from another body. The women look away from us, as if someone had just dropped a dish in the next room, or stare at the floor in contem-

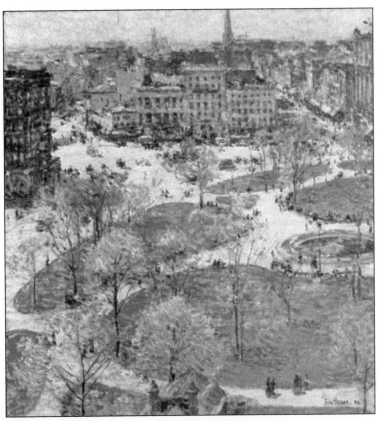

Childe Hassam, *Union Square in Spring*, 1896 (Smith College Museum of Art, Northampton, Mass. Purchased with the Winthrop Hillyer Fund)

plation or at something in their laps; sometimes their hats hide their faces. On the rare occasion when they look our way, Hassam blurs their features. His grasp of Impressionism was complete, however, and his best pictures are so dramatically structured and explosively chromatic that his shortcomings are easy enough to overlook.

Hassam's most rebellious act was to join the Ten American Painters, a group of artists that seceded from the Society of American Artists in 1897; they felt underrepresented in the soci-

ety's shows. Besides, they saw greater commercial opportunity in arranging their own exhibitions. The members were in their thirties and forties and had all studied in Paris, but they worked in styles ranging from Impressionism to the kind of genteel portraiture that Chase had made his calling card. In 1905, three years after the death of one member, John Henry Twachtman, Chase accepted an invitation to take his place ("My dear Hassam—I like to keep in good company," he wrote, as cheerful and diplomatic as always, in his letter of acceptance). The Ten stayed together for two decades.

When Hassam bought a summerhouse near the ocean in East Hampton in 1919, he was fifty-nine, financially comfortable, and pressed to keep up with the demand for his work. The Metropolitan Museum of Art found him to be popular enough to deserve a short film: the museum sent a cameraman to East Hampton in 1931 to make a silent four-minute movie about the great man. "His prominence, professionally and socially, makes heavy demands on his time," reads an intertitle, just before we see Hassam giving instructions to a secretary. The film shows Hassam playing golf and crashing into the surf at "the exclusive Maidstone Club," in a swimsuit fashioned largely from straps and trusses. Later, he makes the journey back to his "estate" in a chauffeur-driven touring car.

He lived in East Hampton from May to November each year until his death in 1935; he is buried at a cemetery in the village.

Ulrich Hiesinger, a Hassam biographer, wrote that some critics found fault with the painter for repeating himself in the last dozen years of his career; one critic wrote that he "became literary, arrogant, and, finally, dull" and another that "the artist has appeared frankly bored." But his etchings of saltbox houses in East Hampton Village and views of Main Street, with its dense canopy of elms, are richly atmospheric and highly skillful.

Like Thomas Moran, he was a first-rate illustrator, and the pastoral East End supplied abundant subject matter.

Hassam's 1920 painting *The Easthampton Elms in May* does for that town's Main Street what Chase's *The Bayberry Bush* did for the Shinnecock Hills—it captures the essence of the place definitively. The picture illustrates just how dense those trees were, and just how Edenic Main Street looked, years before Dutch elm disease began its slow devastation. The dirt street is quiet; two carriages stand in the middle distance; and two men in suits, dwarfed by the trees nearby, are quietly observing the scene. Though a few storefronts are also in evidence, and we can see a flagpole on the green at Town Pond in the distance, the village seems subservient to nature; the massed greens of the towering elms overwhelm everything else in the picture.

That painting shows us picture-book East Hampton, its image from Moran's time to the present. But *Adam and Eve Walking Out on Montauk Point in Early Spring*, a bizarrely allusive and far more adventurous picture, gets the light and the atmosphere of Montauk, the wildest and windiest part of the East End, just right. It and a few other late, allegorical pictures are Hassam's neglected masterpieces. They put him, briefly, in the company of Brueghel and Blake, though critics saw them as a betrayal of Hassam's gift for what had become the academic style of the day.

Using his own interpretation of Impressionism as a foundation, he added nymphs and dryads to these landscapes, even biblical figures in *Adam and Eve*. "I am treating the modern with the classical," he said. No one liked these pictures very much, and they are still less in demand than his straightforward pictures. But here he forged an unexpected connection with the panoramic landscapes of Bierstadt and with American primitive painting. The pictures have an otherworldly calm and suggest a visionary's heightened connection to nature.

Childe Hassam, *Adam and Eve Walking Out on Montauk Point in Early Spring*, 1924 (Guild Hall Museum Permanent Collection)

Adam and Eve is just under two feet high and five and a half feet wide. The thin, pale, nude figures of Adam and Eve, each about five inches tall, are accompanied by a dozen little lambs as they follow a path out into a vast expanse of yellow-green fields surrounding a pond of intense blue. The ocean can be glimpsed over distant dunes, and cirrus clouds scud across a brushy blue sky. The windswept quality of the landscape is immediately identifiable as Montauk. The inclusion of figures such as a childlike Pan—who, with his pipes, is seated on a nearby rock, though how he came to be acquainted with Adam and Eve is anybody's guess—makes the scene mythical as well.

In *Dome Green* (*Maidstone*), another panorama, just eight inches high and twenty-one inches across, Hassam again quite specifically reproduces the look of the light. This time, it's the clear, slanting rays of late afternoon that saturate the greens of the Maidstone Club golf course fairway and ignite a stretch of beach grass, turning it orange yellow. The underlit clouds—horizontal streams of cirrus—are so strongly defined by the sunlight they seem embroidered onto the canvas. Nothing has changed since Hassam made the picture, and no one would translate the East End's light so effectively until de Kooning, whose own late pastoral pictures seem to rise out of a vision.

Hassam's allegorical paintings were in part a conscious re-

action to modernism, which he regarded with suspicion, even though a couple of his canvases had been included in the Armory Show of 1913. Like Chase, he always had one eye on the marketplace, and modernism presented a threat to his livelihood.

Hassam was not alone in disliking the young artists; Chase hated them, and raged in particular against the Futurists, whom he considered outright phonies. Had Chase and Hassam lived a few years longer, they would surely have been sent into even deeper depression, for the Surrealists were very soon to come to town. It's hard to imagine Hassam, so much a figure of the nineteenth century, shaking the hand of Fernand Léger, who stayed on Wiborg's Beach at Sara Murphy's family compound, just a quarter mile from Hassam's house. And if it is difficult to imagine André Breton and Chase in the same room, how wonderful and unlikely it is that Breton wrote a major poem in a house a mile or two from Chase's place. But such juxtapositions have always been typical of the East End.

FOUR

Fireplace Road, two lanes of blacktop, sweeps north through Springs, the cheapest and quietest place to live in East Hampton. The road runs past ranch houses, a few preserved farmhouses, and a handful of wheat-colored fields, beyond which you can see Accabonac Harbor. About two miles before the road abruptly ends at Gardiners Bay stands the little farmhouse that Jackson Pollock and Lee Krasner lived in from 1945 until Pollock's death.

It is brown-shingled, trimmed in white, no more than thirty feet from the road, half-screened by trees and a hedge; a silver chain loops across the mouth of its narrow, sandy driveway. Although in its incarnation as the Pollock-Krasner House and Study Center it is on the National Register of Historic Places, it looks much the same, inside and out, as it did the August night in 1956 when Pollock piled his girlfriend, Ruth Kligman, and her friend Edith Metzger into his Oldsmobile convertible and drove off Fireplace Road into a trio of oaks, killing himself and Metzger, less than a mile from home. Kligman, who was thrown clear of the wreck, suffered a fractured pelvis and back injuries.

Pollock was no stranger to car accidents. He'd driven his Cadillac off Old Stone Highway and into a tree, after knocking down three mailboxes and sideswiping a telephone pole, about a mile from home. Although the car was wrecked, he was unhurt.

One time he and Franz Kline had been drinking, when Kline drove head-on into another car, on Main Street in East Hampton. Pollock cut his lip.

The local police did what they could to look out for him. He was on the list of town drunks, and they were used to scraping him off the streets. He drank with the plumber and the electrician, not his fellow artists "from away." When he couldn't remember where he'd parked his car after a night out, the cops helped him find it.

A tenth of a mile south of the Pollock house, Old Stone Highway branches east from Fireplace Road, an intersection that comes as close to a "downtown" as Springs gets. The Springs Community Presbyterian Church, a two-story white-shingled structure with a little steeple and a single chimney, occupies one corner. Pollock's memorial service was held there; in those days it was known as the Springs Chapel.

Behind the church is a small cemetery in the shade of thick evergreens. Each of the small, mottled, dirty-looking headstones bears a filigree of golden lichen; on some stones it's as thick as a coating of breadcrumbs. Many graves are marked by bare stones. Jeremiah Bennett, who died in 1902, was the last to be buried here.

Just across the narrow road is Ashawagh Hall, a snug white-stucco building with a green pitched roof that once served as a schoolhouse and was purchased by the Springs Village Improvement Society in 1909 for one dollar; the name means "crossroads." In the teens, people would gather at Ashawagh Hall to watch slide shows, then a novelty. It's remained the de facto community center, most often hired by individuals and groups for art exhibits. Each August the Fisherman's Fair, a one-day event, occupies the lawn. It was once a familial gathering of Springs residents, who brought Swedish meatballs and clam pies to share. "Mrs. Pollock's" apple pies were a feature for several

years. Jackson did the baking; Lee Krasner would rather eat dirt than bake a pie. Willem de Kooning donated drawings to be raffled.

A little farther down Old Stone is the Springs General Store, established by David Dimon Parsons in the early nineteenth century. In those days it was a place to gather and gossip. In 1902, Charles K. Smith, the owner at the time, reportedly sold two tons of his own pancake mix from the store. Daniel T. Miller, who would buy the business in the mid-1940s, said that figure was probably accurate; people in Springs ate pancakes for breakfast 365 days a year.

Past the store, Old Stone Highway takes lazy turns, rising and falling through woods out of which deer appear. Three-fifths of a mile along, where Old Stone veers to the left, toward the water, and Neck Path heads straight east, toward Amagansett, is the mouth of Accabonac Road, the most unchanged of the three arteries that take Springs residents south to East Hampton Village, or "up street," as natives still refer to it.

William Merritt Chase is buried in Brooklyn; Childe Hassam in East Hampton Village; Fernand Léger in Essonne, France; and Dan Miller in Calverton, an hour west of Springs. But Stuart Davis, who never set foot in East Hampton, and Ad Reinhardt, who visited just a few times, are in Green River Cemetery, three hundred yards down Accabonac Road. It's where Pollock rests and where Springs families have been buried for three hundred years.

At least twenty of the graves dug since 1956 are marked by smaller versions of the boulder that Lee Krasner rolled onto Pollock's resting place. Dozens are inscribed with facsimile signatures, just like Jackson's. Since the release of the movie *Pollock*, people leave things at his grave, the way they do at Jim Morrison's marker in Père-Lachaise.

Although people were buried there as long ago as 1700, it became an official cemetery when the land, where pigs once roamed, was purchased from Emmett Miller in the late nineteenth century. Some said that it took its name in part from Miller's father, Sam Green Miller. But the nearest river, the Peconic, is about fifty miles away.

Dan Miller had a more likely explanation. The story goes that Emmett Miller once visited Green River, Vermont, a place he found so gloriously advanced that on his return he tried to enlighten his neighbors as to how things were done there. Weary of his incessant badgering, they began calling him Green River, and the name stuck to his property following his death.

Starlings and sparrows flit through the cypresses, oaks, and red maples that canopy much of the place. A simple, low white fence provided by the town separates the cemetery from Accabonac Road and the woods on its other three borders. Two parallel paths, about forty feet apart, each just wide enough for a car, run uphill from the road to the rear of the original two-acre grounds, where they meet to complete a horseshoe. Pollock's boulder, which can be glimpsed through summer foliage, sits just beyond the property's highest point, overlooking it from the southwest corner. It seems to belong not to the graveyard but to whatever lies beyond it, over the hills' crest. For thirty years it marked the rear of the cemetery, where the woods resumed in a scrubby sprawl.

Krasner and Pollock often stopped at Green River "on walks in the neighborhood, and Jackson many times expressed a desire to be buried there," Krasner said. "I really had no choice in the matter."

At his death, she purchased the equivalent of three plots—sixty by forty-five feet in all. "Jackson had a thing for boulders," Krasner said, and a forty-ton specimen was placed there with

considerable effort by Pollock's friend and neighbor Jeffrey Potter, who, as the owner of the East Hampton Dredge and Dock Corporation, had the equipment for the task.

The forty-ton marker was a replacement for a considerably smaller stone that now identifies Krasner's plot. A few days after Pollock's service, Krasner told Potter that the marker "didn't work," using a phrase Pollock employed when evaluating paintings. She set off to find a bigger, better boulder, going as far as Sag Harbor. "She was obsessed," a friend said.

One day, Pollock's friend the painter John Little, on his way to the town dump, noticed a likely candidate about two miles away. "Lee took one look and said, 'That's it,'" Little told Potter, who offered to transport the boulder to the grave site, gratis.

"We decided we could handle it with our heavy equipment in half a day. I told Lee that there was nothing to it," Potter wrote. But he and his assistant soon discovered that there was more to the boulder than they had assumed; it "went way down to a point" underground. They asked Krasner if they might dynamite the boulder to make it more manageable; its appearance aboveground would not have suffered. But she would have none of it.

It took the men two days to get the big rock loaded onto a reinforced trailer, and when they tried to climb the cemetery's slope, the load was so heavy that the tractor and trailer dug straight into the hill. Later, they would have to repair and regrade the driveway.

Rolling the boulder from the trailer into the excavation wasn't much easier. Pollock's coffin was unprotected by a vault, so, "it being only wood, you slam a boulder against it and you've got a cracked egg," Potter's assistant said. Although the boulder landed "just where we wanted it," Krasner wasn't satisfied. "We turned it for her, what we could, then that was it—turned any more the pressure against the coffin would have shot Pollock out of it like a cork out of a pop bottle."

There are about forty cemeteries in the town of East Hampton, though most were filled to capacity long ago, and the majority are family cemeteries that saw their last interment in the late nineteenth century. Some hold single plots, such as the one that Benjamin Hubbard, who "died of the small pox" in 1789, occupies, and another in the Northwest Woods section of the town that holds Ned, "faithful Negro Man-Servant to Jeremiah Osborn." Some are abandoned or deserted. But by 1967 Green River had become so famous that people were "dying to go there," as Ad Reinhardt cracked not long before he himself was to be buried at Green River. When *The New York Times* published an article about the cemetery in 1968, people from all over the country wrote to ask if plots were available.

In 1987, when all the plots were full or spoken for, the Green River Cemetery Association, five Springs residents whose families go back several generations there, purchased an additional acre of wooded land from Donald Ferriss, who lived in the original Miller farmhouse adjacent to the cemetery grounds. The new section was almost completely stripped of trees; walking from the original grounds to the new plot, across the imaginary line marked by Pollock's grave, is like walking out of a church and onto a golf course.

When Steven J. Ross, the chairman of Time Warner who lived part of the year in the wealthiest section of East Hampton, near the old Wiborg estate, died in 1992, his wife purchased 110 of the 400 plots in the Green River annex for use by her family. The cost for a plot then was $700; Mrs. Ross paid $77,000. Mrs. Ross and Steve Ross's close friend Steven Spielberg had gone to Green River on a reconnaissance mission some time earlier. "It looked so empty," a Ross associate said. "The cemetery seemed to have a lot of space."

Some objections were raised to the purchase, particularly

when Mrs. Ross made one of her plots available to the family of the film director Alan J. Pakula following his death in 1998. "It emphasized the privileges of the rich," Ferriss explained. "If you're a local person, you can't be buried there, but if you're rich and famous, you make a phone call and get a plot."

When the association approached Ferriss about purchasing the additional land, he agreed to sell it to them for a reduced price because the income generated by the sale of plots at $700 would have made it difficult for a purchase at market value. "I suggested that they might raise the price, but they feared that a price hike would put plots out of reach of local people. It was a point well taken."

When Mrs. Ross snapped up the 110 parcels, Ferriss said he felt that "my effort at philanthropy resulted in welfare for a woman with $860 million, benefiting the posthumous social aspirations of people other than my neighbors. It's a form of cultural imperialism."

Association members argued that the Ross purchase provided them with the capital to expand the cemetery further if they liked, but when Ferriss agreed to sell them another acre at $125,000 in 1999—again, a price well below market value—they never followed through. "They said they'd buy it as soon as possible," Ferriss said. "But I never heard from them again." Why? Ferriss speculates that "everyone just thought, 'Who the hell are we doing this for?'"

Joan Ward lived directly across Accabonac Road from Green River in the house she and Willem de Kooning shared from 1961, when they moved there from New York, until 1964, when he moved into the residence and studio he built for himself about a mile away.

"It's a local cemetery. You see the same names over and over again," she said. "There are a few artists, here and there. But now

there are people with cameras, photographing their friends leaning on gravestones. And I've seen a tour bus go through." Directions to the cemetery are dispensed at the Pollock-Krasner House.

Families who owned plots had received telephone calls from persons "making generous offers." And the cemetery association heard from someone who "wanted to pay for a survey to be sure there wasn't room next to Pollock."

De Kooning was "horrified by the idea of all the boys buried up on a hill together. He said, 'Joanie, don't let them put me there,'" Ward recalled. De Kooning, who died in 1997, was cremated.

You have to walk about thirty feet uphill from the horseshoe path to reach Pollock, and you have to pass Krasner to get there. On that flank of the cemetery, running almost clear to the road, artists are interspersed with members of Springs families. Beckwiths, Millers, Kings, Collums, and Bennetts share the land with Stuart Davis, Ad Reinhardt, Jimmy Ernst, and Elaine de Kooning.

Davis's monument is a six-foot-high black marble monolith with his signature etched deep into its face in large, fluid script. Reinhardt lies beneath a smooth white stone laid flush to the earth, a reverse image of Frank O'Hara's dark marker just a few feet across the path.

Elaine de Kooning is buried beneath a rectangle of pink granite with a bronze sculptural relief laid into it. She and Willem de Kooning were married from 1943 to 1957. It wasn't easy for two ambitious painters to live together, and neither Elaine nor Bill liked keeping house. "What we need," Bill once said to her, "is a wife."

In 1977, Elaine returned to look after Bill. She bought a house in Springs but spent most of her time reordering his

chaotic life. She helped him to finally stop drinking, dismissed his assistants, and screened his visitors. It's common knowledge in East Hampton that in Bill's later years of drinking, small works of art—drawings and oils on paper—routinely walked out the back door. That phenomenon ceased once Elaine was back on the scene.

The hill drops off dramatically just behind Pollock's marker and runs at a steady grade to a narrow driveway, a nice, short run for a sled. If the boulder were to break off and tumble to the foot of the hill, it would easily take out the polished slab of the conceptual artist Hannah Wilke; if it veered just a bit to the right, it would crush the little boulder that marks the resting place of the critic and curator Henry Geldzahler. If it rolled to the left, it could dislodge Steve Ross.

Pollock was buried on a hot August day following a very brief late-afternoon service at the Springs Chapel that brought together friends, family, neighbors, fellow artists, collectors, dealers, museum officials, and critics. Krasner had asked Clement Greenberg to speak, but because Metzger had been killed in the crash, he refused "on moral grounds." Instead, an Episcopal minister who knew little of Pollock read from Saint Paul.

Pollock was forty-four years old when he entered Green River, and the poet, critic, and curator Frank O'Hara was forty. O'Hara had been struck by a Jeep on Fire Island just a few days before; although he was seriously injured, he would have had a better chance of surviving had his liver not been so damaged from years of heavy drinking, doctors told his friend Joe LeSueur.

O'Hara and his friend J. J. Mitchell were on their way home in a beach taxi after making the rounds of Fire Island bars; it was

about 2:30 in the morning when their taxi broke down and its passengers stepped onto the sand to wait for another taxi. O'Hara wandered off toward the sea; blinded by the halted taxi's headlights, the young couple in the Jeep didn't see him until it was too late.

O'Hara had visited Pollock's grave in 1958 in the company of a friend's young daughter. He was sufficiently affected to later write a poem in which he addressed Pollock as a kind of muse: "like that child at your grave make me be distant and imaginative / make my lines thin as ice, then swell like pythons."

Almost two hundred people attended O'Hara's service, on July 28, 1966, just two weeks short of ten years after Pollock was buried, and on a similarly scorching afternoon.

"Grace to be born and live as variously as possible," a line from an O'Hara poem, is inscribed in the slate marker that lies flush with the earth like a gray page just a dozen yards downhill from Pollock. "Frank's head is at Jackson's feet," Lee Krasner said after the service.

Some time afterward, J. J. Mitchell realized that he had O'Hara's overnight bag in his apartment. In it, he found a manila envelope containing a copy of a paper written by Pollock's psychiatrist that described "the role of the analyst vis-à-vis the artist/genius."

Mitchell also discovered a small journal whose sole entry, on the first page, was a poem written in O'Hara's hand three months before:

OEDIPUS REX

He falls; but even in falling
he is higher than those who
Fly into the ordinary sun.

Between O'Hara and Pollock and under simple, identical gray headstones lie A. J. Liebling and Jean Stafford. Stafford and Liebling lived in a small farmhouse on a thirty-acre parcel on Fireplace Road a half mile north of the Pollocks. Liebling purchased the property, which also included a couple of outbuildings, for $16,500 in the mid-1940s. There is no record of their ever encountering the Pollocks, though they might have bumped into each other in Dan Miller's parking lot; everyone did.

FIVE

The museum was the same, and, surprisingly, the people there looked much as they had. There were more of them than before, or maybe this was a holiday of some kind. A little booth stood at the foot of the great staircase, where an admission fee was asked, but he stepped around it, and the guard, who could have been the son of any of the guards he remembered, for the uniform was the same, though his hair was wilder, didn't notice him.

There was the same air of walking about inside a temple or a castle. The echo of conversation carried across the huge room, voices and shoes combining in a sibilant rush.

He could find the usual galleries blindfolded but had left parts of the place unexplored. Peering at the schematic diagram on the wall with the red X marking the spot where he stood, he saw that there was a new wing of American painting. He felt a twinge of anticipation and carefully examined the map, deciding to walk there directly, but slowly, to put his mind in order and to calm himself. He did not know how he was so certain of it, but somehow he knew that if there was a new wing, then he would be in it, and Bill, and maybe Franz. For the first time he wished Lee were with him and imagined how grand it would be to see her face when she saw his picture on the wall of the Metropolitan: she'd be so happy she would bust. But, no, she would find

something wrong. It would be the wrong picture, or they would have hung it badly, or she'd curse whoever had sold it to them.

He felt unburdened, light-headed, and hardly noticed the paintings he passed, though here and there something stopped him in his tracks, as if Tissot or Titian had held a hand to his chest. He felt diminished before the big pictures of soldiers on horseback, the subtle patches of red and ocher that popped out from vast, densely populated canvases, the dizzy feeling that looking at Tiepolo's chubby angels gave him. As he walked through the centuries, things seemed to get greener, and eventually it seemed like green was all there was, and then because there was so much green, the other, primary colors followed, one by one. And around the time of the Armory Show, colors were isolated, then shapes, shapes taken half out of context. It was as if once you learned everything there was to know about painting, once you could paint a dog or a flower or a sunset better than anyone, then you began stripping away the elements, dismantling what had taken two thousand years to put together. If Giotto were here, he'd like Picasso, but he'd think Renoir was crazy. All those silly red-haired girls, all that wooziness, wasn't it shallow, obsessive? He'd think Picasso was crazy, too, but he'd see that he could paint.

What would a Giotto have looked like to an Italian sitting in church? He would have seen the characters, not the art, taken pleasure in identifying the story. He would have been thinking, maybe, about what he was going to say in confession. Art had become so specialized over the centuries, so unimportant, really. No one in Springs had had any reason to look at his paintings. They saw nothing there that had anything to do with their lives. That was why no one would take them in trade for even the homeliest of solid goods when he offered them. There was nothing to be gained.

Whom was he painting for? It was the kind of question no one ever bothered to ask, and if they did, how to answer? Most painters would tell a half-truth. They painted because they were painters. It was what they did. That was reason enough, and honest enough, but it left out the competitive aspect. You painted because you believed you could do it better than anyone else. This was easier to do than it would seem to most people because most people, including most critics and most painters, wouldn't know a good painting from a drop cloth. What was the expression—it's easy if you know how? Patsy asked him to show her how to bake an apple pie, and he told her, genuinely surprised, that there was nothing to it. Few of the painters he knew had the slightest clue where they stood in relation to Giotto, say, and probably never would. It wasn't even a matter of taste. Taste came into play only if you could make the broad distinctions to begin with. If you couldn't see what made great painting, then what difference did it make if you preferred one lousy artist over another lousy artist? If you'd never tasted fresh tuna, then you might think that it mattered whether you bought Chicken of the Sea or Bumble Bee.

In his best moments he knew he would be a great painter, and that nothing else mattered. As a kid, he'd felt apart from the world his brothers lived in, and though it sometimes made him lonely, it made him feel special, too. He knew that other kids felt like outsiders. But he felt that he had been singled out for something. It gave him strength, or maybe it was just stubbornness. He knew that all he had to do was wait and his time would come. He knew that he was more than the inarticulate oaf or the brute that he later realized he looked like to people. He had even come to relish playing that role; it meant he didn't have to talk to people he had nothing to say to anyway. If his inclination was to drift to the edge of life, well, that allowed him to gain perspec-

tive. You couldn't get a clear view of things if you were in the middle of everything.

Look at his teachers. Look at Benton. He loved Benton, but even when he was his student, practically his son, he knew he'd outstrip him. Benton had a formula for everything, and even while he learned to draw the way Benton wanted him to—and that was a struggle—he knew that all this would fall away in time and that he would find a place Benton could never understand. The limitations were painfully clear. They were clearer now, of course. But even then he'd felt them.

He'd gotten no respect from older painters and even artists his age. They saw a hick who couldn't draw worth a damn. He did have friends who encouraged him, but he knew that secretly they thought he was a loser. Only Lee believed in him, and it didn't really matter whether that was simply through love, though it wasn't—he saw how quickly she fell into a manner of working that was a variation on his own, how the imagery in her work changed.

The only painter he looked at as an equal now was Bill. The problem with Bill, of course, was the strong possibility that Bill was better than he was, in the end. He had it all. Almost. He would never be able to do what Jack could do with paint; it just wasn't in him. So it was childish, probably, even to compare, because each of them had something new to say. Actually, it was a kind of miracle that they were alive at the same time, not to mention that they knew each other, that they lived a mile apart. That certainly must have happened in the old days—all those Italians who handed painting down as if it were shoemaking, so many of them masters—and then there was van Gogh and Gauguin, of course. But him and Bill knocking them back at the Cedar, sitting drunk on a curb together, living in Springs.

What Bill had that he didn't was an ease with everything,

with his work, with other people, with all the crap you had to put up with. None of that came easily to him. You could see clearly that Bill believed in himself so completely that he could make a joke of his own shortcomings. He was so confident of his abilities that he simply ignored everyone else. He was generous, even. He'd say encouraging things to other painters, especially girls, of course. He even seemed to take everything with a grain of salt, though the more time you spent with him, the more you saw that he was driven by an ambition that was every bit as powerful as Jack's. He ran over everyone in his path without even meaning to. That could be enjoyable.

There was cruelty in Bill. You saw it in his actions, sometimes. He could be a mean drunk. And sometimes he was mean to people, in the Cedar, or at a party, in an offhand, cold way. It was frightening because it was so casual. Jack didn't have that in him. When he felt a mean streak coming on, it was usually for a specific reason. Lee had pissed him off, or some asshole had said something stupid about painting. He felt the rage coming, and when he was drinking, it was easier to let it play out; it felt good to let loose. If you got in the way, well, you shouldn't have put yourself in the way. When he was on the tranquilizers, those things didn't really faze him, or not as much.

But when Bill said something cutting, it came very easily, as if he were talking about the weather. It didn't happen all that often, so most people saw only the charming Bill. But he had cold eyes. There were times when Jack had felt diminished, belittled, trivial, just because Bill had glanced at him, ever so casually, with those hard eyes, and he felt that Bill was amused by him, that Bill felt that no one in this world could touch him. Even when Bill was sober and friendly and full of laughter, his eyes were cold. It had always bothered him, for you felt then that at bottom Bill was cold and calculating, that all the goodness was a kind of act.

61

But surely that was taking things too far. Maybe seeing things so clearly just gave him that look. You saw it in people's eyes when they were concentrating on something they were saying, when they were focused and intent, but Bill's eyes were always like that; they had that hardness and that little flash of light in them. He said he only saw parts of things, that when he tried to paint he could only see pieces of the scene or the figure in front of him, that it was hard to put it all together; maybe he was always trying to put together the scene in front of him, and it made him look more fiercely at the world than ordinary people.

But if Bill was so seemingly easy with himself and other people, why did he drink the way he did? They said that drunks like him and Bill were haunted by something, that you thought less of yourself than normal people did, that you were trying to obliterate some part of yourself. What did Bill hate? He was handsome, all the girls wanted to fuck him, all the painters thought he was a genius, he had a sense of humor; even Elaine, who was a complete bitch, worshipped his every move. Sure, she slept around. A lot. But she was still Bill's. There was a marriage. They both screwed whomever they wanted to. So what could Bill be unhappy about? Maybe it was the Dutch in him. The Dutch were like the Scandinavians: they liked to drink; they were gloomy because they lived so far north.

And then it could be that Bill was just like him, that there was something in his chemistry that kept him from processing alcohol like other people. Everybody he knew drank, but they didn't get drunk for a week or two weeks or a month the way he and Bill did. They got hangovers, but it didn't make them sick the way Bill got sick. And the Dutch had strong constitutions, too.

The matter of Lee complicated the way he looked at Bill, and he tried not to think about it, because it disturbed him in a very elemental way, made him feel queasy and anxious. She hated Bill,

everyone knew that. They said it was her competitive nature, that Bill was the enemy because he took attention away from him. But all their friends knew that Bill had humiliated her, that she had tried to make him at a party and Bill had dumped her on the floor when she'd sat on his lap and tried to put her arm around his neck. She was very drunk, and Bill was drunk, too. She meant it in a playful, flirty way, but she was loaded and he was disgusted by her. She'd been loud all night, and when she climbed onto him, a look crossed his face as if he'd smelled shit. He stood up abruptly and she fell, spilling her drink, landing on her side in a heap. Someone had laughed much too loudly, and she got to her feet and began yelling, calling Bill a son of a bitch and a scumbag until finally someone dragged her out of the apartment.

Lee was tough, and as the years went by, she just got tougher. But she would never forgive Bill, and she hated Elaine so passionately that the mention of her name was enough to set her off. Those who said he was quiet usually noted that Lee more than made up for his silence, and it was true. She liked to talk—she was on the phone half the day—and did not shrink from letting people know what she thought of them, right to their faces.

She never talked straight-out about the incident with Bill, but you could see it colored every thought she had about him and his art, and his friends, and Elaine. Her face changed when someone mentioned either of them. You could see everything she was thinking on her face most of the time anyway (except when she was with Peggy, Mrs. Moneybags, trying to get something out of her—then she looked as innocent as Lee could look). But mention Bill or Elaine and it was as if someone had thrown a switch.

He decided, looking back, that being alone, being on the outside, took its toll. Some people were beaten down by life

through no fault of their own. They just weren't built for it. He could see that now. All the years he had been patient and waited to paint well, to show everyone what he could do, for all of the abuse he had taken, he had suffered. When he thought of himself as a kid, he saw a quiet boy. But he didn't remember ever being particularly unhappy. His childhood was pretty normal, really. If happiness meant having a hundred friends and living the life of a child in a Norman Rockwell painting, then maybe he hadn't been happy. What was happiness, anyway?

Toward the end he'd felt uncomfortable most of the time. He'd lost the flexibility that had allowed him to roll with the punches. He didn't like talking to people any more than he ever had, and it took more effort even to try. Mostly it was that he didn't feel good, physically. It wasn't so much the hangovers as

Jackson Pollock's passport photo, 1955 (Jackson Pollock Papers, Archives of American Art. Courtesy of the Pollock-Krasner House and Study Center)

an allover fatigue. He didn't have an appetite, and he didn't have much energy. He slept longer, thinking he would wake up feeling better, refreshed, but he would feel worse, as if he were underwater. When he got out of bed, his muscles ached and he felt queasy. His face looked puffy, and he didn't like carrying the extra weight he had put on. He had always been skinny; he had never been uncomfortably aware of his own body, as he was now. When he got into bed and rolled onto his side, he felt his stomach hanging, a sack of fat. How disgusting fat people looked as they waddled down the street. One time, years before, Alfonso and Ted had been over, and Alfonso and Lee were talking about poetry while he and Ted listened. Alfonso could quote poems by the yard, and most of it sounded too flowery to him. Lee didn't like it, either, though she pretended to. He and Ted listened politely. But one line had lodged in his head; he'd asked Alfonso to repeat the poem it was from, and he had. He'd long since forgotten its title, and who had written it, but lately the line, or part of it, kept coming back to him: "fastened to a dying animal." It struck him when he felt mysterious, sharp twinges in his side (liver? appendix?) or when he woke feeling half-dead. When he got out of bed, his legs were leaden: the legs of a dying animal. His physical condition depressed him, and the line didn't make him feel any better. But it hit the nail on the head. It was the only time that a poem had made that kind of impression on him. He liked the scraps of poems that Clem and Bob Friedman had sometimes suggested as titles of paintings, phrases from Homer and Shakespeare, because they suggested meanings and feelings without coming out and saying it straight—he liked the mystery of those titles. *Full Fathom Five* was from Shakespeare; you didn't need to know the play, though, to get its meaning, and it worked with the picture; it reflected the image, its depth and its swirl. He was wary of titles; he didn't want people labeling his

pictures, for they spoke for themselves. Bill was the same way. He'd let others name them, or he'd make up something on the spot that struck him as funny. But naming them was largely a way of keeping them in some order, a way for the dealer to tell them apart. Now it seemed like everyone put numbers on their pictures instead of making up titles. He'd started that. People were sheep, and painters were no different. Maybe one in twenty had a good pair of eyes.

His fans were as blind as anyone, but sometimes a youngster would come by who was excited by meeting him in the flesh, and then got excited by the pictures themselves. When he took them out to the barn, a kind of quiet came over them, and he knew they felt something from the work that couldn't be spoken. That pleased him; it was, after all, what he was after.

He stopped in a big gallery with pictures up to the ceiling. On one long wall was something worth looking at. Here was a painter who felt the energy in things, who knew something about rhythm and music. Poussin's picture was about seven feet wide, five feet high, just the right size to suck you into its flow. This was about as good as it could be done before he came along and made it work on a real, one-to-one, man-size scale. It was *The Abduction of the Sabine Women*, which he'd thought was called *The Rape of the Sabines*, but no matter. There was almost too much to be said for it, so much going on in so many different ways that really all you could do was stare.

Of course it was stagy, artificial, because each of the dozen or so figures in the foreground looked posed, the plump women with their heads thrown back in despair and their arms flung out as they were carried off by the men. The men all held daggers in the air, and the one who had no shirt on looked like a perfect Michelangelo model, an anatomy chart. But if it was a little bit phony, like a Hollywood movie, other things made up for that

in so many ways. There was the light, which was also staged-looking, but so exaggerated that you almost believed it—nature really looked that way sometimes. The sky in the background was threatening, with sunlight breaking behind storm clouds, and it was near sunset, or sunrise, so the light came at everything sort of sideways rather than directly. That would almost explain why certain people looked spotlighted, and others were in shadow, why bits of white clothing stood out so powerfully. He was familiar with this slanting light; you saw it before thunderstorms anywhere that was fairly open, he'd seen it as a kid in California and in Wyoming, and it was his favorite kind of light in Springs. Just before a storm the light would flatten over the harbor by his house, it would get a filtered quality, and when you turned to look from the gray water, you'd see at once how white the trim on the houses looked, how certain small features seemed dramatically outlined, as if full sunlight made everything so equally bright that it was all the same; the intensity washed out things you might otherwise see. Poussin got that. The action took place in an open square, and the sky in the background explained the filtered, selective light. And Poussin underlined it by putting a dim grayish building at the edge of the square, a dark backdrop for all the commotion in the foreground, as if it were already growing dark everywhere but in the square where the women were being torn from their babies, who crawled in the dirt screaming. It was supposed to make you sad, but it had become too corny over the years for that. What you felt was a rush of excitement at all the activity, all the urgency. If you asked what kind of music it was like, people might say Beethoven or Wagner because of the high drama, but that wasn't it; it was as organized and tightly woven as Bach. It was like Bach at his most frenzied, when he'd built up a whole series of melodies, from one instrument to the next, and now the entire orchestra was playing this

complicated arrangement of melodies, all of which were related like pieces of a puzzle. And, amazingly, everything fit. The picture was like a mathematical formula, like algebra. You had the feeling that if one figure came out, the whole thing would look lopsided, but it took a little while to appreciate that, because there was so much going on.

You understood it in stages. When you first saw the picture, you were completely taken over by its rhythm. Then you saw how complex it was, how artificial. And then, once you understood how it worked, and got over the staginess, you could see how beautiful it was. But in the meantime, it had lost something of its power because you saw that it was so deliberate, every finger, every lock of hair, placed just so. So you admired it. It was a great picture, no doubt about it. But it didn't seem genuine anymore; it didn't get you in the gut. That was also because it was about some event that probably never happened, and because it told a story instead of meaning something on its own. The story it told got in the way. It wasn't Poussin's fault; that was what painters did then, they had to have some kind of artificial subject. Today there was no excuse for putting boundaries between the painter and the viewer. You wanted to show the energy in life, you wanted to make the connection, let it move through you onto the canvas—and if you were painting well, it didn't freeze up when it hit the canvas. It was like capturing lightning in a bottle.

Leonardo said that painting was better than poetry because painting presented truth and poetry presented words. Alfonso had explained this to him. Painting was direct knowledge, it was science, it was factual. You looked at nature and put it on the canvas. Poets had to use their imaginations to try to find words to describe what they saw. So as far as being one with nature, poets took a backseat. There was just no comparison. Leonardo

said, too, that painters got a raw deal for just that reason—their tools were colors, not words. Painters didn't talk; they painted. Poets made the case for poetry—they talked themselves up—while painters just kept putting paint on canvas.

That was why Clem and Harold were necessary. They knew how to make the pitch for him and Bill. He'd gotten a little better at it over the years but never enjoyed playing that game. He left it to Lee and the others. He liked being famous, but it brought as much bad as good. Bill felt the same way. Elaine did all the fancy footwork. Bill liked to say it was because his English was bad, but he knew better. You couldn't help but feel like a faker sometimes, with these people trying to convince everyone what a genius you were, as if they were talking about someone else. You wanted to hide. But it was necessary if you were going to pay the bills. If he and Bill didn't have Lee and Elaine, they'd both be drunk under a table at the Cedar now and no one would know who they were. Well, they'd know them, but they might not be climbing over each other to suck up to them.

He realized, moving through the galleries, that he felt good. No hangover, no crud in his eyes, no film of sweat that he could never quite scrub away, no headache, no queasiness in his stomach. The anxiety that he had lived with for so long was lifted. He felt light. If he wanted to run ten blocks down Fifth Avenue, he probably could, and wouldn't be winded. So this was what it was like, being dead.

For all the times he'd been here, he always got lost at some point, found himself passing the same Fragonard for the third time when he'd thought he was progressing into another century. He had a vague sense that he was heading in the right direction, and when he came to a blank gray wall, he kept going, thinking that the new wing might be there somewhere, and it was.

He turned a corner and found himself in a huge gallery fit to house a small airplane, and there was a Barney Newman and a Rothko and there—there, looking strangely small—was *Autumn Rhythm*.

It looked—small. The white patterns at its edges were brighter than he'd remembered against the dull weave of the canvas, and there was enough light in the room so that you could see the fine webs of paint clearly. He stood back—no one else was in the gallery—and watched the picture. It was an energy field; it was magnetic. He felt pulled toward it. It had the same magnetism as the big Poussin, but his painting had urgency, and Poussin's didn't. There was a big Kline that looked good, too. And the Newman was fine if you stood close to it; you had to be next to it to get drawn in, to feel the way the field of color vibrated. On the wall opposite *Autumn Rhythm* was a portrait of Elaine de Kooning he'd never seen before—Lee must have had a stroke on the spot the first time she saw it. It was a nice, colorful picture, a little like Bonnard, and it was by Fairfield Porter. And the Bill—instead of an abstract picture they had a woman, a nice painting. It had beautiful shapes in it, where it started breaking apart, away from the figure, and you could see all of Bill's drawing in it. It was pretty old-fashioned for Bill, but a good one to pick if you wanted one of the more conservative pictures.

He stepped to the center of the room. The air was still, the light neutral, flat. It was a strangely inhuman space.

The barn in Springs wasn't all that much bigger than the New York quarters he was used to. His city studio was eighteen feet square, and when he and Lee first moved to Springs, he worked in the smallest of three upstairs rooms, no more than ten by twenty feet. The studio in the barn was about twenty-one feet

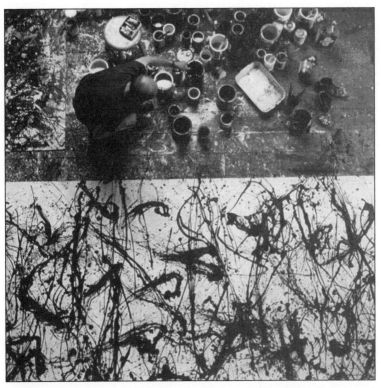

Jackson Pollock in the studio, 1950 (Courtesy of the Pollock-Krasner House and Study Center. © 2005 Estate of Rudy Burckhardt/Artists Rights Society [ARS], New York)

square, but the ceiling was eighteen feet away, and a mosaic of windows high on the north wall let in natural light. He could see that it was perfect when he'd first busted open the lock and walked inside. First he had to clear out all the junk that was crammed inside it, years of trash accumulated by the previous owner. He dragged it and threw it out into the yard, piles of broken furniture and rolls of some kind of mildewed fabric, scraps of rusted metal that might have come from a boat trailer, old gas cans, milk cans, watering cans. He swept it and mopped it and cleaned the slatted walls the best he could: when he could afford

it, he'd nail up Sheetrock. He built a shelf for supplies. There was a small cast-iron stove, and he cleaned that out, oiled the hinge on its door, and found a little scuttle to put wood in.

When a canvas as large as *Blue Poles* or *Autumn Rhythm* was laid out, along with dozens of paint cans, there was just enough room to move around it. That's why there are cigarette butts and bits of glass stuck in the pigment of his big pictures of the late 1940s. Why not elaborate on those accidents, throw in all kinds of little bits of crap?

He liked working small, and most of what he made is considerably smaller than the epic dripped paintings that made him famous. He crouched, marking off smaller rectangles within the large rectangle of the cotton duck unfurled like a magic carpet on the floorboards. He worked in sequence, making one image after another. The black-and-white pictures of 1951 were painted that way, a series that, seen together, as they are in the photos that Hans Namuth took, looks like a modernist cartoon strip. He thought of them that way, as panels in an epic cartoon.

Lee had thought that moving to Springs would sober him up, keep him away from bars and bad influences. He liked the country. What did someone like Hans Hofmann, with all of his theories, know about the connection he felt with nature? Use nature for a model, Hofmann had told him once. "I am nature," he'd told him, the presumptuous little Kraut.

At first he didn't have a car, so if he wanted to drink, he had to catch a ride to the village with his neighbor, or else ride his bike a mile to Jungle Pete's, a bar down the road that had palm trees made of burlap. You could get food there or drink at the bar with the local guys, who kept to themselves. He kept to himself, too. After a while he felt like an intruder. The locals weren't just

quiet; they were actually pretty unfriendly, at least the ones who drank there, though Nina, the owner, was nice enough to him.

So he'd usually stock up on beer—nothing stronger was available—at Dan Miller's new general store, which was just down the road from the house.

Dan Miller was someone he could talk to for hours about all kinds of things. He could talk to Dan without giving it a thought, but most people made him nervous. One time he was crossing Eighth Street on the way to a few quick bourbons at a Blarney Stone when Bill and Franz suddenly appeared, two peas in a pod.

Bill said he'd seen Jackson's new pictures at Betty Parsons and he was intrigued. What, he asked, was he up to? Something new?

Franz looked at Jackson pleasantly. Bill's gray eyes were shiny and hard. His gaze was always like that, specific, piercing. His wide mouth was set in an implacable line that Jackson thought made him look very practical and very Dutch.

He couldn't speak. Parts of words came to his throat, then stuck there.

"Big image." It came out in a kind of mumble. He was intimidated; he felt like a third grader talking to a big kid. Franz glanced at the sidewalk, embarrassed. Bill smiled. "Big image? Vots dat?" Jack walked off with a little wave, his stomach contracting like a fist.

Lee used to laugh at people who asked why he never spoke. Jackson spoke plenty, she said. You have no idea. You don't want to know, she'd say. Bill told someone who asked the same question that he talked just fine when he was in "that in-between stage"—when he'd had a few but had yet to have one too many. That took some nerve. In general, people had nothing to say, including him, so why bother? "Fucking whores, you think you're

painters." That's what he'd said at the Cedar one time, he was told afterward, when someone had been pressing him to talk about art. That's what happened when you pushed someone to talk who just felt like having a quiet drink.

He was in the kitchen, hands streaked with flour, rolling dough out on the counter next to the sink. Lee had peeled and sliced green apples she'd bought at Dan's store, and they sat under a thin coat of sugar in a ceramic bowl nearby. Fats Waller played "Your Feet's Too Big" while Jack kneaded and rolled again, then sliced a perimeter in the dough, balling up the extra bits and placing them to one side. The dough was the color of the sand at the bay in winter, pale and clean. He saw the fine striations of flour running through it like capillaries, the crust just this side of crumbling. The crust seemed a bit thin here; he pressed his thumb in the dough to even it out. It would tighten in the oven but retain its flakiness. This was how Stella had taught him to make a pie in Fresno thirty years before.

He pulled a handful of apple segments from the bowl and let them drop in the pie dish, then smoothed them quickly into a single layer, pulled out another handful, and placed them carefully one by one to make a regular surface, filling in holes, piecing the pie together. Fats Waller stopped singing, and he went to drop the needle in the groove once again. Lee sighed. "Could you play something else, Jackson, maybe just once, for a change? Jackson?"

They'd moved there in late November 1945, in the midst of a storm. They were forced to break in since they had no key. He'd asked to borrow a neighbor's key, reasoning that since their houses

were of similar vintage, the locks might be interchangeable. The man had looked at him like he was out of his mind. "Why would you think my key would open your house, my friend?"

There was neither heat nor hot water nor a bathroom, and the house was almost as stuffed with junk as the barn. After they'd cleared it out, they got down to work.

Toward the end he hadn't painted much. It was a sad time. As he felt worse physically, he couldn't think right; when he painted, it felt empty, as if he had nothing to say. He'd started drinking steadily again, and he no longer cared. The village cops had scraped him off the street and driven him home enough times that he knew he had a reputation as a drunk. None of his neighbors talked to him, but Lee had never wanted to have anything to do with them anyway. But he still loved this place, the way the field and the harbor smelled in the morning, the sound of the birds, the look of everything, so clear and clean, even when he felt dirty and tired and confused, out of gas.

People in Springs had theories about him, Lee had said. They said that he never got up until afternoon, only worked after midnight, and was supported by New York money. In fact, he reflected, this was the truth, except for the part about working.

If people were going to make up stories about him, he figured he could make up some of his own. When some kid painter asked him how he met Lee, he said he walked up to her and said, "Do you like to fuck?" The rest was history. He offered no further details. Peggy said he was "devilish." But she and Lee agreed that he had an angelic side as well.

They'd met at a dance in the mid-1940s. He'd stepped on her toes. She didn't seem interested in him till they were in a show together, and came to his apartment to find out more about him. She'd thought he might have something on the ball. He seemed different from the other painters.

They married at Marble Collegiate Church just a few months after they bought the Springs house. Harold Rosenberg's wife, May, and a church janitor were the witnesses. The Rosenbergs had bought a house in Springs the year before. May took them to lunch at Schrafft's afterward, and he then went out and got drunk.

Lee cooked big American meals for him, roasts and mashed potatoes. She kept the house as neat as a pin. She had an ashtray upstairs that said, "Scorpios keep very busy. Just to watch them makes you dizzy! Ask them what they do it for, if you want to make them sore." When she wasn't cooking or cleaning or talking on the phone, managing his career, she worked in the garden, where he liked to putter around, too, though he lost patience quickly. Lee pretty much stopped painting.

While she was buzzing about, he slept or bumped around the house or brooded out in the damp barn in his denim coat, taking off the chill by making a fire in the little stove.

The barn was made of horizontal one-foot planks, and until he got the money to insulate it, big chinks of daylight were visible between them. He would sit on a stool, smoking a Lucky Strike, wearing a T-shirt, jeans, and ankle-high work boots spattered with enamel, his forearms on his knees, staring at the canvas on the floor.

Around one he wandered out into the yard. Blue jays screeched from the woods. Out in Accabonac Creek, someone leaned from the side of a gray dory, peering at the still steel blue water. A whir of cicadas from the wheat-colored marsh grass. Robins paced the grass in the middle distance, feeling for worm vibrations with their feet.

He sat in his rocker, one of the two wooden chairs he and Lee had left outside the night before, and felt the sun's warmth spread over his bald head. A pair of swallows traced a sine wave to the eaves of the Schellinger house next door. Thin blond weeds sprouted from the cinder blocks that marked the perimeter of the barn's old foundation, a frame around a cracked slab of yellow gray cement half-buried in dirt and grass. Beyond it, an acre of meadow rolled like a just-washed crew cut to the creek. A slice of white vapor like a big check mark was seeping into the blue sky.

The dull black carapace of the Model A in the driveway sat absorbing all the colors in the spectrum. The screen door closed with a gunshot crack, and he heard Lee drop something soft onto the earth with a thump: a spade or shears. The sun was just beginning to click off the notches of its decline.

The short emerald grass gave beneath his loafers as he walked to the barn, stepping up through the door into the damp little storeroom where paints were neatly stacked on shelves against one wall. Up another step and through a narrow doorway was the studio. Dust motes drifted in the thin planes of sunlight that cut across the room, let in through the spaces between the wallboards. Birds were faintly audible, and sometimes a car racketing past on Fireplace Road, sounding like a machine gun in a garbage can. Otherwise there was just the muffled thud of each footfall, its uninflected flat echo bouncing back from the pitched roof as he walked the twenty feet from the doorway to the north wall to sit on a squat four-legged stool and pull off his loafers, lacing on his boots.

Two dozen open paint cans, their labels smeared, rested on the floor at this end of the room. Quarts of Devoe silver luster, ultramarine blue, and Pittsburgh Metaleaf aluminum paint, gallons of tile red, pink, burnt sienna, burnt orange, titanium white, black floor enamel. A gallon of Devoe sash-and-trim black held

a foot-long turkey baster like a fat thermometer, its glass syringe coated on the inside with a thin film of black, the copperish rubber-bulb thumb printed with black and red smudges. More basters charted the fevers of other colors. Commercial paint blended in thousand-gallon batches the consistency of custard, it came in unspeakable flavors: liver, brick, fresh tar.

The brushes, a dozen here, a dozen there, in clean Martinson's coffee cans holding a few inches of murky thinner. Brush handles leaned lazily in paint cans, an inch wide, five inches wide, their handles mostly coated. More basters, some lying on the floor crusted with a pointillism of color. Cigar boxes on a shelf held tubes of oil, a few rolled-up drawings. There was a box of Kleenex.

He rolled the canvas out on the floor and tugged it even with the edge of the floorboards. Five feet on either side left enough space to walk around it. And then the first thin flicked whip of black hit the surface—*prrrrrrrrrrrrrrrrrrrrt*. Ribbons and strings of shiny enamel glistening on the dull cloth. He stepped onto the canvas, bending, can in his left hand, brush in his right, holding it six inches above the surface, keeping the rhythm of the paint going.

Sometimes he'd roll a stretch of sailcloth out on the concrete pad that lay in the cleared land between the house and the meadows that ran to the creek. It was the barn's old foundation slab, left behind when he and Lee had moved the building north. From there, you could look back at the house eighty feet away, the back door and the little porch with its overhang, the window in the pantry, the two upstairs bedroom windows, and the little chimney breaking through the roof's steep slope. At the far end of the narrow grassy driveway you could glimpse the blue black ribbon of the road.

Turn 180 degrees and a vista opened. Past the hard slab, the

green thinned and mixed with brown, then turned to a gently rolling golden meadow. Narrow ditches cut into the land held runnels of swampy water, fiddler crabs, hard brown clams covered with green slime, wet dark clumps of bladder weed. Things grew and died in that dense muck; it sucked at your shoes as you drew closer to the creek.

There were jays and swallows in gangs, pairs of cardinals appearing, then vanishing. Out beyond the meadow was a band of blue creek whose surface trembled with wind, terns skidding on drafts above its occasional coruscations, someone's flat gray rowboat tied to a small banged-together dock on the other shore, where the Accabonacs had harvested oysters and clams, collected shells for wampum, camped for a few months.

In summer there was a chorus of sounds in the grass, the white hiss of midday that held all things that whirred and chirred in the heat. In the cool evenings the birds gathered noisily in the leaves, and when they moved on, the katydids turned up their volume, a mad chorus that stopped for no apparent reason, then resumed at even greater volume. Later, there were faint owl hoots and sheets of crickets, and much later, in the dead time before morning, the bloodcurdling scream of a single screech owl, whereabouts unknown.

Lee picked up a rug from the living room floor, walked it to the back door, and shook it in the morning air. It was late June and summer was closing in. She imagined a shimmer of heat in the sky over the still gray blue creek. Birds were walking in the grass.

Like Lucy and Desi, Lee and Jackson had twin beds in their little upstairs room. She heard Jackson's feet hit the floor, then his journey down the stairs, the thump of each slow footfall muffled by the thin beige runner that they'd tacked to the treads. She

imagined him ducking his head as he always did at the bottom of the flight, where his head came within a half inch of the ceiling. On drowsier mornings, he'd mistime it and she'd hear the curse as he smacked the crown of his head on the plaster. Sometimes she could actually hear the contact; the first time, the *thwack* alarmed her so that she'd jumped up from her chair, sure he'd be on the floor, unconscious, or bleeding, or both, but he simply stood scowling, eyes squinched shut, rubbing the spot where he'd hit, and only mumbled "Fuck" when she asked if he was all right.

Lee watched him walk sleepily to the kitchen, an overgrown child who had to be told to brush his teeth and wash his face. He ran tap water into a coffee cup, drank it quickly, and sighed, standing with one hand on the smooth curve of the porcelain sink's edge.

"Do you want breakfast?" she asked the back of his green T-shirt. The U of hair on the back of his head was fine as a baby's, his scalp turning from pink to tan.

"I'm not real hungry," he said, turning to the Kelvinator that had come with the house. Someone had given it a new coat of paint before they'd arrived, and Lee always found her eye stopping at a long white drip that ran down the side of the door nearly to the floor, where it had run out of steam, freezing in place, its terminus a little bead like the blob of mercury at the base of a thermometer.

He pulled a bottle of beer from the refrigerator and swung the screen door open, standing there a moment as he felt the brightness shoot through his irises to the back of his head, where it landed with a pinpoint of pain that felt like the briefest of sticks with a shard of glass. The sensation dulled and spread lazily, coating the inside of the back of his skull. It felt warm, like blood. He closed his eyes and saw little flashes of red and blue light in the blackness. He stepped onto the porch, still in shadow; his head

seemed to resonate with some far-off, unheard explosion. He watched Lee as she moved past him in quick steps to the barn, to rummage through the bits of glass, shells, rocks, and broken tiles that she was using to make a mosaic table. A chipmunk stared at him from the furry border of grass at the barn foundation.

Jack sighed, took a long pull from the beer, felt briefly nauseated, then dizzy, then drained it. He got another bottle and sat on the edge of the porch, staring at his dull black shoes. He began to feel better.

Lee was trying to learn about birds but kept forgetting their names. She recognized the distinctive calls and songs but couldn't put them together with the names. Lately there had been cardinals in the mornings, appearing suddenly, tongues of fire in the cedar and oak trees after the ponderous crows made their early-morning visit. Once or twice she spotted something tiny and vibrating she suspected was a hummingbird, but they weren't indigenous, were they? She loved the putty-colored feathers of the woodpeckers. Their insistent hammering at the big oak near the pantry window made her smile: they took themselves so seriously!

From the kitchen she could see part of Jack. His blue pant legs jutted out like bent straws from behind the wall separating the parlor from the rest of the house. The music, Max Kaminsky's band, grew louder and harsher as she walked toward him, seeing now the thin blue plume of smoke rising from the ashtray on the table before him, the bent torso, elbows on his knees, head hanging. Were his eyes shut? No, he was staring at the floor between his feet as if there were a landscape there.

"Gee Baby Ain't I Good to You," "I Cover the Waterfront," "Until the Real Thing Comes Along." Sometimes the songs changed

with his mood. Sometimes it was all Fats Waller, or Artie Shaw's "Jungle Drums." Sometimes it was Jimmy Yancey, or Nappy Lamare, Hot Lips Page, Jack Teagarden. Dinah Shore with Maestro Paul Laval and His Woodwindy Ten.

He liked old-fashioned jazz; she preferred bop. When they had some money and he got electricity out to the barn, he played his records out there. He'd been given a violin as a teenager, but smashed it when he realized how much work it would take to get actual music out of it.

He wasn't the first painter to drip paint onto a canvas and never claimed to be. He told anyone who asked who his influences were. But he was the first artist to make a whole body of work that grew from improvisation. The accidents—there had to be another word, they weren't really accidents—were the best part of what he did. He relied on that. But people didn't appreciate how much control went into what he did. It took real skill to drip paint accurately, to make it do exactly what you wanted it to do. Squirting paint from a baster sounded silly, and looked it, too, until you tried it. He knew how to use accidents as they happened, how to control the process just enough. If someone stepped on a canvas or if a butt stuck to it, that was fine.

As he worked in the barn or out on the slab, he waited for the moment when the energy began to come, and he didn't fight what was dictated to him. People thought he was playing tennis without a net, but there was so much to take into account. The paint's viscosity had to be accommodated, he had to select a brush or baster or stick, the canvas had borders, he restricted his palette rigorously, and he was often working through a hangover or a haze of tranquilizers or was half-drunk. He rejected sketches or preconceived notions of any kind; he had to make it up as he went along and hope that something clicked.

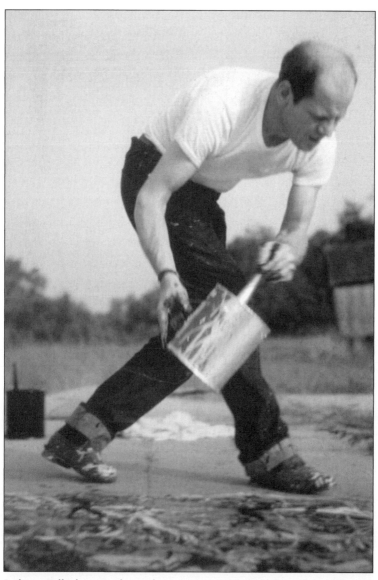

Jackson Pollock at work on the concrete pad behind his house, fall 1950
(© Estate of Hans Namuth)

The continuous look of the big paintings, the integrity of the overall image, was arrived at only after he had started and stopped and started again; he worked in stages, hoping that one good stretch of work would engender another the next time he picked up his tools. Sometimes he gave up on paintings that he felt had reached a dead end. False starts were part of his working method.

Images moved in and out of focus; some of the time, he was very representational, but he liked to say he was "a little" representational "all of the time." Often he'd start with a letter or a number, just to get rolling; it would be swallowed by the flow of the picture. When a painting felt like it was almost done, or he'd come to a standstill, lost contact with it, he'd call Lee and together they'd lift it from the floor to a wall, where he could size it up with some perspective, see the way it would hang.

One inspired session had to lead to another. Because he relied on rhythm and feeling more than technical concerns, and because the more complex paintings were composed of layers of continuous drawing in paint rather than abutting or overlapping images, he couldn't tune up pictures finely, the way old-style painters did. Even Bill did that. He couldn't. The paintings would lose all their energy.

Before the Olds, before the Model A that preceded it, there was a Schwinn. He rode it three-tenths of a mile to the Springs General Store, where he and Dan Miller would chew the fat. The bike was heavy, and Pollock rode it slowly, Camel in his mouth, pedaling steadily along the weedy, sandy edge of Fireplace Road. Before the left onto Old Stone he had to stand in the pedals and pump, the shaky fenders making a cheap racket, to gather momentum

for the brief uphill climb. He could feel the nubby rubber grips of the pedals through the soles of his shoes. The road suddenly grew a pronounced crown, so he couldn't tack the bike like a sailboat, just stay in the groove at the road's edge and crunch up the grade. The air was suddenly warmer here, where trees had been cleared for the pale gravel parking lot of the Springs church, and the sun amplified the church's stark white paint. The world was too bright and too hot; his head clanged with hangover. At the top of the little hill he settled back down onto his seat, breathing hard. The cigarette tasted bad and he spat it out, wormy little shreds of tobacco sticking to his lower lip.

The bike coasted gently down the gradual grade that led past the store. To the left he saw Accabonac Creek beyond the church's little graveyard with its low white fence. He leaned a bit to the left and glided into Miller's blue gravel lot, avoiding the thicker spots that were like quicksand. It was hot in the lot. He got off the bike and leaned it carefully against the bottom step of the porch.

The store was drowsy all year long, an occasional car crunching across the gravel. While Dan was pumping Phillips 66 or selling fly traps from behind the counter, Jack would sit in a ladder-back chair on the porch, or consider the shelves with their cargo of Spam and Ajax, the rack of Life Savers and Sugar Daddies, the tilted glass front of the meat case, the red cooler chest with its sliding silver cover, within which wet bottles of Hires root beer and orange soda rested.

Dan Miller took to Jackson. He saw that people didn't understand him; they distrusted him because he was quiet and didn't seem to have a job. Miller liked a beer or three, so, though he wasn't a drinker of Jack's capacity, he sympathized with his thirst.

———

He made paintings in layers, in successive sessions. He worked from all four sides of the canvas, leaning into it, hovering over it, stepping in, working on his knees or on his feet, bent at the waist, the paint leaving the brush or stick in thin arabesques or poured from the can in ribbons. Sometimes he'd walk sideways, legs crossing like scissors. He'd load a brush with paint, pull it from the can, hold it steady, parallel to the floor, then snap his wrist, spattering the enamel onto the surface. It didn't matter how the paint went on as long as something was being said.

He had found a new way to draw. As he worked, he took pleasure in spinning out one variation after another, making the line as fine as a filament or as thick as an arm; in some canvases the unprimed cotton showed through, and in others it was completely covered, so that images might seem evanescent, as if drawn on the air, or as solid as the studio floor. Sometimes, when he started with a calligraphic shape, it remained half-visible and gave the picture a formal structure. As in Poussin.

He liked keeping the colors toned down, so when he added something bright, some green enamel, say, or red, it was as if the painting were grabbing you by the lapels. The earth tones kept everything grounded, like a bass line in a song. So when he unleashed screaming ribbons of cadmium yellow, it was like a hot trumpet solo. It was thrilling. He'd never forget the first time he'd tried aluminum paint—its unearthly shimmer reminded him of the halos in religious pictures, the way they popped out so oddly from the surface. If he used a lot of it, the picture became like a dream. *Lavender Mist* was like that. If he only used a little, it was like sending an electrical charge through the image.

Once he gave up trying to be Picasso, everything started falling into place. It was when he started pouring the paint that he felt loosed from the past. It had been such a relief to stop fighting the paint, to stop struggling. It was as if something had

taken over, some force, like the hand of God, was showing him what to do, how to work.

Intent on the canvas laid out on the concrete slab, he felt released from the earth, lost in the work. The fields and the creek behind him seemed to stretch for miles. The sky was cloudless, the late-afternoon light sharp and clear, the air beginning to cool. It was autumn. The faint sounds of birds and insects.

In his jeans, T-shirt, and scuffed shoes, he was a laborer at the end of his shift who, taking a shortcut home through a scrubby field, found an artist's tools. Putting down his lunch box, he decided to see what he could make with them. Hesitant at first, he dripped a thin loop of paint onto the off-white canvas, then another. The paint ran easily from the end of the brush, and he loaded it up again. It was a big canvas; why stop?

(1947)

SIX

From the air it resembled an aristocrat's pinball machine—dozens of sculptures fixed like tacky jewelry to quadrants and fans of green lawn separated by thousands of trees and shrubs in hundreds of species, a sixty-acre quilt of earth tones. The house, the studio, the garage, the pool, were set off by sand-colored gravel drives. The seawall was a thin white line that kept Georgica Pond from seeping into the cellars at the Creeks, as the place had always been called. Jackson and Lee had found it for him not long after they'd moved to Springs; Jackson had been on his way over on the night he died.

He stared into the box of eyeballs, then selected two brown ones and placed them on the table. They would do. But what the picture really needed was something about nine feet long to connect the human skeleton at the upper left to the antler at the bottom right, one oblong shape.

The studio, big enough for a basketball court and thirty feet high, was silent but for the hum of fluorescence, low bursts of static from an old Grundig radio set on a stool. The panel lay across a pair of sawhorses. He'd painted it over the last two days, pouring rivulets of red, yellow, and blue, a network of capillaries across its surface. Atop the panel he had laid the skeleton, the big, round black-faced clock, the spoked oak lamp fixture like a

ship's wheel. On the table next to it he had arranged hat forms, the wide, graceful rearview mirror from a 1960 Oldsmobile, a cow's hip bone, some bright plastic letters.

A mountain of bleached bones on the concrete floor. Shapeless pools of yellow epoxy like stained egg whites on a trestle table next to open cartons of glass eyes, a pile of boar tusks, stamped-tin fetishes. A wall of antlers arranged small to large. Hat forms by the dozen. Hundreds of gallons of enamel, box upon box of oil tubes, dry pigment, watercolors, pastels, pencils, nibs, ink bottles, erasers, etching needles, bags of sand, boxes of rocks, sacks of sawdust, heavy yokes for cattle, jars of rubber cement, glue sticks, glitter, rollers, tongs, puddles of egg tempera in plastic ice trays, plaster saints, pilasters.

Nothing here would do. It was late. A moth circled a light fixture high overhead. He stood, scraping back the stool, and crossed the room, throwing light switches and pushing open the door.

Insects sang as he crunched along the gravel to the main house. There was a splashing from Georgica Pond, beyond the seawall. He walked there, bent over, saw bubbles, a shimmer of starlight on its greenish surface, a hint of quicksilver beneath. Killifish? Snappers?

He looked past the pond at dim trees massed like blown ink on the far shore, the waning moon a yellow blur with distinctly carved but unreadable features, a Dubuffet face. Through the front door and into the entrance hall he passed between two big Stills, then through an ivory parenthesis of elephant tusks, through a series of rooms to the kitchen, and then down the cellar stairs.

Among the blue cartons of Ivory soap flakes and the stacked blue bedsheets a box of radioactive Cheer glowed even in this crepuscular light. He saw the ironing board.

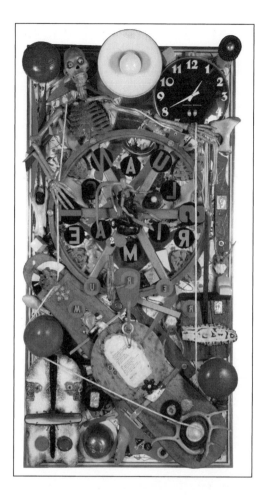

Alfonso Ossorio, *Poem*,
1982–83. Congregation of
mixed media on panel
(© Ossorio Foundation.
Courtesy of Michael
Rosenfeld Gallery LLC,
New York)

It screeched as he folded it. He carried it up the stairs and
propped it by the front door, where he was sure to see it in
the morning. From a side table he extracted a notepad, wrote,
"Please do not move the ironing board," in black marker, and
tacked the note to the board's cushiony cover with a pushpin.

Once there had been seven Stills, and Still himself had spent
a summer living in the gardener's cottage, in partial payment for
his work. But a year or so later, after an argument, he'd de-
manded the return of a picture, and when Ossorio refused—he

had paid for it, hadn't he?—Still took a train from New York to East Hampton and a cab from the station to the house, walked through the front door, cut the painting out of its frame with a razor knife, rolled it up, got back in the cab, and drove off. Ossorio had never known such a disagreeable man. Jackson, on the other hand, had been nothing but agreeable. Of course he drank, but so did the people who told stories about him. It had never altered their relationship, which was one of mutual respect and affection.

In the old days he and Ted had entertained. There had been concerts and lectures and dinners and dances by the pond, with hundreds of lanterns in the trees. Jackson had been on his way to one of their concerts that night; he'd called to say he would be late.

Jackson had started with a couple of blasts at Cavagnaro's while waiting for Ruth to arrive on the morning train, sitting at a table by himself before a damp cocktail napkin. Three other early birds were hunched at the mahogany bar. The stamped-tin ceiling reminded him of bars he liked in New York, the ones in midtown where he disappeared into the dim decor, and when, lost in reflection, he happened to look at the plate-glass window, he was startled to see East Hampton there, not Third Avenue.

As the alarm bells clanged and the candy-striped barrier jerked down, he walked the hundred yards to the platform, drunk enough to be annoyed by wide-awake, perky citizens astutely going this way and that in the daylight. Ruth hugged him, her mouth already running, and Edith looked so young and silly that he wished they would both go back to New York so he could go home, have a couple more peaceful belts, and lie down for a few hours. But they were hungry and chatty and excited, and Ruth wanted Edith to see the ocean, so he drove around, silent, while she kept trying to draw him out so Edith could bear witness to his

depth and sensitivity. They stopped at the beach for a look and went to the IGA and the liquor store. The world looked fuzzy, and he felt sticky in the increasing dampness and heat.

By evening he was exhausted, and though the heat was receding, the girls were still chattering. He stopped for a couple of beers to brace for Alfonso's party while Ruth talked about all the rich and famous people Edith would meet, all of whom knew Jackson was a genius, and the closer they came to the Creeks, the less he wanted to go. He thought how Ruth would only get louder once they were there, drawing even more attention to him, and he had nothing to say to all those cocksuckers anyway. Why couldn't he just go home and retreat to the barn, where he could drink in peace and listen to music? So he pulled onto the side of Fireplace Road, glanced back over his shoulder, made a sweeping U-turn across the road and up onto the opposite shoulder, straightened out, and stepped on the gas, throwing a rooster tail of sand and pebbles, while Ruth said with alarm, "Where are you going!"

And she kept jabbering, then shouting, as the big, comfy car hit fifty or so. Then, as the road narrowed and grew twisty, he finally lost it, and he was surprised and felt a queasy rush as a view of oak trees filled the windshield—this was terribly wrong—and the car hurtled over the sandy shoulder, jouncing hard on its soft springs and tossing all three of them up off the seats, as if they were on a roller coaster. Then it slammed to a stop, though he and Ruth kept moving, awkward projectiles. He hit a tree headfirst, Ruth hit the ground, and Edith was crushed in the car.

There was something touching about Jackson's vulnerability and the way that Lee tried to nurture him in her coarse way. He liked them both and felt sorry when he saw the way they lived. The

house was small and tidy, but there was neither hot water nor heat, and they could barely pay the bills, their combined income hardly allowing for improvements to the place.

He'd bought a painting, *Number 5, 1948*, a few months earlier, at Pollock's show at Betty Parsons Gallery. When it was delivered to his apartment on MacDougal Alley, he saw that some paint had been smeared in transit. He got Jackson and Lee's number from Betty and called to see if Jackson would like to repair the picture.

"Stay overnight," Lee had said. "It's a long drive, and we have an extra room. It's beautiful here, we live right on the harbor." Hanging up, she turned to Jackson.

—His family is Domino Sugar.

—You told me. So did Betty.

—He's interested in you.

—I know he's interested. Stop acting like he's Daddy Warbucks.

Alfonso laid a heavy woolen blanket in the station wagon's bed, and they slid the picture, in its shipping crate, inside. The crate was seven feet long, and one end rested on the backrest of the backseat. It was May; there were sparrows in the trees, and the taxis seemed a brighter yellow.

They'd never been so far east on Long Island. Indeed, they'd never been beyond the airport. The estates of Great Neck and Roslyn were not visible from the road, of course, though Ted had hoped there would be something interesting to see. A new world of suburbs was spreading like ground cover in Nassau County just a half hour from the city. A hillside was patched with recently carved lots, each containing a structure, fresh sheets of plywood tacked to two-by-fours, holes awaiting window frames. Men in flannel shirts stood on rafters, bulldozers nestled.

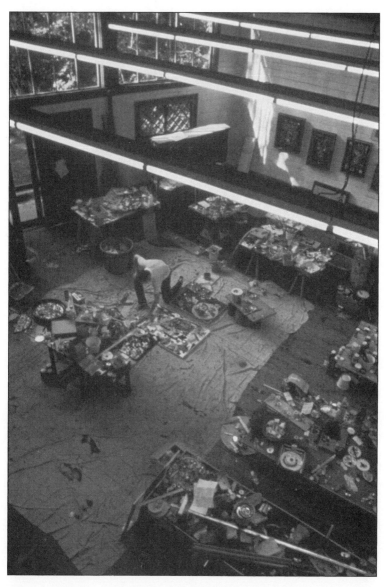

Alfonso Ossorio in his studio in East Hampton, 1963 (Photograph by Ronny Jaques. Courtesy of the Pollock-Krasner House and Study Center)

They pulled into a Texaco, and while the attendant wiped bugs from the windshield and the headlights and checked the oil and the tires, Alfonso went inside in search of a map. He found the one he wanted in a dusty wire rack and went outside, where Ted was opening a pair of Cokes at the red machine. The caps clanked into the metal receptacle. He handed a bottle to Alfonso.

—We've been in Manhattan too long.

—What do you suppose they do out there?

—I can't imagine.

They stopped for lunch in a town called Riverhead. The coffee shop could have been in Iowa. The food was cheap, and everyone seemed to know each other. Along the road were potato fields dotted with farmhouses, ponds like oversize puddles. There were duck farms, too, each heralded by its aroma. They could even hear quacking.

The road passed through scrubby woods, with glimpses of bays to the right and left; just as they became aware that they were on the main street of Hampton Bays, it was gone. At the top of a gradual hill, the trees gave way and there was water on both sides, boats docked below them: the Shinnecock Canal. Alfonso had spied it on the map; it was, Lee said, the landmark to look out for.

—There was an art school here at the turn of the century, in the hills.

Then there were lawns, and a large stone church, and a Ford dealership, and a war memorial, and a movie theater in Tudor style: Southampton. A dozen produce stands hinted that tourists were abroad. They got stuck behind crawling tractors and horse-drawn wagons piled with dusty potatoes.

East Hampton was a pleasant surprise: there was a large, quiet pond under enormous, spreading trees, and then Main

Street, a wide, peaceful boulevard lined with elms, with a charming windmill visible at its end. They spied a Bohack's supermarket across from the windmill, and Alfonso slid the station wagon to a stop before it. There were few people on the street.

They bought a turkey and vegetables, an apple pie. Alfonso decided against searching out a liquor store; if Lee offered something, fine, but he didn't want to tempt Jackson if he was on the wagon. The woman at the checkout told them to drive past the windmill and under the railroad bridge, then to follow the road north.

"If you drive into the bay, you'll know you've gone too far," she said.

Not a hundred yards north of the village there was a smaller shopping district, with a grocer's and a butcher's and a dry-goods store, and already everything seemed more rural. There were shacks and farmhouses, and fields full of grazing horses and sheep. The late-afternoon light was clear, and the yellow of an occasional forsythia seemed to pop on the air. Alfonso wanted to pull over to look more closely at things—grass, tree bark. But they were almost there.

The mailboxes were numbered, and when they reached the 700s, he slowed, passing a bright white steepled church that Lee had mentioned, behind it a slice of garnet blue water and a band of beach grass dyed orange in the slanting sun. And then they were there. It was a white frame farmhouse with a single narrow chimney and a wide porch, the picture of modest New England living. There was a wide, sparse lawn, and a few twisted trees reached into the sky. He pulled into the empty driveway. The Pollocks couldn't afford a car. Lee had told him that Jackson got around on a bicycle, and that they depended on friends to take them to the village to shop, or to the train. How could anyone live in this backwater without an automobile?

As Alfonso turned off the engine, he saw Jackson. He waved, a thin figure in a white T-shirt against the blue sky. A screen door slammed.

—Well, they're here!

Lee walked from the house, smiling. She was much smaller than he'd remembered.

Jackson approached warily.

Lee led them on a short tour. The house was uncluttered, with white walls decorated by small paintings and an anchor that Jackson had found on the property. In the living room was a striking mosaic table that Lee had made, and Jackson's records and hi-fi set were neatly arranged on bookshelves in the front room, which gave onto the wide porch. The house was built close to the road, Jackson explained, for easy access in snowstorms.

Up a narrow flight of stairs were three compact bedrooms— Lee used one for a studio—and the sole bathroom, whose toilet froze in the winter, Jackson noted.

Jackson said he went clamming in the harbor and they had an account at the general store down the road, Dan Miller's place. Miller had taken a painting in exchange for a mounting grocery bill. Jackson had attempted similar transactions with a few other merchants in town with no success.

Alfonso thought he might advance them a monthly sum against future acquisitions. It would ease their financial hardship, and he knew he'd want to buy more pictures. He weighed whether making such an offer now, as soon as they'd arrived, might seem impulsive. But surely they would be grateful for the money—they weren't ashamed of their need, it was just a matter of fact. Yet bringing it up this quickly might be insulting; it might seem that he was so horrified by their bare-bones existence that he needed to pay his way out of pity. And they were staying overnight, after all, and it would color their incipient friendship

from the start. The Pollocks weren't going to starve between now and tomorrow afternoon. He would wait, and make it a proper business arrangement.

After the house tour Lee and Ted began unpacking groceries, while he and Jackson carried the painting from the station wagon to the little barn. It was cool inside. Light poured from windows set high in the north wall onto a canvas that lay on the floor; another was hanging from a long pole on one wall. They leaned the crate against the doorway and looked at the paintings.

The next morning after breakfast Lee and Jackson took them on a tour. They walked on the sand at Gerard Drive, an isthmus between Accabonac Harbor and Gardiners Bay, and they stopped at Dan Miller's store, where Jackson showed Alfonso the picture that Dan had hung on the wall of his office. They drove southeast from Springs on a narrow twisting road bordered by acres of scrub oak through the sleepy village of Amagansett to the ocean, where they again went for a stroll on the sand.

—The Rosenbergs live nearby, and Marca-Relli, and a few others. I don't really bother with the neighbors much. But Jack is getting so much work done here. It's so much better to be here than in the city. There are too many distractions, too much going on. Life is simple here. But there's always the train when you get cabin fever, and we both get in whenever we need to.

—So you'll keep an eye out for me?

They uncrated the restored painting when it was delivered a few weeks later. Pollock hadn't just repaired it; he had repainted it completely.

(1982, 1956)

SEVEN

Walking downstairs from his office to the street, he could take a route that wound back through history, starting with his friends Jap and Bob and Bill and Jackson and snaking the corridors through the dark Braques to Cézanne's slender green blue bather, who, hands on hips, was oddly poised on one foot as if he were about to turn and launch into a jeté.

He was tired and unfocused, but lunch and a dose of New York air would cure that. He stepped from the stairs into the lobby, where the garden seemed pasted to the gray glass wall like a huge transparency, the back of Rodin's black *Balzac* looming there and across from it, on the brick wall that kept Fifty-fourth Street out, three Matisse backs, reliefs he had gazed at many afternoons while seated under Balzac's glare in one of the rickety chairs like steel baskets that people sat in while munching cream-cheese-and-date sandwiches and drinking orange juice. The garden was meant to have a French flavor—there was even one of Guimard's Métro markers, with its fruity lamp and flowery lettering. And it did feel European, but more like a Left Bank stage set. You thought Audrey Hepburn would arrive at any moment, and indeed he had seen Audrey Hepburn here, on this very concrete palazzo. Because of the smoked glass and because he was usually lost in other thoughts, he was always surprised to find

the sun when he stepped into the garden, which was not for flora but for sculpture, and he liked it better, in fact, on gray days, when it seemed almost ethereal. Sitting there with a little paperback Reverdy or Ponge took him away from West Fifty-third Street, not that there was anything wrong with West Fifty-third Street. To the contrary; to be sitting in the middle of Manhattan, with its vaguely gritty air, and hear the river of taxis honking just over the walls, to look high up at the apartment house windows across the street and know that someone was probably looking back, at a skinny, balding man in a skinny black tie seated at a little table in a courtyard under a big black Rodin, was heaven, really: think of it, to be sitting as if in your backyard in the middle of New York. There were even birds, and murmuring people, and the smooth paving slabs here were more civilized than the bumpy sidewalk outside.

He crossed the lobby, where the big autumn-colored Pollock hung, through quiet knots of Kodak-slung tourists and past a lightly buzzing clump of children who had come on this Friday-afternoon outing with their teacher, a girl with ironed hair and black stockings who had herded them, a many-headed organism, to one side of the room and was leaning into their midst, speaking quietly.

Working in the museum building itself was uplifting after the years spent in the little brownstone annex next door, but the promotion it reflected sometimes troubled him in a way he hadn't expected. He'd gone to work at MoMA because he liked art and he needed a job, not because he wanted to rule the art world. And now that he was, rather excitingly, associate curator of exhibitions in the most prestigious pile of modernist stone and glass in the world, the first thing he'd done was to compromise his integrity with the Motherwell show, a major survey of work by a thoroughly mediocre artist who furthermore was both

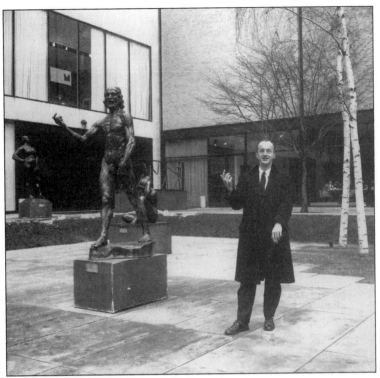

Curator Frank O'Hara in the Museum of Modern Art garden, January 20, 1960, with Auguste Rodin's *Saint John the Baptist Preaching* (© Fred W. Mc-Darrah)

rich and famous, in art world terms, when there were a dozen people in his phone book who were desperate for money and acknowledgment and deserved them far, far more.

But you made compromises in order to be able to put up the first big David Smith show or get Reuben Nakian or Franz Kline the retrospective he deserved. If you wanted the goodwill of Mr. Barr and the trustees, you were willing to sway a bit from your instinct.

He pursued de Kooning because de Kooning was the master of the age, and because he couldn't imagine anything more beau-

tiful than rooms full of de Koonings, dozens of them, from the 1930s right through today. What could be more sensational? What could be better than to walk through a show of great paintings with a friend and be moved by them together? And what if it turned out that your friends were people who made great paintings of their own?

In the little museum shop, clerks pointedly ignored the handful of people who slowly spun the postcard racks: Rousseau, Matisse, Picasso, Derain. The greatest-hits collection. And Warhol, Lichtenstein. Why all the fuss over those two? Bad art would dry up and blow away without his help, but Pop had its own posse of critics and rich fans, and its backhanded adoration of popular culture made it even better grist for the publicity mills than Jack the Dripper.

He realized he felt threatened when he found himself snapping first and thinking later when he was asked his opinion of Warhol. So he'd decided to back off and focus instead on sculpture, something no one felt like arguing over. Pop was a nonissue. He'd never really needed to call on this reservoir of calculation, and it made him uneasy. If this was how he acted in the grown-up world, what would his life be like in ten years? Would he evolve into a bureaucrat, a tasteful eminence, another old queen at the end of the bar?

So many painters, so many dead: Pollock gone ten years, and now David, whose big sculptures scraped in transit he had touched up in Amsterdam with paint that David himself had prepared for that purpose; David, big and tender, dead in a car crash, like Jackson. Patsy always said that Jackson was tender, too, with her kids and with her, though he'd never seen him being affectionate or even particularly friendly, just withdrawn. How lucky he had been to have Lee, or had he been?

It didn't matter now, he was gone. It had shocked him at first

when they began to die. Now it seemed more a matter of course, and to be a few days short of forty was to notice yourself becoming a bit more resolute, more accepting, but also to feel pulled half-under by a current that hinted at despair. He felt that way some mornings as he was shaving, sipping orange juice with a splash of bourbon, his face not quite focused in the mirror.

There was always too much to do, and it was hopeless ever to think of catching up, so as things backed up on his calendar and in his head, he began simply to block them out. Everything would sort itself out, sooner or later. It was the weekend, time to get a move on.

He passed the cool modernist slab of an information desk, where two boys made a point of looking over the heads of people who asked questions. The cute one glanced up as he passed, then whispered something to his friend. Did he look to them the way Alfred Barr had looked to him, when he first landed here? That could hardly be the case; he was the least venerable of souls. But he was middle-aged now, or practically so, and at least looked that way to artsy kids. Why was he, a senior administrator at a major museum, living in a tiny apartment with the equivalent of a college roommate, an apartment whose bookshelves were the brick and two-by-four affairs twenty-year-olds cobbled together? Wasn't he supposed to be living on the fortieth floor of the Heaven on Earth Building by now, with ewers and Aubussons and a silver tea service and an Irish wolfhound?

As he pushed against its heavy glass, the front door let in Fifty-third Street's arbitrary music of sudden whistles, distant scaffolds collapsing, snatches of Spanish, a taxi crossing a sewer cover in two clanks, like the clopping of a horse's hooves.

The flesh-colored expanse of the Donnell Library beckoned, with its strange window displays of books, the Bonwit Teller of literature. He crossed the street, dodging traffic, forded a stream

of single-minded pedestrians, and entered the pregnant calm of the fluorescence-bathed, vaguely Bauhaus two-story lobby, with its magazines and bestseller racks, then trotted up a short staircase to the balcony, where they kept the music. He sat there for a while, headphones plugged into a big cube of wood that held a turntable, listening to a little Poulenc and a little Scriabin and gazing out at the street, which looked greenish through the strip of windows over the entrance.

With the headphones off, the library hush was deafening, the creak of a book cart pushed by a woman twenty feet below a muted shriek. The street was a movie, and he watched it while making a mental list of what to do before cabbing to Penn Station for the 4:19. Grab lunch, maybe stop at the Gotham. Should he get something for Bill? And Joan? Patsy said they were coming for dinner on Saturday. It was almost three, so he burst into the midtown flow for a quick walk down windy Sixth Avenue, a canal at the bottom of an International Style canyon—did anyone really want cities to look this way? Still, it was beautiful.

No one to meet for a change: McAnn's would be quick and cheap, and though the bartender wouldn't know a Negroni from noodles Romanoff, sometimes straight bourbon was the ticket. It was dim until your eyes adjusted to the gloom, and he claimed a little table along the wood-paneled wall opposite the bar and dropped his bag on the chair. He slid his tray onto an ancient wooden track, germy steam-table mist rising behind the humid, smudged glass like a special effect in a Cocteau movie. The man in the paper hat sliced roast beef onto a roll and scooped mashed potatoes with a motherly gesture. He was thin in checked pants, with a lightly lined face, like an older John Cage. He saw him sitting in his little room after work, in a Stanley Kowalski T-shirt, playing the radio softly and smoking a Camel, staring up at the ceiling and listening to an argument, in Spanish, between two

men sitting on a park bench across the street from the residential hotel on Broadway in the Eighties where he lived. It was a fourth-floor room, and if he stuck his head out the window, he could look down at the top of the hotel marquee, where a crumpled pack of Luckies and puddles of yellowish rainwater looked back.

The bartender poured the bourbon, and he lifted it with a slightly trembling hand and drank it down, then carried a stein of beer to the table and ate and drank peacefully. A woman with a tan elastic bandage that hugged one leg from ankle to knee was sitting at the bar, smoking and reading the *Daily News*, and three men were playing cards at another table, also smoking. He pushed the plate away and lit a Gitanes, had a second shot while perching on a vinyl stool at the bar, grabbed his bag, and walked into the too-bright day.

As usual the diamond district was full of handcarts and Hasidim in doorways, the thin silver tape of alarms framing glittery shopwindows with recessed golden lighting, rolled-up grates just visible at their edges. Crosstown traffic stopped and started, pedestrians dancing between the cars. The Gotham was jammed into a narrow ground-floor space three gray steps down from the street. *The Ticket That Exploded* stood in the window, also Robbe-Grillet, Rechy, Rexroth. He navigated the shelves to the back room, suddenly bored with literature, to see what was in the little magazines and, suddenly bored with those, too, stared for a moment at the famous photo of the poets packed into the front room, Eliot and Miss Moore and so on, all even stuffier-looking than he remembered, in hot-looking suits, with too many books around them.

At the front desk he retrieved his bag from the clerk, whom he didn't recognize and who didn't recognize him, and politely purchased some Genet plays and Waugh's *Decline and Fall* in case someone hadn't read it and a pocket-size booklet of Giotto

frescoes, just the thing to keep around the house and pick up when you needed to see something good in a hurry.

Forty-seventh Street was too crowded to be pleasant, and as he swung back onto Sixth Avenue, he felt lighter, buoyant, his errand completed and the weekend only beginning. It was a twenty-minute walk to the train, but he was tired of walking. The yellow hump of a Checker appeared as if summoned and he got in and said "Penn Station" to the slice of driver's face in the rearview mirror.

To get to Track 19, whence the 4:19 of the Montauk Line departed, you rushed through the glass doors of the new Madison Square Garden, an amazingly ugly building that resembled a giant rotor, and hurtled downstairs to the basement, also known as Penn Station, a labyrinth of dull, low-ceilinged corridors that suggested a state mental institution.

If you were lucky enough to rent a place out east or accept a weekend invitation to the Porters' or to Ossorio's, and like most New Yorkers you didn't have a car and none of your friends was driving, this was the way you went there, in the herd of men in gray and blue suits released from work on Friday afternoons who gathered with briefcases at the sign that said Track 19, sometimes Track 20, waiting for the gate to open, to pour from the station's dingy fluorescence down escalators into the dim cavern where electric trains hummed. They whisked you through a tube under the East River, your ears popping, then the trains rose gradually into the grimy light of the industrial graveyard of Queens and trundled to the elevated platforms of Jamaica, where the journey actually began.

As the electric train slid into the station along the platform's gentle curve, he saw his own surprisingly puffy reflection in the window and the faces of the men who stood with him, tired but

expectant, some with jackets slung over a shoulder, no one speaking. On the track facing theirs, just across the narrow concrete platform, the Cannonball waited, its two diesel locomotives thrumming in their sheet-metal skins. Designers had made no attempt to streamline or decorate these creatures, which were more beautiful for it. Their reined power, the platform's trembling, was almost frightening when you stood beside one of them. Ladders ascended their barnlike flanks, and seen from the front, they were high and impossibly narrow. Not until you heard their throttles open with an ascending roar and watched them shake did you understand that they were so heavy that they simply couldn't be tipped over; it would be like trying to overturn a pyramid.

The Cannonball was the name everyone remembered. But the earlier and later express trains had names, too, and he and everyone he knew had taken those as well. There was the Advance Cannonball, for those who left the office even earlier. There was the Weekender, the East Ender, the Beachcomber, the Ebbtide, the Sundowner, and the Twilighter. There was a Wall Street Special, and a Shelter Island Express, which didn't go to Shelter Island.

The railroad had purchased a fleet of used parlor cars in the last decade, each built in the happy years just before the Crash of 1929, and if they were a bit musty, they retained a faded air of ease and glamour. You could have drinks, and everyone did. There were only two dozen or so seats in each, and you could even take one of four or five seats jammed together on a tiny observation platform at the end of the last car, there to sip your drink and watch the sky brighten as the sun descended. Kenneth and he had spent part of one journey on the platform, talking about Apollinaire and baseball, watching the ribbon of gravelly

roadbed. Each of the parlor cars had a name emblazoned on its side, but he'd noticed that each also bore a small plaque inside that hinted at the southern aura of its previous incarnation. The Montauk, for example, which he was now boarding, was once called the Virginia Dare. And the Shinnecock had been the Julia Ward Howe. How wonderful to tell Patsy that he and Joe would be catching the Virginia Dare and would she meet them at the station? Or to call Jimmy and say, "See you on the Julia Ward Howe."

You could have drinks at your seat rather than stand in a sweaty, packed bar car, and he did so now, a bourbon and soda in hand and an envelope of poems he might read in his lap. The others were settling down. He'd get a cab at the station if no one showed up to collect him. In the old days, before he and Patsy divorced, Mike would be waiting in his green Bugatti with a silver thermos of martinis.

Years before, he'd taken over Larry's house for a summer and it was glorious, swimming in the Southampton ocean every day, listening to Prokofiev in the afternoons, having drinks and dinner at a long table in the backyard with all his friends. How nice it would be to do that again: a month at Patsy's in Springs, say. He could spend all afternoon at the bay, lying half-conscious in the sand, and he liked trimming things in Patsy's yard and sitting at the little Olivetti at her kitchen table writing letters. There were so many people to see and things to do that sometimes he remained motionless out of exhaustion at the possibilities, and sometimes it was a two-day whirl that left him wondering if he shouldn't have just stayed in New York and communed with the cat.

Each summer was a new adventure, and you never knew who would be renting where and with whom, who you'd bump into at

Frank O'Hara, Southampton, 1962 (© John Jonas Gruen)

Two Mile Hollow or at the roadhouse or in the hardware store buying a rake. As everyone got older, though, certain constants had evolved among the people he'd virtually grown up with. Patsy remained in Springs, and of course Fairfield and Anne were in their big white house in Southampton. Lee ruled Jackson's estate from the house on Fireplace Road, and Bill spent most of his time in Springs, too. Some of them he never even saw in New York, only in the country. And now things had to be planned in advance, and he found that it was the young poets who came to him, kids, really, while it used to be that he was one of the kids. Sometimes he felt like Peter Pan with all these twenty-year-olds (some of them very attractive indeed) who followed him around now that his poetry had attracted a "cult" following, and *Lunch Poems* was in all of their back pockets. People expected him to be effervescent and charismatic and light on his feet and to dispense wisdom as well; he did his best to be encouraging.

Now there was less time for the kids, and less time for poetry. But poetry wasn't even an issue, if he were to be honest about it, for he'd found to his surprise that he had nothing to say. The impulse, or the compulsion, had left him. Once it had been as natural as breathing to move in mid-conversation to the Olivetti and tap out some lines, or write something on whatever envelope flap fell to hand, or spend a weekend hour or three working at something long, but a couple of years had somehow slipped by in which he'd written virtually nothing. It sometimes nagged. Concocting catalog copy and correcting press releases weren't the same thing. He wrote letters out of the same impulse, or rather with the same stop-and-start lyrical rush, but letters didn't strike to the quick the way poems did, and he hadn't even written many letters lately, come to think of it. It was really as if something were dying inside him, and he wasn't sure what it was. Rilke had stopped for a decade or more, then wrote the *Elegies* in a big

hurry, but even to call up that cliché was demoralizing. When he needed to write, he would write. But still he had the childish feeling that he wasn't doing his homework, even though it was the homework he most enjoyed, that he was neglecting his inner life, that a psychic roadblock had somehow dropped into place when he wasn't watching. These were boring thoughts, and it was ridiculous to wonder why he and poetry had separated, for it had always simply been there and it still was, somewhere. But the feeling of disconnection made him unhappy.

Why this great anxiety to be happy at all costs? Why did it settle like a fog?

He remembered visiting Alice Neel's studio up in Spanish Harlem a few years earlier, how, once she'd finally "got" him in profile, after five sittings, she asked if she could do a quick one of him facing her. She worked fast, and when he looked, he was struck by her facility but above all shocked because, though he knew he had bags under his eyes, he certainly didn't suspect that he looked such a wreck. In photos he was maybe tired but after all retained some boyishness, or so it had always seemed to him. But here the lines around his mouth and eyes were etched, the smile was grotesque, and the teeth cartoon tombstones. It was a death mask. Even his tense slump suggested nerves and exhaustion, although he'd been happy enough and laughing, talking to Alice while she painted in her businesslike way. Should he have taken this image as a prophecy or a warning? That her pictures seemed artless was her biggest strength; for all her technique she saw through a child's eyes, and wouldn't you be alarmed if a child drew a picture of you as a ravaged husk?

This landscape was at the bottom of so many paintings he loved, from Bill to Jackson to Jane to Fairfield and a dozen more; it

showed up in them in so many ways. But the best was Springs, where it was quiet and where everything came together—the water, the marshes, the scrabbly soil, the big, oxygenated sky. Patsy's house was on Accabonac Harbor, and sometimes you saw deer mysteriously crossing the lawn down by its marshy edge. They said that they swam out to the little islands to graze, but why would they do that? He'd have to ask someone. He'd seen opossums lumber across the road, too.

Just across the water you could see the clearing at the edge of Lee's property, where Jackson sometimes painted on the concrete pad. Jackson was tiresome, but you put up with it not so much because he was a genius—there were several of them around—but because he seemed to have a direct connection to whatever the source of art was. How could anyone so preternaturally gifted be such a bore? You got either Jackson the overgrown, brooding child or Jackson the obnoxious dipso, and he had no patience for either one. Jackson was not stupid; he knew the measure of his own gift, at least when he wasn't trying to kill himself. But his discomfort in this world made him repellent. His best friend, Patsy, told him that Pollock was as gentle as a puppy, but Patsy was a beautiful girl and Jackson went all gooey for her kids. He'd never seen Jackson particularly interested in anyone except those who came to do homage.

Life had to mean as much as whatever art you created along the way, otherwise why bother? There was no pleasure to be had in art if your life wasn't pleasurable, and therefore no reason to create art. The real question might be, how did Jackson make those pictures if he was always in the kind of misery he seemed to be in? He must have been happy only while he was painting. What courage, then, it must have taken to work at all.

———

Frank perched birdlike on a stool at his little desk, a slab of wood on a pair of black file cabinets facing an exposed-brick wall. He was wearing a white cotton short-sleeve shirt and jeans, and he hunched one shoulder where the phone was jammed to his ear, swinging his torso left and right and tilting his head back as he laughed. He was moving papers about as he talked, a rippling blue line of smoke rising from a gray glass ashtray, the coiled black cord of the phone carrying a charge that kept him moving and talking.

Then he hunched over the little kitchen table, in the same shirt, this time peering down at the green Olivetti portable as he stabbed at its white keys, curling his fingers a bit as if he were playing the piano. He paused to read something, then began tapping at the keys again, and threw the carriage back with the sound of a violently yanked zipper, and then tapped some more. The phone rang, he let it ring, three times, four times, and then it stopped and he stopped typing again, rolled the paper up a few inches and read, then pulled the sheet from the machine and walked out of the room. He heard people laughing in the next room, Rachmaninoff on a tinny record player, a car horn out on East Ninth Street. It was night, and lights burned yellow in the windows of apartments across the street.

Frank O'Hara was inclined to the theatrical, and drinking brought that out. It also brought out his mean streak, the Irish drunk looking to pick a fight. He could snap at people, usually at parties where he had perhaps stayed too long, and though he was quick to apologize the next day, in a charming, roundabout way, people nonetheless grew wary of him, especially in his later years—if you can say that someone who died at forty had later years.

He was outgoing and chivalrous, and if you were at his place with a group of people you didn't know well, he always saw to it that everyone felt comfortable and included, especially the young people who started following him around in the mid-1960s. He was generous with himself, but if he felt you behaved badly, he could just cut you off at the knees. He was loyal and fierce and devoted, and you found yourself devoted to him without realizing it had happened.

In the last four or five years, when he wasn't writing much, which depressed him, he was puzzled that his famous fluency had just seemed to disappear, and he was disturbed that he really didn't care. He had lost the compulsion to write, had fallen out of love with it. He knew he was drinking too much, and he must have made the connection between that and not being able to work, but he was helpless to do anything about it. Everybody drank, but Frank had two to everyone else's one. Jackson and Bill used to go on amazing, horrific benders, weeks at a time. Frank was an everyday drinker; he didn't need to go on benders, because he never stopped.

People didn't go to rehab then. If someone went off the deep end, he might end up getting dried out in a hospital, but that was relatively rare—only true alcoholics, Bowery bums, went that route. It was Jackson's route from early on, and it would be Bill's later. It was far more likely that someone would just crack up completely, like Jimmy, than be told that he needed to stop drinking. No one really thought that they drank too much, because everyone did.

The nature of friendships had changed over the years. First the Porters had taken Larry in when he was going through a bad patch, and later they virtually adopted Jimmy when he was

in and out of the hospital, and he had been friends with them all, all along. But later they grew tired of Larry's childishness and boorishness, and then, when Jimmy's feelings for Fairfield cooled and their affair ended, there was a certain amount of awkwardness for everyone, and he felt distance from Fairfield. Everyone stayed friends, but it wasn't the same.

Then Fairfield needed to sell the de Kooning pictures he'd bought for a song in the early 1940s and which had appreciated in value by 1958. So he called Frank and explained he'd be wanting his picture back.

His picture? Who knows if Fairfield reneged on a promise or if the understanding between the two was hazy. Frank had so much admired *Summer Couch*—no one knew what the title was until much later, for Bill had written nothing on the stretcher—that Fairfield insisted he accept it, and wouldn't take no. So it traveled with Frank for years from apartment to apartment. Naturally he thought the picture was his—he even called it "my beautiful de Kooning" in a poem. And when things got very tight, he'd even wondered what it might fetch. But he certainly didn't anticipate having to give it back to Fairfield. And Fairfield probably never dreamed that he would need to sell it. When he called Frank to say that he wanted it back, Frank turned it over without complaint, and that was that. And Frank kept seeing the Porters, and sat for Fairfield a couple of years later—a sunny portrait of him sitting in white shorts on a floral couch—and all was well.

How many times had plans been made over martinis that went up in smoke when the alcohol burned off? Maybe it took a few years for Fairfield to come to his senses. Maybe he was just an Indian giver. Alfonso once offered Jackson $10,000 so he could do nothing but paint for a year. It was a huge sum then. The next day, sober, he took the offer back, saying that he realized that he really couldn't make that loan (or really didn't want to).

Lunch Poems and *Love Poems* had come out in the last two years. The few reviews had been bad, but they didn't have any effect on his growing reputation. He'd given a few readings since then, and taught a workshop or two. The kids loved Frank because they could tag along when he walked over to the Cedar for a beer after class and listen to him talk about Max Jacob or Balanchine or Deanna Durbin—it was like being inside one of his poems. He was respectful. He listened to you as if what you had to say was important. He was like that with small children, too. You sensed how much poetry meant to him, but you also knew that to him it was like breathing. Writing poems was as pleasurable as going to the movies or swimming in the ocean, and you were on earth to take joy in everything you could, for each had something to do with the other.

Sunday morning was clear and warm, with a rare light breeze drifting in from Accabonac Harbor across the lawn, where he sat with a mug of black coffee braced with a shot of Armagnac: what luxury, his bare feet plunged in the cool, damp thick grass, which was just long enough so that it folded underfoot to make a thick, wet carpet.

The pale disk of the sun sat on the sky's plain blue cloth, and when a small gray bird on a branch just above shook its wings, he looked up and saw through the branches a silver needle pulling a thick white thread through the sky: it was moving east, to what foreign city? And who was looking down at the South Fork, its frothy coast ridged like an old saw blade where it met the sea?

He got another coffee, and then everyone got up and ate in a casual way and went off on errands, or to bring the kids to the beach with lunch in a cooler. Time passed with little indication.

The birds moved from one part of the yard to another, and he read the ads and the police blotter in the local paper—chicken and canned corn on sale at the IGA, kids knocking over mailboxes on Widow Gavits Road. There were strawberries in the fridge, and he ate a few with his fingers, then tore off some baguette and chewed on it while looking at the kids' drawings on the fridge door and a little de Kooning charcoal drawing of a jittery woman with a cloud of funny hair that Bill must have made with his eyes closed—or maybe not. He wondered if Patsy had chosen it or if Bill had decided it was a good one to give her. He was funny about his work that way; he liked some more than others but didn't really distinguish among them otherwise—women, bits of landscape, it was all the same thing.

He wondered what Lee was doing right now, just across the water. There was no sign of life on the little bit of her land he could see, and the house was set back under trees, out of sight. Maybe she was in Jackson's studio painting, maybe she was cleaning the house, maybe she was still sleeping or feeding the dog or watering the plants or fending off the tourists: she said that people simply showed up at the house from time to time, young painters or the morbidly curious, and she shooed them away. In the old days Jackson would often talk to them, but they had nothing to say to her, whose work they did not know, and she had nothing to say to them.

On the way to Patsy's everything looked like a de Kooning. On the train, there was a stretch outside of Southampton, a good five minutes' worth, when everything looked like a Fairfield Porter. Frank had been riding back to the city, reading Gide in French and therefore concentrating harder than usual, when he looked

up and saw in the window a Porter: a liquid green slope of grass rising to a bumpy horizon, smudgy brown trees, Queen Anne's lace in the foreground. In a second he was startled to realize that he was looking at the Shinnecock Hills, from a moving train. From that day on the Southampton terrain seemed Fairfield's creation.

As he biked north toward the water, the blue shapes between the branches and the wavy strip of sand at the road's edge had the smeary quality of Bill's brushstrokes, and it occurred to him that the bicycle itself must be part of Bill's M.O., that the hour or two he spent riding each day, lost in his thoughts, down the asphalt road, through the dense brown gray thickets of scrub oak, with the pale blue sky peeking through the trees and the water just out of sight, provided a bank of images, glimpses of the world that fueled his work. That woman stepping from the front door of Dick Harris's store was a blur of auburn hair and yellow shift; her features froze on the air for a moment as she looked up, and then she was gone, replaced by a silver mailbox and a split-rail fence. He must remember to ask Bill about this. He would write about it in the exhibition catalog.

Cemeteries seemed touchingly banal no matter who was parked in them, but something came over him at Green River, a streak of Irish sentimental morbidity heightened by a tendency to the theatrical, and for all its quiet beauty—it had a stillness unlike any other graveyard he'd walked through—it seemed particularly otherworldly, because Jackson was there in the company of a legion of long-departed farmers and fishermen who had breathed the same air he did and walked through the same landscape that Jackson made into *Autumn Rhythm* and *Lavender Mist* and all the big dripped paintings. For all the aesthetic posturing and the

art chatter that hung in a cloud over his work and indeed over New York, Jackson's pictures were as direct as a dive into the bay. He stopped there on his way back to Patsy's—it was just a few hundred yards up the road—and sat in the grass and listened to the birds.

One afternoon he'd walked through Green River with a little girl who lived nearby. He pointed out Jackson's marker, the blunt, coarsely textured boulder that rose like part of a whale from a little knoll way at the back of the grounds, at the edge of the tangled scrubby woods.

—That's a man I knew who lived just down the road. His name was Jackson Pollock. See that? That's his signature.

She looked at the stone.

—He isn't under there, he's out in the woods.

A little chill of pleasure and fear ran through him, and he felt that Jackson was indeed out there in the tangled scrubby woods. That evening, as the train jounced west over the long hump of the island's bristly, bayberry-clothed spine, he watched the sky dim in the greenish window and felt unaccountably sad, as if he were leaving someone behind he'd loved and would never see again, as if a part of his life had just ended.

(1966)

EIGHT

Fairfield and Anne Porter's big white house in Southampton was the New York school's summer camp from the late 1950s through the 1960s; young painters and poets went there to play on warm weekends and sometimes found houses of their own to rent or, eventually, to buy. Larry Rivers and Jane Freilicher, among others, became permanent East Enders after spending time at 49 South Main Street. The Porters all but adopted James Schuyler, who was also Fairfield's lover, on and off, for several years (Anne simply looked the other way). He lived with them for over a decade, until they finally eased him out of their lives in the 1970s. Even then, and after Fairfield's death in 1975, Anne supported Schuyler financially; a long struggle with mental illness had made it impossible for him to earn a living on his own.

Fairfield was twenty years older than his friends and fans Freilicher, Rivers, Schuyler, Frank O'Hara, John Ashbery, and Kenneth Koch, who also saw him as an eccentric uncle. Porter endured resentment of varying degrees from all quarters. As a painter, he was a bit of a black sheep among his true contemporaries, the Abstract Expressionists, for his own work was representational and owed the kind of debt to French painting, particularly Vuillard, that his peers were determined to shake

off. Furthermore, he was rich enough that he didn't have to work, though not as rich as everyone thought.

Younger painters like Freilicher and Alex Katz found a model and a sympathetic eye in Porter, who was the most clear-headed critic of the time. He wasn't interested in pigeonholing painters, lacked the appetite for self-aggrandizement that compromised the pens of Harold Rosenberg and Clement Greenberg, and had no ax to grind. To read his short reviews for *ARTnews* and *The Nation* is to meet painting face-to-face; the usual scaffolds of jargon have been demolished.

Porter's great-grandfather had bought a marshy farm on Lake Michigan that turned out to be the perfect place to build downtown Chicago, and thus the Porter Realty Trust was born. Fairfield's father hoped that his children would never have to work, but the trust had diminished over the years, and it became necessary to supplement it—at first, small checks for short reviews helped, then the occasional sale of paintings, then the occasional semester or short residency at a university. But until he was well into middle age, Fairfield didn't work at all.

After a childhood in a wealthy Chicago suburb, he moved east to study at Harvard and then at the Art Students League. A quiet boy, Fairfield read all the time, but slowly, for he was dyslexic before the term existed, and he wanted to be an artist— a sad and terrible ambition, the neighbors said, since he had no talent. The family had always spent summers on the island his father had bought in Maine, Great Spruce Head, in a barnlike house decorated with friezes and gargoyles, dragons painted in garish colors on the living room walls. There was a motor launch that slept eight and a little speedboat, and the dining table seated twenty-two. There were many visitors, whose memories of the place would be of cold temperatures and an edge of hunger. They bathed in the sea and picked berries and read. Eliot, his older

brother, spent all his time taking photographs in the woods. Their mother said that Eliot lost fifteen pounds in nesting season.

Anne Porter's family had money, too, and she was a poet. After she married Fairfield and began having children, they continued to visit Maine in the summer. But with expenses draining the trust fund, Fairfield decided to find a reasonable place to live that wasn't too far from New York, and Southampton, where the schools seemed decent and, even better, where there was sea air and light, fit the bill.

They bought a hundred-year-old white-shingled house with seven bedrooms a half block south of the village center, on a few acres of land that ran gently downhill to a lake which stretched from the village nearly to the Atlantic. There was a garage and a toolshed, a barn, an arbor, an orchard. It was the house of a whaling captain successful enough to settle in the heart of town, just downwind of the gentry.

Southampton was even sleepier than East Hampton when the Porters landed there in 1949, and though it had retained its status as a summer resort from the years when Chase taught there, its year-round residents were unsophisticated with a vengeance, and the Porters made no attempt to fit in. Here was a man with no occupation whose wife, nice enough but mousy, didn't socialize except to help at the church. Their children were silent, too, so you couldn't call them stuck-up, but they were far too smart for their own good. They weren't people you felt comfortable inviting to dinner, and you didn't want your kids over at their place, for they had strange houseguests, artists and apparent homosexuals.

Fairfield and Anne's generosity to their friends came naturally to them; Fairfield was from a large family and liked having people around, for all his reticence—he was as famous for his silences as he was for his abrupt way of entering and leaving

rooms. Fairfield might drop in to your place to see what you were painting, sit there wordlessly for an hour, then suddenly leave. People grew used to this. Caring and distant, generous and stingy, rigorous and irrational, he wore his inconsistencies on his sleeve. Her constant adjustments to Fairfield's haplessness led Anne Porter to compare their union to that of Dagwood and Blondie Bumstead.

Porter's economical comments cut through the baloney at gatherings at the Club, an artists' salon of the 1950s. The Abstract Expressionists wondered: Should one sign paintings on the back, on the front, or not at all? Was it vain to sign your paintings or was it vain not to sign them? If you were vain, it was vain to sign them and vain not to sign them, Porter said. If you were not vain, it was not vain to sign them and not vain not to sign them.

But it was Porter who insisted on racing through railroad crossings even when a train was coming, with the result that he was the only American painter to be struck by the Long Island Rail Road and survive. When the police arrived on the scene, at a crossing in Bridgehampton, he was staggering outside his old yellow station wagon, bleeding. "My wife told me this would happen," he said.

He installed an expensive and beautiful Swedish woodstove in the Southampton house, the sort of thing that thrifty rich people liked. From its oven he would withdraw the oatmeal that overnight had cooked to a smoky paste at a glacial pace, and take it to the dining room table, which held the remainder of yesterday's breakfast—a china teapot, a small vase of flowers, napkins, a volume of Stevens, a jar of marmalade—lying where it had landed when everyone was finished. He was trying to paint the scene, and asked that it be left undisturbed.

In the first hour of light, crows paced like convicts in the yard, which stretched from the house all the way back to one narrow end of Lake Agawam; he could see its surface, a distant sliver of metallic blue in the quiet gray dawn. Anne and the children were asleep. He heard the vague thud of Jimmy's footsteps as he moved in the bedroom overhead. The dog, Bruno, lay by the kitchen door, head on its paws, watching, waiting for their morning walk down South Main Street. He carried the oatmeal to the dining room and sat at one end of the table.

If there was an aspect of Abstract Expressionism he embraced, it was the idea that one must be attentive at all times. To see what was in front of you, and to see it clearly and with respect for its natural appearance, was to be alive as a painter. This was the lesson of de Kooning. Hence the breakfast table. If you tried to arrange such a still life, it tended toward chaos. If you left it alone and simply looked, its order would be revealed. Things landed where they were meant to land.

He suddenly rose and walked quickly out the front door, down the path between the two horse chestnut trees and out the little white gate, Bruno breaking ahead and veering into someone's yard, then reappearing, tail at a level wag, and trotting down the sidewalk. The Porter house was almost the only one on South Main that was occupied all year round, and though the kids' schoolmates saw it as a mansion, it was modest for the neighborhood, where white-columned summer palaces rested behind shaved hedges and shrubs packed in burlap.

The dog was sniffing at something in the road a hundred yards ahead, where South Main seemed to collide with a ten-foot hedge that half-disguised a sprawling house on the other side of Gin Lane, which ran parallel to the sea. There the dog trotted off to the right, out of sight, and soon he followed, walking along the lane as it became an isthmus between Lake Agawam, a

choppy and chilly blue, on his right and the unseen ocean on his left.

Bruno turned to see if he was following, then bounded up a steep apron of sandy asphalt and over a dune, seeming to disappear into powdery blue light. At the dune's crest he could see the waves crashing. He leaned into the wind and headed for the hard-packed sand at the wave line; Bruno was a speck to the east, where the coastline eventually vanished.

Jimmy had come to visit in 1953 and returned for longer and longer weekends more and more frequently until he had simply moved in. Along the way he and Fairfield had begun meeting secretly in New York, then driving to Maine a couple of weeks before the rest of the family so they could be alone. Jimmy's feelings cooled first, but Fairfield, the very embodiment of a

Anne and Fairfield Porter breakfasting with James Schuyler (center) in the dining room at 49 South Main Street, ca. 1962 (Photograph by John Button. Courtesy of the Henry W. and Albert A. Berg Collection of English and American Literature, New York Public Library)

straight-talking, clean-living, commonsense Yankee, had the soul of a fifteen-year-old boy, and he was as hurt, jealous, and angry as a jilted teenager could be. His withdrawal was protracted. He implied that all of their mutual friends had betrayed him, and they were embarrassed for Uncle Furl, as they sometimes referred to him behind his back. Meanwhile, Jimmy, who irrationally blamed Frank O'Hara for taking the spotlight off his own, virtually unpublished, poetry, irreparably damaged his own close friendship with Frank.

For all his emotional fragility, Schuyler was tough. He had come to treat Southampton as home and saw no reason to admit that it wasn't. As his mental health began to break down, he knew that the Porters would be reluctant to ask him to leave.

He lived above the kitchen in a bedroom at the rear of the house, writing poems, reading aloud to the children, ordering from garden catalogs, and looking out his window toward the lake, watching for the woodpecker that came to the maple tree or watching Fairfield gather wood or settle himself in the yard with his easel. There Fairfield would smear Maroger medium onto the canvas, and then work the pigment in. It was the crank in him that was attracted to Maroger medium; it was said to have been used by old masters and took days to cook, on the kitchen stove, its smell permeating the house. He was attracted to unpopular causes, too; in the late 1960s, Fairfield carried petitions demanding a halt to the construction of a nuclear power plant in Connecticut, cementing his neighbors' opinion that he was an irresponsible leftist and perhaps a communist.

His friends had grown used to his bizarre habit of dropping in and out of their homes; it was like Cary Grant rising without explanation from the dinner table in *Bringing Up Baby*, napkin in collar, soupspoon in hand, to wander off into the night. Fairfield was handsome in the manner of an overgrown prep-school

boy, and he had a dazzling, open smile. But he could be rigid, taciturn, and graceless in company and sometimes, after a few Scotches, would embark on obsessive and tedious monologues.

His affair with Jimmy made him look foolish, though he didn't realize it. They loved him for not knowing, even as they cringed to think of the two of them together. Jimmy liked older men and wasn't above using them, and that part of him was inseparable from his fondness for Fairfield. Anne had simply come to accept Fairfield's infidelities, and she became used to Jimmy's self-centeredness; there was something of the martyred saint to Anne, though she had a wicked sense of humor.

Fairfield was a mile up the beach when Jimmy came down for breakfast and Anne set off for morning Mass. On her return she saw that Jimmy had gone back to his room, and she cleaned his and Fairfield's breakfast dishes, and then slowly went through the entire house with a broom and dustpan. Jimmy heard the approach of the broom in the hallway and then its retreat. There was a sheet in the typewriter.

> An orange devours
> The crusts of clouds and you,
> Getting up, put on
> Your daily life
> Grown somewhat shabby, worn
> But comfortable, like old jeans: at the least,
> Familiar.

Now what? It was warm outside; time for a walk into town perhaps. He put on blue canvas shoes, rolled up the sleeves of his light blue oxford shirt, and headed into the perfumed air as a

James Schuyler, ca. 1957 (Photograph by John Button. James Schuyler Papers, Mandeville Special Collections Library, University of California, San Diego)

scarlet tanager regarded him from an oak limb. Where to? Bob Keene's bookshop, maybe. What was at the movies? He'd have to pick up a paper.

He walked through the little gate and swung left onto South Main on short, thickish legs in khaki shorts. The sun was climbing, birds singing in scattered clumps in the tall trees; two hundred steps and he was at the crossroads of the town, the postcard-perfect Presbyterian spire on one corner and on the other, behind a red brick wall, the Tudor facade of the library, in whose stacks rested a single copy of his only book. Next to that was the Parrish Art Museum, with its William Merritt Chase collection and its Madonnas . . . who was Parrish? He knew the collection, but couldn't remember anything about its benefactor.

He paused at the corner for a long moment, though there was no traffic; his medication made his movements deliberate. The clerk at Silver's nodded as he entered; he was in almost daily to scan the periodicals, sometimes for lunch at the counter. Though he was polite, his deep voice was gruff. She watched him leaf through *The Atlantic*; his movements were like a robot's, as if he'd been so thoroughly drilled in the right way to turn a page it was beyond his ability to do it any other way.

Down Main Street past the hardware store, with its window of bright green rakes and red seeders, there was the jeweler's, the thrift shop, a restaurant with a new name: when had it changed hands? He used to drink stingers there with Frank and Larry. Or was it bee stings? He and John and Frank used to drink them at the Carlyle; it was the bartender's specialty. That seemed like years ago; it was years ago. Who would have dreamed that Frank would have been the first of them to go? If anyone, it should have been him, Jim the Jerk: how many breakdowns? Not to mention passing out in bed with a lit cigarette: what a cliché. He'd spent months in an airplane splint.

He liked sitting for Fairfield, two hours at a stretch, in the house, in the studio, thinking. Neither of them spoke; there was just the sound of the trees outside, steam hissing in the radiators, or a fan smoothly whirring.

Fairfield's people came out oddly, with a paint-by-numbers quality. They weren't stylized like Alice Neel's, but there was a naive quality nonetheless. His people were self-contained; their gaze was inward even when they looked into your eyes. They were somehow tentative; they lacked the frozen authority of conventional portraiture. For this reason he had problems with commissions; more than once, clients had found the likeness wanting and refused the picture. Perhaps the truest surface appearance he'd managed was in a brightly hued picture of Elaine de Kooning.

When Fairfield painted Anne or Jerry or Laurence or Katie or Lizzie, they looked like themselves but also like his memory of them; there was something changeable about their appearance. Did it make sense that someone who never learned to express emotion in conventional ways would project his feelings in paintings of people he cared for? Of course. But what made them memorable was the reluctance you sensed behind them; you could feel Fairfield hesitating, wondering if he'd gotten it right. That quality was evident elsewhere in the pictures—especially in the cars he painted. They were cartoonish, blobby, and only incidentally geometrical, more like oddly shaped fruit than machines. There was no such hesitation when he painted a house, though, for architecture was a kind of religion to Fairfield.

He'd shown him an ink sketch of Main Street that Jimmy loved immediately for just that combination of sureness and hesitation. There were the big trees whose contours were so casual and so right, the outlines of sidewalks and shops and a clock tower that he recognized. But best of all, in the foreground Fairfield had tried to get a station wagon just right, and had man-

Fairfield Porter, *Main Street, Southampton*, n.d. (Henry Art Gallery, University of Washington, Seattle)

aged despite himself; its foreshortening makes it look as if it has been in a head-on collision, its front bumper is awry, its roof is asymmetrical and dented, a roof rack resembles debris... moreover, he'd scribbled in shadows that look like cartoon static. Nevertheless, it is true to its car-ness, and it brings the whole scene to life.

Then there was the picture they called "The Four Ugly People." Fairfield had painted Jimmy sitting in a chair on one of the porches in Maine, looking down at a book, reading aloud to Lizzie and Katie. Katie stares into the distance, distracted; Lizzie is looking at something on the floor. Anne, approaching the house from outside the frame, glances in as if the sight of Fairfield at the easel has surprised her from her thoughts. The four of them are like islands, disconnected. Fairfield had put himself in the picture, too, in the form of a can of Imperial Brush Cleaner,

bright yellow, precisely lettered, resting on a shelf of the rolling table he used as a palette. It is the sharpest thing in the picture, which moves, as Fairfield did, from rigor to a kind of dreaminess, the leaves in the trees outside vaguely defined pools of green.

There was a picture of Anne lying in bed, a book and her glasses nearby, on a sunny afternoon: another family non-favorite. She'd been ill; he painted her listlessness and fatigue, but it was hardly flattering. Behind his back, she called it "The Last Illness of Marvin Ginsberg."

The most beautiful of his pictures was the one that veered the closest to sentimentality. It was of Jerry in a wicker chair, aged about five or six, hands crossed on his bare legs, which are made of short brushstrokes; there are little reflections of the sun on his knees. In the shadow of a baseball cap his eyes seem to show resignation mixed with plaintiveness: can I get up now?

He turned from Main onto Hampton Road, crossing carefully. Saks Fifth Avenue: if only they had a men's shop in this branch, he could divert himself there. Sip 'n Soda: what did that mean, exactly? They had good cold tuna salad, with the right proportion of celery, correctly diced. He picked up a *Press* at the counter and settled into a cozy back booth, facing the street. Too late for the breakfast crowd, too early for lunch: what a luxury to have a coffee shop nearly to yourself, with just enough customers to keep it interesting. The clear plastic menu felt slick, like oilcloth. Had he brought money? Enough for homemade pie and coffee.

Judging from the front page, the popular activity in Southampton this spring was the presentation of proclamations and commendations. The smiling owner of Arrow Laundry held one corner of a check for $5,000, and the smiling president of the college held the other; who would let go first? The basketball coach

135

loomed between them, looking angry; the check was for his new gym. A local restaurateur held the coveted Crusade Award, and the king and queen of the high school prom wore crowns that resembled inverted colanders.

The postmaster, an air-force colonel, and the president of the Community Club gazed into the distance, Rushmore-like, at a Memorial Day observance; the photographer apparently lay at their feet. A man named Frank Dull had died. Bonne Bell moisture lotion and a powerful new foot powder were on sale at the pharmacy, and Bud Smith played piano nightly at Ridgely's. Studley's Chalet specialized in "steaks and steak sandwiches—steaks, steak sandwiches, chopped steak." The roller rink would open for matinees "on rainy days." Someone named Ham had been arrested for burglary.

He liked to imagine applying for one of the jobs listed in the classified section, though this week's offerings were particularly grim. Under both "Help Wanted—Male" (man to work on cesspool truck) and "Help Wanted—Female" (if you like to talk on the phone, you can make $20 an hour), he found little from which to construct a fantasy.

There was always the movies. Over in Sag Harbor, they were arty: *Far From the Madding Crowd*. Here, it was *Guess Who's Coming to Dinner*. A command, not a question. The drive-in—how he loved the drive-in!—offered a double feature, *The Scalphunters* and *Operation Kid Brother*. The heavy metal speakers that hung clunkily on the car window, the odor of frying fat, the gravel crunching underfoot as you carried your milkshake to the car, the beautiful fanlike shaft of projector light spreading through the night to the gently curving screen. Children falling asleep on car roofs.

He and Fairfield had gone to the movies last winter, a ten-minute walk down Job's Lane, past the art museum, just at the

opposite end of the little village. Not too many years before they could have simply walked out the back door and across the property to the spot where it ran up against Lake Agawam, then cut across a few hundred yards to the movies. But Fairfield had sold off lots over the years, and other people's houses now stood in what had been meadow.

It was a winter night, and the snow was coming down thick as they emerged from the velvet dimness of the theater onto Job's Lane with a dozen other patrons who carefully walked to their frosted cars. They walked side by side up Job's Lane, listening to the faint hiss of falling flakes. What movie had they seen? He couldn't remember. The snow fell without wind, clung to the elms on South Main. Fairfield slowed.

—This is a snow picture worth painting.

—The weather said, "Turning tomorrow to bitter cold."

—Then the wind will veer round to the north and blow all of it down.

As usual, he was right. It was a Fairfield thing. So was his comment about a gray sky—that just one cloud spread from Richmond to Bangor, and its center was Southampton.

He looked up from the paper. The customers were familiar but unplaceable, as he guessed he was to them. The mirrors on a far wall reflected the griddle man at work in his white apron, the backs of customers at the counter, a slice of bright outdoors with cars gliding through it. How unlike New York it was, and what a pleasure when in New York to sit an hour in a coffee shop near the museum, under the harsh light of Sixth Avenue, and consider the rush of people and taxis honking by, and remember the quiet of Southampton, a hundred miles away as the crow flies.

He climbed the stairs and sat at the typewriter but didn't feel like writing. He picked up a diary someone had given him. Today was Housman's birthday ("I could no more define poetry than a

terrier can define a rat"), and Frost's, and Tennessee Williams's. And, the diary said, it was the date of Virginia Woolf's first breakdown—how did they know that, exactly?—"following the publication of her first novel." And it was publication day for *This Side of Paradise*—twenty thousand copies in a week. What had his book sold? Surely fewer than a thousand. Poor Scott, poor Virginia, poor Tennessee, poor Housman. And poor Frost—him, too.

And it was Whitman's death day. Think of Walt, reading the bloated ninth edition of *Leaves* on his deathbed in Camden, cotton-candy beard haloing that wrinkly face, that dark brow. He liked rough trade and schoolboys—they ran him out of a town not far west of here, tarred and feathered him, after a boy he'd slept with told on him. What town was it? Not Huntington, that was his birthplace. Somewhere close to it.

How little he knew about Long Island. Montauk and Amagansett, East Hampton and Wainscott, Bridgehampton and Sag Harbor. Water Mill and Southampton. And then there was a blur in the railroad window, followed by Manhattan.

I take the train and go
to the city. Then I come
back. Mastic Shirley,
Patchogue, Quogue. And for
all the times I've
stopped, hundreds, at their
stations, that's all
I know. One has
a lumberyard.

He'd first come here on the train to visit Fairfield. Frank had written about the train ride, and so had Anne. And so had Fairfield! It was a very matter-of-fact poem, just the way he liked

them. It was true to Fairfield's painfully literal way of thinking and seeing, but it had something more than that.

> The train rolls jouncily toward the city
> With a slight tilt against the landscape seen on both sides.
> The green sky is heavy with impending rain.

A jouncy roll—that was just right. You could hear it squeaking. And the careful assessment of its tilt. And the green sky! As seen through dirty tinted windows.

> A thin passenger takes off his jacket.
> Everyone is preoccupied with his own newspaper.
> No one notices anything else or the dripping bushes.

He saw him sitting with his beat-up leather briefcase, writing in the little notebook he used for taking notes at galleries, and imagined the rustle of newspaper pages turning. Fairfield had learned something about observation from him; that was clear. How does the poem end? Deadpan, of course, with the conductor taking tickets; that was Fairfield.

You can't separate the poet and the poem, finally, no matter what Cleanth Brooks said. Look at Auden—there was transparency. The artist is revealed in his work. Fairfield said he didn't like Andrew Wyeth's paintings, because they showed him something about Wyeth that he disliked. And Ad Reinhardt—the reason people sputtered before those black-on-black pictures, he said, was because Ad was an infuriating man, and it came across in his work.

When Rudy wanted to make a movie at their house in the 1950s, Anne decided to portray a cleaning woman, out of general sympathy, even though it was a comic character. Larry and

Rudy improvised the script as they went along, but the basis was Anne's story—she and Fairfield portrayed the hired help, who fall in love. To see it now was to realize how much they'd all aged in fifteen years, though Anne, not yet forty, already had gray hair. Fairfield looked like an overgrown college boy, perhaps a slightly retarded college boy, given that he wore the torn Mr. Green Jeans outfit he liked to paint in, and his "acting" consisted mainly of pushing the lawn mower through the backyard and smiling in a dazzling way. He was Elmer Turnip, and Anne was Mrs. Rocket.

It was a silent comedy that featured special effects of a fashion—Rudy ran parts of it backward. Anne, wiping her brow, scrubs the floor on hands and knees; her life changes utterly when Larry, in Svengali makeup, introduces her to a magic dust mop. When waved, the mop does dishes, returns spilled cornflakes to their box, and even places clothes into the washing machine as Anne looks on fondly. When Elmer slips an engagement ring on Mrs. Rocket's finger, Anne said later that she felt married to Fairfield in a way she never did in life.

He heard the wet flutter of the old mower's blades turning as Fairfield shoved it along purposefully, crossing the window from right to left and vanishing, then reappearing and vanishing to the right. The dog lay by the swing set, watching seriously. Fairfield's hair stuck up like Alfalfa's, and a corner of a handkerchief trailed from a pocket of his overalls. The sharp smell of cut grass drifted through the window screen.

Books on a shelf: *Colour in the Winter Garden*, *The Old Shrub Roses*, *Shrub Roses of Today*. The flowers he'd planted at the Porters': the splendid Nevada, yellow Lawrence Johnston, Mme Alfred Carrière, Rosa Mutabilis. Golden Wings, Rose de Rescht, Souvenir de la Malmaison. Would they go when the house went, as it would someday? Good-bye Mabel Morrison, Mme Pierre Oger, Georg Arends.

Fairfield Porter naps with Bruno (Photograph by James Schuyler. James Schuyler Papers, Mandeville Special Collections Library, University of California, San Diego)

He selected the Ilford rose book, nudged off his shoes, lay down with the book opened to Variegata di Bologna. Time for a nap.

A CARDINAL

in the branches of
the great plane tree
whistles its song:

or is it that mimic
Fairfield
saluting the day

under the branches of
his great plane tree
in his springtime yard?

(1968)

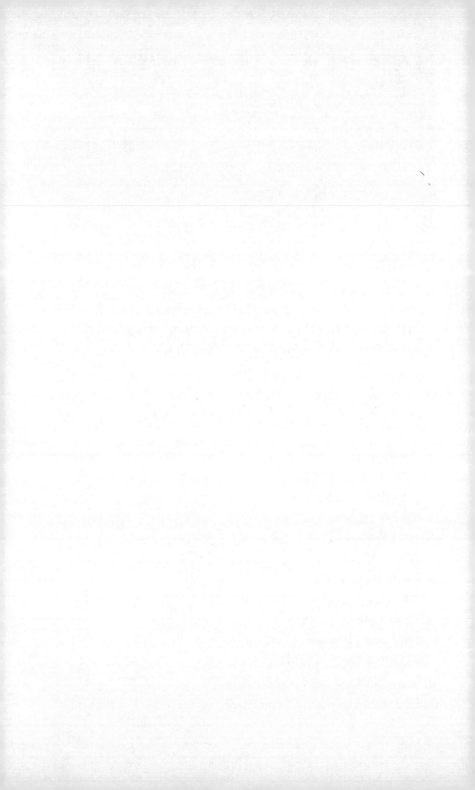

NINE

From where he sat in the oak rocker, the woman's shoulder, a mass of pink and red, didn't seem connected to the rest of her body, and for that matter the body hung together only in fragments, tenuously connected by threads of oil. She looked like a cloth doll that a dog had gotten to. She was a bit silly; that was okay. But she should look like someone you'd see for a moment on the street, out of the corner of your eye, at the very least, and that hadn't happened yet. He'd already wiped her out a dozen times.

He crossed the room, looked up at the bristly tops of cedars and oaks swaying in the summer breeze, the Windex blue sky beginning to drain of color as the sun descended and threw shadows across the room, where paint cans stood on neat newspaper islands and sheaves of drawings had frozen in mid-landslide. The studio, with its big rectangular windows high on the walls, was like a glass ship in the forest.

He sometimes considered installing fans, and imagined their white propellers, thirty feet overhead, turning slowly, ready to pull the house gently from the earth through the trees' scratchy canopy, allowing it to drift, timbers creaking, through the warm air above Springs, out over Accabonac Creek, above Gardiners Bay, the stubbled coast of Long Island's North Fork visible as the

studio gained altitude, Connecticut's brown shore on the horizon, the ocean to the west like chipped slate.

He briefly submerged his freckled hands in a plastic tub of turpentine and water in the metal sink at one side of the room, then ran them under a cold faucet. He noticed, not for the first time, that they looked like sausages now that he was past sixty. He dried them on a spotted strip of white sheet and re-rolled the sleeves of his work shirt, glanced at the ashtray by the rocker to be sure the cigarette was out, and went to the door.

Stepping into the remaining midday heat, he shut the door, pulled the Royce Union three-speed from where it leaned against the house, walked it clicking to the driveway, threw one dungareed leg over the crossbar, and stood checking his pockets for cigarettes, matches. He put a foot on a pedal, shoved off.

The driveway unrolled smoothly beneath the wheels. At its end he walked the bike awkwardly between his legs to open the big dull silver mailbox, and adjusted his rectangular black-framed glasses to read the return addresses: bills from Pearl Paint, East End Hardware, LILCO, and Bell Telephone, postcard announcements of shows by artists he didn't know, a letter to Elaine from the University of Iowa. He'd have to forward that. He put everything back in the box, closed it, and glided down the hill, pursued by a friendly golden retriever, pulled on both spongy handbrakes, and squealed to a stop where Woodbine Drive abruptly dove into Springs Fireplace Road at the exact center of a curve: no way to see if cars were coming. He cycled north on the bumpy shoulder of the oncoming lane for a thousand feet, past the tree Jackson had driven into, then quickly crossed the two-lane blacktop to the right lane, the road leveling as he pedaled steady and easy in third gear all the way to Dick Harris's store, where he stopped to buy a root beer, drinking most of it quickly in the shade of a tree outside and tossing the bottle with

a sharp crack into an oil drum. There were silver, yellow, and green gum wrappers crumpled in the sand at the edge of the road, at least a dozen bottle caps, and a torn *Newsday* page with part of a headline that said, "Survivors Feared." A black dog with a smooth, shiny coat lay silently in the shade by the side of the store, gazing at him neutrally with brown eyes whose pupils were so black they were like holes. "Good boy." The dog raised his tail and let it drop, then groaned briefly, or maybe belched.

He pressed his thumb into the smooth chrome curve of the shift lever until it clicked with the slightest resistance into first gear; he could sense increased strain on the thin cable that threaded the bike's tubular frame to the rear wheel. He peeled out, the rear tire spraying a plume of dirt at the dog, who, head on paws, watched him ride away.

People said that East Hampton was like Holland. He supposed it was; the land was as flat as it was over there, and there was the same feeling that water was always nearby. He liked the northern light, and felt he was at home when he approached Gardiners Bay. One of the best things about living here was that it wasn't like the rest of America. He liked the idea of shopping centers, supermarkets the size of small towns, the Grand Canyon, and the Grand Coulee Dam. But to live there would be overwhelming. Better to stay on the periphery, keep an eye out from a safe corner.

He liked riding in a car, as long as there was something to look at. He liked the half-hour trip to Southampton, passing through the string of little towns with their little Main Streets, their shops and cafés and traffic lights. He liked the stream of things going by, signs, houses, cars in different colors, people walking in the street, the different expressions on their faces as you passed them, laughing or frowning, looking down or up or at nothing in particular. He liked the sky swinging around overhead as the car turned.

Saul had told him that he, too, liked the vastness of America, the big highways—thousands of miles of nothing! In the old days, not long after coming from Romania, Saul would get on a bus and ride across state lines, like a spy, and what he saw came out of his pen. If only things were that clear to him. He had to tease what he wanted out of his brushes; he had to do the same thing over and over and hope it would come out fresh. He wanted to get at what was behind what he saw, the sensation of asphalt rushing beneath him as he pedaled, the asphalt flecked with so many little bits of rock, and the soft whoosh of the rubber tires.

He passed Ashawagh Hall, where a man, watched by a duck, was unloading a cardboard box from the trunk of his car. The duck was just standing there on the grass, watching him! There were a few cars in the white gravel parking lot of the white-shingled Springs church, and a sign outside announced the ANNUAL MEATLOAF DINNER in neat black letters: a nice job. Maybe it would be fun to go. Him and Joan and Lisa. They would know people there.

It was very hot the few times he'd stepped outdoors that day, and the humidity was just breaking as sundown approached. The disadvantage of living near the bay rather than the ocean, he thought, was that the air didn't really cool as you neared the water. Sometimes there was a breeze, but the air remained hot. On the bike, though, it was nice to feel it rush over his face, puff out the sleeves rolled into soft collars at his elbows. The road ran gently downhill now, and the bike sounded like a roulette wheel as he coasted past Jackson's house. The front door was open, and he saw in the backyard the slumped figure of someone in a simple wooden chair, facing away, toward the creek. Lee, probably, or maybe her nephew over for a visit.

He used to wonder what it was like for Jackson as a boy, growing up poor on little farms in California. It always made him think of *The Grapes of Wrath*. He thought of the mother in that movie, big and warm, and the devotion of her son, played by Henry Fonda. He remembered Jack's mother, who was big but not warm. Maybe she just didn't like her son's artist friends; maybe that was why she seemed so remote. Maybe she didn't like foreigners, like a lot of Americans from the Midwest. It was strange, that, since they all had come from Europe. His own mother didn't approve of anyone or anything, and most of the time he managed to make believe she didn't exist.

Someone on a bike swung into the opposite lane about a quarter of a mile down the road. The figure was indistinct; light glinted off the bike's chrome fenders. It grew larger and he saw that it was the boy he sometimes passed on this stretch of road. He must be heading home after a day spent . . . where? At a friend's house? He wasn't coming from the beach, as he was dressed in jeans, not a bathing suit or shorts, and he saw now that he had a camera slung around his chest. The boy had a blond crew cut and a light sunburn and looked shyly over and nodded as he approached. Bill smiled and waved as they passed, the boy and his bike melting in a metallic blur.

He passed the little gray-shingled house Joe Liebling and Jean Stafford spent half the year in, and he could imagine Jean seated before the upstairs window at her typewriter, looking out across the road to Accabonac Creek, or maybe sitting on a downstairs divan with her cat and a tumbler full of Scotch. Joe was a very funny guy, very nice to be around. He was a reporter during the war, but the stories he told were about the meals he had eaten, nothing about the usual business of war. He liked that about him. What good did it do to talk about all the horror that

everyone had to live through there? Joe talked about the different birds he had eaten, and where he had eaten them, and the people he had eaten them with, and what the weather had been like.

Three chestnut horses stood at the split-rail fence that marked the border of the Talmage farm, with its wide, cropped pasture; a little bird stood on the fence right next to them. As the road swooped downhill to the right, toward the water, scrub oak and mottled white birch trees hunkered down at its edge. At the bottom of the turn he leaned to guide the bike onto Gerard Drive, a peninsula that unfurled like a pennant between Accabonac Creek and Gardiners Bay.

The oak leaves were showing their silvery green undersides, and a shelf of cumulonimbus clouds was breaking into flak in the pale sky over the water that lay at the road's dead end, a mile or so away. Now the houses were shacks on stilts, looking as if they'd been banged together in an afternoon, as if the builders simply accepted that collapse was inevitable on the arrival of the next nor'easter, which would take the houses and most of the beach with it.

The gray asphalt had a rash of blue black tar patches the shape of states for several hundred feet, and then, where the highway department had gone to lunch or just given up, there were dents and holes that cars rolled over but bicycles dropped into with a bone-slamming shock, so he threaded his way through till the road smoothed. Looking up, he saw that the houses and trees were gone, replaced by a low border of yellow and tan and white boulders on the bay side, and scrubby brush along the creek.

The bay was gunmetal on the left, the creek a more luxurious blue on the right. Over his shoulder, on the creek's far shore, he saw the waterfront houses he'd just passed on Fireplace Road, each the size of a Monopoly hotel. Cedars blanketed the little

isles in the creek—Tick Island, for one, off whose shore he'd gone clamming for the first time and where he'd seen, to his amazement, deer swimming across the creek. Their antlers looked like mobile driftwood. Deer swimming! They said it was because they were looking for food. But wasn't there enough for them on Tick Island?

The road straightened, telephone poles marking a warped corridor. A white speedboat at anchor just offshore turned lazily like a compass needle. Queen Anne's lace dotted with shiny black bugs sprouted from rocks where the road edge crumbled. Shadows of foliage crossed the road darkly, like stalagmites, or the black fingers that creep down a Clyfford Still painting.

The road gave out abruptly in an apron where asphalt crumbs lay in white dirt and hummocks of beach grass lined the perimeter. He stopped the bike and laid it down against some reeds, walked to the edge, and looked across the little neck of water that joined the bay and the creek, its current seeming to flow rapidly as always. But which way was it going? And what determined the tides? Was it the far-off pull of the ocean that caused the bay and the creek to rise and fall? Why such steady commotion?

He stood at Gerard Point looking over at its doppelgänger, Louse Point, another sandy spit with a crown of beach grass, less than an eighth of a mile across the little channel. Tick Island, Louse Point: you had to admire the humor in naming such beautiful places after their unhappiest features. Why Gerard Point was named thus he didn't know. The two blunt points faced each other like opposed index fingers, the water sliding between them. Once the peninsulas had been joined. It was the hurricane of 1938 that washed out the land, and the water poured into the breach. The points had been retreating ever since, though no one paid much attention except when big storms passed through or

when clammers wading into the shallows looked back to see how the sandy shelf was collapsing from beneath.

He descended the little slope to the shore, feeling the sand leak into his shoes. He sat on a flat rock and listened to the tide. Terns carved the air with wings like little scythes. A dragonfly wavered at the water's edge, a prehistoric helicopter.

Today the light was powdery. Sometimes you knew it was there only by its effect on the water or the shore, but today you felt you could touch it. It was remarkable, really. The branches of the scrubby bushes seemed to be pushing through the light, as if it presented resistance. It soaked into some things and wrapped around others. The green of marshy spits on the far side of the creek was so intense it seemed drenched in chemicals. Yet the greens and browns of nearby bushes were subdued. Who could paint that? Fairfield got it, sometimes. You could only catch glimpses of it, the way you catch a certain look that crosses someone's face for a fraction of a second before disappearing forever. That was how you saw light.

He wheeled the bike back onto the road and retraced his route past the shacks, then the peninsula broadened as he left Gerard Park and pedaled uphill on Fireplace. The bottom seemed to drop out of the heat, and he felt a breeze as a pickup truck with a barking dog in its bed passed and grew smaller, the dog shrinking, its bark getting fainter, then the whole apparition vanishing around a curve. The sky seemed lighter, more distant, as treetops drew together overhead. The treetops closed in on the sky, and he felt as if he were entering an enchanted forest. It was time for a drink.

He liked the studio quiet. By 5:00 p.m. people would be there, but for now it was him and the sweeping sound that watercolor paper and oil-soaked pages of *The New York Times* made as he moved them around on the floor. Everything he did produced a crisp, immediate echo in the big, simple studio. He'd worked in

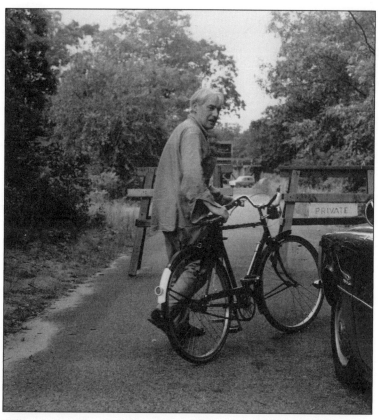

Willem de Kooning outside his studio, Springs, 1965 (© Renate Ponsold)

dark apartments, on Leo's sunporch, in a garage. Finally he made a beautiful loft on Broadway with polished floors and good furniture and a nice big refrigerator. That was about as good as the city could get. But now he was where he wanted to be. He didn't have to worry about where he'd work next, and he could make any size painting he wanted. Reuben Nakian said that a studio had to be big enough for you to swing a cat around over your head. This was bigger.

The house was simple and roomy. On the ground floor there was a kitchen and a dining area and a living room, all pretty much

open, like a warehouse or a loft. He'd hired a carpenter to build wooden benches around the perimeter of the studio, so there was always someplace to sit or put things down when you needed it. And you could store things underneath, paint, supplies. The benches were new enough so that the smell of fresh wood filled your nose as you entered the house. When he'd drawn the plans for the wide central staircase, he'd thought of Corbusier, and the staircases in the hotels and department stores he loved to visit when he first came to America. But he made it airy, as if it were floating. And the supports that grew from the studio floor to the roof, white steel vees, were like seagulls' wings.

He'd been moving between women and landscapes for a year or so. Now he was painting a woman on a door. It was a good size for a standing figure, almost seven feet tall but only a yard wide, so he'd have to squeeze the figure in. It solved the problem of the background. The picture would be all woman, with little room for anything else. He'd banged together a dozen two-by-fours to make a square ladderlike frame to lean big canvases against when he painted them, and he put the door there. It was good to meet the figure face-to-face. To paint the very top part, he'd stand on a stool.

Real painters always had a system. That's what he told the young guys who asked him. You had to have a system. After working for years and years, you figured out ways to get things done. They were shortcuts, really. Sign painters had them, and so did billboard painters and landscape painters and portrait painters. You had to have a starting point, too. Something real. A tree, a shoe. Once you'd gotten a picture going, and had an idea where it was headed, certain parts of it filled themselves in—background, framing devices, and so on. You changed these as you went along to suit the main focus of the picture—a woman, say. As the woman changed, the rest of the picture had to change with her.

The trick was to make each stroke new, never to repeat yourself, to keep the image alive and mysterious, the way things really looked.

He usually had a few paintings going at once, and the ones that might be finished or that he wanted to leave alone for a while leaned against the walls. Working the way he did was like doing several jigsaw puzzles at once. Sometimes the piece you held in your hand belonged to some other puzzle, and you made a note to yourself to use it there. Sometimes the pieces seemed to fit, and you got a whole corner right, but when you looked at it later, you realized that they didn't fit at all, because you'd forced one.

When this happened, and it happened all the time, he just scraped the paint away with a palette knife and started over. He'd get to a point where everything seemed to be coming together, and then he took a whole series of wrong steps and the whole painting went flat. What the hell. Begin again.

There were drawings and oil-smeared sheets of newspaper spread in sloppy sheaves on the floor, most of which was covered with tarps or ribbons of heavy brown paper rolled out like red carpets. The tarps were so finely spattered with dots and little driblets of color that they looked as if they'd been sprayed from above. They looked like Jules Olitski's paintings, someone teased him.

He sat in the rocker thirty feet from the painting and considered it, smoking. Between him and it the floor was like a narrow runway temporarily cleared of traffic. Along its left border ran an irregular row of metal and plastic and glass cups and bowls, dozens of them, many with brush handles protruding. To the right of the runway were the scattered drawings and newspaper sheets, and a glass-topped steel table covered with more paper, pencils, charcoal, gesso, quarts of black enamel, neat rows of brushes ordered by size, shiny white and silver tubes of pigment, a straightedge, tan rings of masking tape, razor knives, a big dented can of thinner, and a carton of Camels. Carpenters were

coming in a few days to install cupboards he'd designed to keep a lot of things out of sight.

He sat in the rocker facing the camera they'd set up about ten feet in front of him. The man, who was big and bearded and earnest, sat in a chair to his left, and a pretty girl wearing headphones stood behind the man, holding a boom with a microphone at its end above the two of them, as if she were fishing. She wore a tape recorder slung over one shoulder, and the tape spools were turning. She looked to be in her mid-twenties. She reminded him of Joan Mitchell years ago.

—Isn't that heavy?

—No, it looks heavier than it is. I'm used to it.

She smiled.

The bearded man tilted his head to one side, drawing his eyebrows together.

—Bill, you've been living in East Hampton for seven or eight years now. Is East Hampton for you what Giverny was to Monet?

The girl shifted her feet and the microphone wobbled a little over his head. He looked across the room, at the window behind his easel.

—There's a space for each artist. Kandinsky said it very good—not here, not there, but somewhere. There's a place where it happens. Like for instance, right now I'm very much influenced by the water here. We're all surrounded in this neighborhood by water. So I go on the bike and look at the water. I try to get the light of this water, or the light here. And it helped me enormously, because in New York I felt that I was using colors just prismatically. Red, yellow, blue, black, white, you know. I had no way of getting hold of a tone, you know, the light of a painting.

When de Kooning looked at him, the filmmaker felt that he

was being examined. De Kooning's eyes were hard, yet he was friendly. He talked informally and in such an unaffected way about his work, like a plumber discussing pipes and joints. He saw how focused and driven the young painter must have been, how confident.

—Do you have favorite periods in art history?

—I'm an eclectic artist, there seems to be no time element, no period, in painting for me. Like last summer I was in Italy and those early Christian Roman wall paintings—they just threw me for a loop.

He took a drag off his Camel and put it back in the ashtray.

—What made you decide to leave Holland, Bill?

—Well, I felt a certain depression over there. I mean I felt caught. It's a small nation. I went to Belgium and worked for a while. The American movies—Paramount, Warner Brothers—America seemed to be a very light place.

He smiled a Mona Lisa smile.

—Of course I didn't know the movies were all taken in California. But everything seemed to be so light and bright and happy. Particularly with the comedians. Harold Lloyd, Charles Chaplin. Tom Mix, you know. I always felt like I wanted to come to America, even as a boy.

He answered questions for about an hour, and then abruptly stopped.

—Painters just paint pictures, you know. I have nothing against talking, but enough is enough and we ought to call it a day.

The poodles were barking their heads off, and he waited for Al to poke his head out the front door before moving beyond the wire fence hung with BEWARE OF DOG signs that enclosed the property. He'd been drinking off and on, mostly on, for three days, and he

wanted to get out of the house, where he'd been sitting, drinking, watching TV. Joan was in New York and Lisa was away at school and he felt dizzy and jumpy. He had slept badly, waking many times during the night in a sweat, lying awake in a kind of half consciousness, and he couldn't eat. It was always like this when he drank. He'd lain in bed all morning, and now it was afternoon and he'd finished the last few belts of Scotch in the house.

There was even more stuff in Al's yard than he remembered seeing the last time: a bathtub in the shape of a whale and a red baby buggy had joined the laughing plastic Santa Claus, the pale plaster Virgin Mary, and Al's sculptures.

They met in the yard, the big gray dogs trotting over to sniff at his ankles, then darting away nervously, glancing back at him as they wove paths through the little junipers and all the objects strewn about.

—You have some new things, Al.

—I do. Just finished this one over here.

Al walked him over to a woman and child hacked from a tree trunk, the hatchet marks visible where the woman's arm curved protectively around her baby. It looked like a raw version of something Indians made, or Eskimos.

—This is good, you have to keep at it.

Al smiled all the time. He had a broad red face that tapered to a sharp chin, and his hair, cropped close on the sides and in the back, peaked at his brow in two little mounds that made him look like the devil. People said he had a violent temper, though Bill had never seen a sign of it. They said he'd gotten in trouble in the South and had come here to start a new life.

The house was next to Green River Cemetery and directly across the road from the house Bill lived in with Joan while the studio was under construction a mile and a half away. Al had been a coal miner in West Virginia. When the miners went on

strike, he moved to Long Island, where his brother lived, to look for work. Now he trimmed and repaired trees for the town, and for rich people. Bill took a shine to him. Al was a good storyteller, and he was skilled at what he did. People thought his front yard was a disgrace, that it looked like Appalachia, but Bill thought it was funny.

—Sit down and have a drink, Al said, as they entered the small, dark living room.

—Why not, a drink wouldn't hurt.

There were photos of Al's two sons in gold frames atop a television and a picture of Jesus on one wall. Newspapers were piled in the fireplace. The room was quiet and cool, and Bill felt better after Al handed him three fingers of Scotch in a tumbler.

Al's wife drank a Scotch and water, and then said she was taking the car to buy yarn at the five-and-ten in Sag Harbor and to see a girlfriend there. The East Hampton five-and-ten didn't carry yarn.

After a while they went outside so Al could show Bill an apple tree he was repairing.

—See, I put cement in the part I carved out of her. First you trace the cut, then you cut out the dead wood and fill it so the bark will grow over the wound. You shellac the live wood, otherwise the air can get in and rot it.

Bill was weary, and it was hard to keep his eyes focused.

—What do you use to carve it?

—Chain saw at first, then chisels. Or just the chisels if it's a small cut. Same as I use with the sculptures.

A car passed slowly, then backed up, whining, onto the shoulder of the road. A man in a blue plaid golf cap got out stiffly. He wore a Brownie on a long black ribbon that circled his neck. The man smiled as he approached the fence. Al and Bill moved toward him, Bill draining his drink as they went.

—This is quite a place you have here!

—Come on in and have a look if you want.

Al showed the man around the yard, Bill trailing behind them. Al threw open his arms in an extravagant gesture.

—I get people come here from all over to see these. Some buy, some just look. My friend here is a famous artist, you know.

The man smiled politely at Bill, who smiled back grimly and nodded. He felt a nervous twitch starting up in his face, the flesh by one nostril jumping arbitrarily as if there were a short circuit in his face. He felt dizzy and anxious.

A catbird on a tree limb just above his head began mewing sickeningly. It went on and on. Something gray and hairy darted suddenly from a low bush, and he gasped as it zipped along the fence, coming too close to where he stood. He wondered if he was seeing things. Then his legs lost power. He was on the ground and Al was bent over him. Al's face was big and red, and his breath was hot and sour. The man in the golf cap leaned over Al's shoulder, but the sun was so bright he couldn't make out his face.

He awoke on the living room couch. Someone had taken off his shoes and draped a thin gray blanket over him, and he was coated with a film of sweat. The light in the room was fading; he must have slept several hours. Had he slept or passed out? At least they hadn't taken him to the hospital this time. He swung his legs to the floor slowly, and his head felt heavy as he put it in his hands for a moment, wondering where Al had gone. He could hear the muffled ticking of a clock somewhere. He looked into the empty kitchen. He looked through the windows: no sign of Al. He stepped through the front door—where were the dogs?—and went through the gate and to his house across the road.

Willem de Kooning, East Hampton, 1964 (© Estate of Hans Namuth)

He closed his eyes and touched the charcoal to the page, making a little squiggle: a vagina. Then it grew legs, then a torso and a head. He turned the charcoal on its side and rubbed wavy shapes onto the page. He opened his eyes. A woman floating in a gray sea. She looked like a flapper.

He flipped to a blank page and closed his eyes again. This time he started with the feet, then tried to get the rest of the figure in one shot, working quickly from left to right, making a standing woman but doing it sideways. He opened his eyes. It looked like a landscape—blurred shrubs growing from her body. Her body was the earth. He turned the drawing ninety degrees; now the woman was hurrying from a party, her makeup smeared.

Next he tried to let his hand move on its own. As he closed his eyes, he glimpsed a robin on a branch outside. He imagined the bird big and fat, its breast orange, the way it would look in

an Audubon print. The bird grew the head of a blond woman. That was enough of that.

He looked: a mountain with clouds behind it. It was very Japanese, especially if you cut off the right side, where the woman's head was. He put the drawing on the floor next to him.

He began again, moving the charcoal across the very center of the page, making adjustments as he went. He made toes, kneecaps, ribs and breasts, eyes and big lips. He spread the arms so he could draw their contour, the muscles.

The body looked like the coastline visible at the far side of Gardiners Bay on a sunny day, a shimmering mirage. He turned the page so the figure was right side up. It wasn't a woman at all; it was a man. The vagina looked more like a penis. It was a crucifixion; there was even a toe that looked like a nail driven through the feet, and the shoulders were in exactly the correct place.

He tried another, looser crucifixion. This time the man was smiling. His body broke apart in the center. The top part was leaning out of the picture, as if seen from above, like the Dalí crucifixion. The legs were hanging like a Halloween skeleton's.

He made more. This woman was climbing out of bed in a big hurry, it seemed like. Her eyes were as big as demitasse cups. Another was rubbing her stomach with long, bony fingers. One was doing a chin-up. One was maybe a whore, all made up with her hair sprayed and naked except for high heels like Minnie Mouse's.

He put down the paper and charcoal and turned on the television. It was a program called *Hullabaloo*, with lots of pretty girls in white skirts and boots dancing in metal cages like big birds. He returned to the chair, closed his eyes, and tried to make a dancer while listening to the music. Then he drew one while watching the TV screen, careful not to look down at the paper.

Years before he'd cut the picture of a woman's red mouth from a magazine and glued it to a canvas. People still asked about it.

—I just wanted to make it easy for myself, to put something right in the center of the canvas. When I put a mouth there, it gave me a point of reference. I placed it, and it gave me a kind of shock. And I knew where I had to go, more or less. And I also felt everything ought to have a mouth! I think a mouth is a very funny thing, because you do everything with it. You don't put spinach in your eyes. And of course a woman's mouth is appealing. I couldn't do it with a man's mouth. I began with the woman because it was a tradition, like the Venuses, like Manet made the *Olympia*. I guess picking up a brush and some paint and making somebody's nose out of it is kind of absurd, but not doing it is just as absurd.

The big cypress in the yard had a blue cast that came with the fall light, so much subtler than the summer light that simply saturated everything. Now each tree and bush was more distinct in the landscape, its outline enhanced, not just in the slanting light of morning and evening, but all day long. The cypress was like a decal pasted onto the rest of the landscape, or like a cutout in a children's book. It was like a tree in the pictures Charles Burchfield made in his last years, when everything looked as if an electric charge ran through it. Or van Gogh, of course. Monet, too, made trees like this one.

—Sweetie, throw me some cigarettes.

Lisa had brought some kids home. They were sitting around the table by the kitchen talking about some project—he couldn't quite hear what it was. They'd been there for a half hour or so, and he'd forgotten about them as he continued working. He plucked a pack of Pall Mall filters from the table, bent, and sent it sailing like a hockey puck across the studio floor and through the doorway. It slid between the legs of a boy seated with his back to him and stopped short of the wall. Lisa picked it up.

161

—Thanks, honey.

The boy turned, startled, to see Bill smiling at them. Then he walked farther into the studio. He was wearing a paint-stained blue shirt just like the one he wore when he'd pass him on his bike and wave years before. He must have been in seventh or eighth grade then. He'd ride to Dan Miller's store for a soda in the late afternoon, and he'd see de Kooning almost every time, always going in the opposite direction. He looked the same, white hair, black glasses.

He looked back at his friends, but he was thinking, *I'm in Willem de Kooning's house. No, I'm in Willem de Kooning's studio. And he's painting. He's maybe fifty feet away from me.* The girls were talking about the play they were trying to do for French class.

He backed his chair out from the table a little so if he turned his head he could see de Kooning without being too obvious about it. His friends didn't even care that he was in there, painting. They were used to coming here, he thought. They came here all the time. He heard swishing sounds and saw de Kooning picking up sheets of paper from the floor, maybe drawings. There was a big painting with fat strokes of bright red and yellow on a big easel against one wall, and de Kooning was about fifteen feet away from it, still moving drawings around. Now he straightened up and faced the painting, not moving. The boy could see his profile. He seemed to be frowning. He stood perfectly still, staring. He could see other paintings leaning against the far wall of the studio. It was like an airplane hangar in there, big and echoey.

The girls were ready to go. He let them walk to the door before him so he could take another peek. De Kooning was still standing, staring, hands at his sides, as if waiting for something to happen. His mouth was set in a grim line.

He picked up a wide metal spatula and pushed white paint

across the table's glass top as if he were getting ready to plaster a wall, then scraped it all up into a shiny glob with the spatula's thin edge and slopped it back down onto the glass. He smoothed it, scooped it, slopped it down. He picked out two silver tubes of red from a cardboard box and squeezed the pigment out like bloody toothpaste, red worms that he folded into the white batter until it blushed.

The studio was his church. He was the only congregant and he was the priest, too. The easel was the altar, at the end of a long aisle that led back to his rocker. Up near the altar, where the choir might sit, was a big glass-topped table with dozens of white china coffee cups and light green bowls, each holding a color, like cups and bowls of punch set out at a party.

If each time he walked from his chair to the easel he was going to the altar, whom was he marrying? Maybe the woman in the painting was his wife; maybe he was creating a bride for himself, like Dr. Frankenstein. After he and Elaine married, nothing really changed; they just kept painting and trying to make enough money to get by. He found some work at a department store, Elaine did a little modeling. The rest of the time they painted. Elaine wasn't much of a housekeeper. She couldn't cook. He remembered telling her one evening when they were sitting having a drink, "What we need is a wife."

It was around then, in the late 1940s, that he made the black-and-white pictures. People wrote about them as if he'd made some big stylistic decision, but it was only because oil paint was so expensive. If you couldn't afford oils, you went to the store and picked up house paint: a gallon of black and a gallon of white and you were in business. Everybody did that, nobody had money. Jackson and Lee were already living in East Hampton then, and Jackson used to go over to the boatyard on Three Mile Harbor, and they'd let him have leftover boat paint. They

thought he was some harmless nut. He took whatever they had lying around. That's why he used those unusual colors, aqua and brick red. And the metallic silver paint.

But working in black and white turned out to be a good thing. You got better at painting without color; you were freed from color's demands. There are too many choices to make anyway; one less made it easier to concentrate on what was in front of you. Now he could afford to buy plenty of the best paints, but that didn't make him a palette painter. He'd decide to use a range of colors for a while—say, reds, yellows, and flesh tones—and then change to a new combination when he got bored. It was almost arbitrary.

He was painting a pink woman on a door. He'd started with her torso, making it red, and then working in white until it was rosy. He gave her a big mouth with red lipstick and big white teeth like Chiclets. Figures needed to smile or they looked sad. He put green and yellow on either side of her pink breasts, and she began melting into a bright landscape, as if she were swimming. She was like a bathing beauty. She was preposterous. He stepped back, took off his glasses, stepped back farther, holding his glasses in his right hand and a coffee cup of pink in his left hand.

The woman split in two, like those doors whose top halves you could swing open while the bottom stayed closed. He extended her legs. Now she needed feet, something to fill the bottom of the door.

He picked up a cup of green and a one-inch brush, held the blond handle perpendicular to the canvas with his thumb and first two fingers, and made a quick zigzag and a vertical line on the left side, then a couple of little curves on the right side. Women's shoes were like rowboats, or parentheses.

He stepped back again, holding the cup and brush and glasses, and cleared his throat. He dimly heard birds in the trees

outside. The woman was in pieces, as if she were on an operating table, but the pieces added up. She looked jazzy. Her legs were very flat, so he gave her garters, two quick slashes across her legs. Now she looked like she belonged in the Moulin Rouge. What a difference! She was dancing.

Dew like cool sweat filmed the windows of cars in their driveways, the green screen doors and white wooden doors of the houses were closed tight, fat slats of blinds shut, as people slept in secrecy. Someone late and drunk had left a car parked at a curious angle on the shoulder, as if it had been dropped there. Roadside shrubs were green and black with wet. In the still dawn air, birds and insects made the same sounds they made at dusk.

Louse Point was ten minutes down Old Stone Highway, a narrow curvy road that gave brief glimpses of water through trees as you went, the road teasing you, pulling you toward the water then steering you away from it. A meditative rabbit in the grass watched him with a sideways eye, then bounced with soft crashes into the brush.

He coasted onto Louse Point Road at the little intersection where Jackson had driven the Cadillac off and mowed down mailboxes before hitting a tree, maybe fifteen years earlier. After Jackson died, he started seeing Ruth, and they'd come here some afternoons, walk, drink wine, and eat sandwiches. Ruth had been in the car when Jackson and the other girl were killed. She'd almost died, too. She was sexy and full of life, maybe a little crazy, but nice to be around.

The trees thinned, the grasping branches overhead shortened, the sky opened up. What a time they must have had making these roads. What obstacles were they avoiding when they twisted to the right or the left? You couldn't tell anymore. Until

here, where the mainland ended and there was nowhere else to go but follow the long sandy spit that divided the creek from the bay.

On one side there were sandy ramps where you could back your boat into the creek. Dories and little sailboats, their anchor lines veiled with a bright slime of seaweed, sat on the water quietly. It was low tide, and the air was tangy with the smell of mud and salt. On the other side of the road, paths cut through the beach grass to the bay, and he took one, pulling off his shoes and socks and trudging through the thick, cool sand, so clean and pleasant on his feet. He rolled up his pants and sat where the sand was firmer. The sun was an oncoming headlight in the palest pink of skies, and the water was layered gray and silver where the sun caught it. He heard a thin squeaking, like a mouse, and saw a tern high overhead, small, sharp-winged. It looked prehistoric, clean and clever enough to avoid extinction. It was a single-minded bird, nervous and quick. Once, when he was walking the end of this beach, a cloud of them came hurtling from nowhere and carved slices out of the air twenty feet from his head, warning him off. Would they have attacked if he'd continued on? They were protecting their nests, Joan said later.

The woman on the door was done, and he had finished a half dozen other women, pink and red and yellow, all on canvas. He lined them up, looked at them together for the first time: they were like a chorus line! The truck was coming to take them to the gallery. He'd started making landscapes again, with a lot of yellow and pink in them. He was trying to get the feeling of early morning at Louse Point, with no one around but the terns.

The writers and the curators and the students all asked the same questions, and it never failed to surprise him that they were so puzzled by him and his work. Why did he paint fast? He painted fast to keep that glimpse of something, he told them. It's

like crossing the street. If you want to cross the street fast, you run across it. When he was painting all those figures of women, he had the feeling that he had just walked into a room and been introduced to someone and, for a fleeting second, got a glimpse of the person. And that glimpse is determined by all the glimpses you've had before. *I want to give somebody else something of a glimpse.*

They always wanted to define Abstract Expressionism. Names like that are for handbooks. Everything is already in art. It's like a big bowl of soup. You stick your head in and you find something there for you. It's already there. But you have to go in there and find it. You have to be rather innocent. If you were too advanced, too learned, you wouldn't be able to paint. I get very elated seeing the sky is blue, the grass is green. That's the hardest thing, not to reason. I think that Baudelaire said that you have to be a little stupid to sit and write poetry all the time. I'm like a very talented housepainter who gets excited once in a while.

(1964, 1972)

TEN

There went de Kooning on his English racer, looking like a superannuated Dutch schoolboy. Where did he go each and every afternoon? She couldn't recall once seeing him on the return trip to his house, which she knew was up on Woodbine Drive. She admired his fondness for bicycles and wondered if it weren't a specialty of the Dutch. You never saw adults riding them here, unless you counted the rummy-looking fellow who carried what looked like the insides of an outboard motor in a basket mounted on the handlebars of his Schwinn.

There was a stretch of blond meadow across the road and, beyond that, Accabonac Harbor, silvery in late-afternoon sunlight. She sometimes saw an osprey circling the thin currents high overhead, its orbits as precise as an ice skater's on the blue air. When it spotted a fish, it fell with sudden, grim velocity, and when it struck the water, there was a furious splash such as Icarus must have made. A moment later it would rise and fly away, a fish in its claws, and the bay's surface was again an uninterrupted sheet of ripples.

It was four-thirty; time for a Scotch. She had been typing, on the little Facit, a letter to *The East Hampton Star*. Writing letters to the local newspaper was small consolation, but it was better than writing nothing. She unrolled the letter from the carriage

and placed it on the desk next to the dictionary and the *Merck
Manual* and a notebook page listing things that had struck her
ear and that she wanted to use, somewhere:

hooligans
Gorgeous George
Confucius say
old timers
scapegrace
greenhorn
lead pipe cinch
coin of the realm

She rose from the desk and went to the narrow staircase.
Once, she'd fallen its length; some friends found her at the bot-
tom, bloody and blacked out. That meant a trip in the back of
the country ambulance to the country hospital, and for that in-
trusion she would never forgive them. Better to put on an ice
pack and crawl into bed. It wasn't that she disliked hospitals; she
was so familiar with their routines that they seemed like a second
home. Give her Payne Whitney or Columbia-Presbyterian and
she was snug as a bug. The condescension of baby-faced country
doctors was what she would not abide.

Her ills were many and drink was little balm. After Joe died,
she'd spent a month in the hospital with a diagnosis of depres-
sion, alcoholism, chronic bronchitis, malnutrition, an ulcer, and
the beginning of cirrhosis. She had heart problems and shortness
of breath, and what she dreaded more than death was what they
told her lay in the future if the dice rolled badly. She was fifty-five
and felt ninety-five.

The compact two-story house was a comfort. It was built
solidly a century and a half earlier by men who had constructed

a reassuringly large fireplace in the little parlor, and she sat there sipping and watching television, Elephi curled on an armchair nearby, through the winter nights.

Like many farmhouses in Springs, it was situated close to the road for easy egress in the event of a snowstorm, its facade like a child's drawing of a house, with a door for a nose and symmetrical, square windows for eyes. Joe had bought it and the thirty-one acres it sat on decades before; they had spent summers here, and now she'd settled in for the long or short haul.

She woke at 5:40 a.m. as gray light spread into the room, the hungry cat pacing the bedclothes and purring. She'd dreamed that she was trying on wigs one after another as Joe sat in an armchair reading a newspaper and chuckling.

The cat rubbed its face against hers and she opened her eyes, the bed stand and the maple dresser assembling in the growing light. It was Friday, and she would putter through the day before a friend came to take her for drinks and dinner at six. Or was that Saturday night? She climbed from the bed and looked out at the apple tree, a giant gnarled hand beneath which she and Joe had sat through summer afternoons drinking and reading and talking. A dozen crows staggered under the tree.

Book reviews were not what she ought to be doing. Nabokov had been right. The worst plight for a writer was to lose the ability to imagine facts, to begin to believe that facts could exist by themselves.

Perhaps she'd drunk it away, perhaps it had simply taken wing. The reviews helped to pay the bills, and it was satisfying to put words in the right order, but they took almost as long to write as a story and they amounted to nothing. The mere exercise of critical intelligence didn't add up to a hill of beans. It was a workout, a warm-up, nothing more.

When she sold the land, she'd have money in the bank at

least, and then maybe she could get back to work. Maybe the problem was laziness. Fiction made certain demands. She would like the paragraphs to flow as if dictated, at least some of the time, and she wanted to be taken care of, to have fun, not to be miserable, and she was miserable, but there was little to be done for it. There was some amusement in playing the role of the widow Liebling, but it wasn't what she had had in mind.

Down the stairs she went, the cat preceding her by a step.

The house was smaller than the one she'd bought in Maine after she and Cal had married and *Boston Adventure* had made her famous for a season, but it was hers in a way that that house, which she shared with Cal and a succession of visitors, hadn't been. She loved the brilliant white yucca flowers, the mimosa that she and Joe had planted. She loved the thrift of the house's low-ceilinged rooms, its small domesticity. She liked lying under the counterpane in the mornings hearing vague bumpings as Mrs. Monsell dusted, the clack of plates in the kitchen, the howl of the Electrolux swelling as she moved from parlor to study, then made her slow way upstairs to see if Miss Stafford was still breathing.

She could hear the tires of the postman's Jeep as it crunched to the mailbox. She put down her needlepoint and went through the back door into the yard, alarming a flock of blackbirds as she circumnavigated the house. The propane man had left a receipt; it hung from the tanks like a yellow tongue.

In the mailbox she found a small booklet of discount coupons for the five-and-ten-cent store in town, which was puzzling, since it was not part of a chain but a mom-and-pop operation; bills from her dentist and the Long Island Lighting Company; a catalog from the Walter Drake company, whose

kitschy offerings she admired; a seed catalog with a large, gaudy zinnia on its cover that she couldn't remember requesting; a newsletter from Assemblyman Perry B. Duryea, who was groomed to personify old Republican money, no doubt in the hope of getting more of it. There was a smudged copy of a free newspaper called *Suffolk Life*, whose illiteracy she enjoyed.

The five operations she'd had to reconfigure her smashed nose and cheekbones after Cal had put their car into a wall thirty years before had left her with watery eyes, and she pulled a Kleenex from the pocket of her slacks to dab at them as she walked to the backyard and settled into an Adirondack chair. The air was warm and still, and the fields were quiet as the insects gathered their strength for their late-summer racket.

She sat under the branches of the apple tree, and Wild Gray Kitty, who had included her house on his rounds for over a decade, came from nowhere and slowly, arthritically, sat and faced her like a thirty-pound pear. His face was fight-scarred, his tail broken long before in some mishap. He wore a look of deep intelligence. Her own cats kept their distance when he was abroad, and he ignored them.

—Hello, Kitty, you old devil.

Later, she put one bill atop the other on the table and tossed Perry Duryea aside. Each page of the pocket-size five-and-dime booklet, titled "Fall Harvest of Values," though it was barely September, bore a coupon with a dotted perimeter—it would be easier simply to tear out the page. There were "fun-size" bags of candy and an Enchanted Halloween Barbie doll. Canned cat provender was on sale, too, but she purchased that by the case, so it didn't present a bargain.

She considered the wider range of goods offered by Walter Drake: a throw rug in the shape of a hydrangea, quilted toaster covers, a Santa Paws dog suit. More to her taste was an auto-

matic card shuffler that accepted four decks—good for double solitaire—and a kind of catcher's mitt to be used in dusting. "Thousands of tiny fibers grab and hold dirt," she read.

She wondered where they found the models who smiled while holding mops and wearing unusual hats. There were customer testimonials—who took the time to write to Walter Drake?—including one from a person named P. Shroud, who recommended the personalized Christmas cards.

Afternoons when she wasn't making slipcovers or potpourris or green tomato chutney and she'd come to the end of the telephone list—plumbers, electricians, carpenters, and delivery people to summon to fix pipes, rewire the study, build cedar closets, and transport the bourbon—she settled before the Facit at the upstairs study window and watched the horses and the pair of donkeys in the field across the road as they sleepily grazed. Mr. Miller, seventy-five if he was a day, would be baling or mowing or mending a fence or milking cows or hammering nails. Though he wore a Stetson and spoke in the peculiar Bonacker drawl that suggested New England—"ayuh" for "yes"—she suspected he'd never been west of Riverhead, or even Southampton.

She'd come to East Hampton from Westport in the early 1950s with a couple of friends and, after a weekend blurred by cocktail parties on the dunes, martini lunches, Bloody Mary brunches, and late-night parties, swore never to return; it was a place fit for social-climbing New Yorkers and not for her. But the memory of Main Street stayed with her; she recognized it as a place glimpsed in imagination. The aisle of elms that led from the willows weeping over Town Pond to the silver-shingled windmill at its north end seemed like home. But the people . . .

She returned reluctantly with Joe in the early 1960s, and Springs began to make a little sense. Here, four miles north of

town, there were cows and quiet, and if she needed to escape, New York was a few hours away. She could avoid the filthy, antediluvian Long Island Rail Road by hiring a driver at the expense of whatever party invited her to visit, whether it was Columbia University or her publisher or a wealthy friend. Cabs or her guesthouse tenants took her to the village on the rare occasions she found it necessary to travel there, and after Joe died and her health worsened, she stayed home much of the time. In the summer, with barbarians abroad, she ventured no farther than the yard if she could help it.

They came in hordes, snarling traffic and forming unruly lines in the markets, braying and demanding special treatment. They constructed unspeakably vulgar, poorly assembled summerhouses in the Amagansett dunes and did their best to turn all of the East End into Las Vegas. There were writers among them such as Mr. Truman Capote, and these scribes converged on Bobby Van's bar for alcoholic bonhomie. She'd rather eat dirt than attend the mass gatherings of inebriates that passed for summer socializing. At least she had the sense to drink at home, where it belonged. The Radical Chic and the Beautiful People could keep their fund-raising lawn parties with unworthy champagne in filmy plastic cups, questionable dips, flaccid crackers.

There were truly good houses in East Hampton, not just the oceanside palaces of the Gilded Age with their turrets and hip roofs, but the solid eighteenth-century shingled places in the village built by Bonackers and even people like Thomas Moran, and the Springs farmhouses where honest people and cats and dogs and horses still lived.

She read the *Times* in the evenings, though its wholehearted debasement of the English language galled her, and the mealymouthed personal essays, which they called "think pieces," were

interminable. The world's vulgarity only increased: Cassius Clay, Mark Rudd, Nelson Rockefeller, John Wayne . . . they could all go soak their inflated heads.

The house was her refuge, and if she made it a jail as well, that was the price to be paid for independence. She converted spare bedrooms to studies to rule out extended visits; she had no intention of hearing advice should she opt for a Scotch in the morning, and until the evening rolled around, she was disinclined to hold a conversation with anyone but an occasional carpenter or a cat. She'd posted a notice on the back door advising that all visitors but workmen were unwelcome, this signed by her imaginary secretary, Henrietta Stackpole. She added to the door another notice: "The word 'hopefully' must not be misused on these premises. Violators will be humiliated."

When the workday was done, she might open a Budweiser with a tradesman and chat about the weather and politics for a spell—she learned about fishing this way, ocean fishing accomplished with great, hand-hauled seines—and she could find friends on the phone at night when she needed them. Word and thought welled up over the course of a day.

They'd asked her to give a reading at Guild Hall, the village's palace of culture, and she'd said yes; they offered $250, and all it required was a trip to town. People she liked would turn out to hear her; there would be enough friendly faces to make it more pleasure than obligation.

What would she read? The stories were decades old now. They'd been collected and reissued just a few years before, and when the book won a Pulitzer Prize, sales increased, but she was hardly a household name, and it seemed that young people— anyone under about sixty, for that matter—had no use for traditional fiction and thus for her. She'd learned that in the year and a half she'd spent teaching graduate students at Columbia.

One of them told her that he had nothing to say about "A Rose for Emily," because, having read two paragraphs, he didn't feel "turned on." "I don't dig Faulkner," he said. Another refused to read *Heart of Darkness* on the grounds that its author had written something called *The Nigger of the "Narcissus."*

While writing *Boston Adventure*, she'd worked as an instructor at a small college for women in Missouri. There, English, under the pseudonym Communications, was among the offerings of the Division of Skills and Techniques. The catalog listed courses in Principles of Dress, Office Practice, and Scientific Eating, not to mention Tap Dancing and something called Pre-commerce. There was a grooming clinic, and between one and two each afternoon siesta was observed. The girls were silly, with rumps like kitchen stoves, and they made her life miserable. At least they didn't pretend to be intellectuals; what excuse could be offered for the cretins at Columbia?

She settled on "In the Zoo." It held water.

Howard was one of the few permanent friends. He was intelligent and amusing. Howard and Joe had worked together at the magazine and had liked each other enormously, and he was not a fiction writer but a poet, which was almost as good as talking to a carpenter.

He had a gentle face, with the mischievous look of a child, and a quiet, conspiratorial laugh that she enjoyed. His tone of voice was mild, and his deportment modest; she had the voice of an undertaker, deep and gravelly and slow. Their styles were complementary. And he knew a good sentence from a bad one. Further, he had a knack for calling just when she wanted to hear from him.

She liked to surprise Howard. Once, when he'd arrived for drinks, she emerged from the kitchen wearing a clown mask with

a red nose; another time she dressed like a cocktail waitress. They'd taken a couple of car trips together and gotten hopelessly lost each time.

Guild Hall was a low, long building of brick whose white paint had faded to show some of the red underneath, shaded by big maples, set back from Main Street by a wide brick path, unassuming and relaxed-looking. It drew a conservative, Noël Coward–loving older audience as well as pot-smoking poseurs,

Jean Stafford in her Springs backyard (© Ken Robbins, Jean Stafford Collection, Special Collections Department, University of Colorado at Boulder Libraries)

for it was the only game in town. It had art exhibits that often included work by locals, both unknown and famous, and the community theater company put on plays. In summer, when New Yorkers descended, its offerings grew shriller. She supported it because it still had something of the air of old East Hampton.

She was led downstairs to a hideous space with linoleum floors used for art classes and occasional lectures. The theater upstairs, which seated 350, was far too large for a Stafford reading, though Betty Friedan could probably fill it twice over. About fifty metal folding chairs had been arranged before a rickety wooden podium under the skylights at one end of the room. There were some friends.

As she sat waiting to be introduced and watching the last of the auditors file into the room, she remembered the uproar *Boston Adventure* had given rise to, the fan mail, the flattery.

It is hard to convey, without sounding hypocritical or grotesquely eccentric, how little I like the small fame I have acquired. I feel what I have always felt: "If only they knew what I'm really like, if only they knew what a fraud I am, they would not flatter me in this way."

Her stomach went swimmy and she felt disconnected, as if she were levitating a few inches. The fluorescent lights made the room overly bright and unreal, and she wished desperately that she'd remembered to take a Valium. It was a familiar sensation, though, and would not last. The panic leveled off to a pervasive feeling of uneasiness, and she knew she'd be all right for a while. She checked to see that she'd marked the story she was to read and took a breath.

Her host listed her books and spoke of the Pulitzer Prize and her brief tenures at universities as well as her letters to the *Star*, a reference that drew knowing chuckles from the crowd, who like everyone else in town followed the weekly obituaries, police re-

179

ports, and letters to the editor faithfully. The woman mentioned the novel in progress and the contributions to various periodicals, and then she was on her feet and their applause was startlingly sharp in the small, uncarpeted room.

The podium was large enough for her book, and there was a plastic cup half-filled with water on a little ledge beneath its tilted shelf. She put the book down and looked out at their faces, a mass of pale amoebas on a microscope slide, and then glanced at the low ceiling, white acoustic tile riddled with thousands of little black holes.

"Good afternoon," she said. "I hope you can all hear me, as there's no microphone." There were nods and murmurs, and she sensed the usual surprise at the slowness and resonance of her voice. Sometimes she liked its sound, and sometimes she deplored it. It had always been deep, and though over the years some gravel had settled into it, she could purr. She read the first sentences of "In the Zoo" slowly, observing each turn of the meandering sentences, pausing slightly when people sighed at her characterization of a blind polar bear sitting in its cage. She had reread the story the night before and had found its rhythms as pleasing to her ear as they had been when she'd finished it twenty-five years earlier. The clauses unrolled inevitably, one following the next like boxcars.

The disused Royal that crouched in the well of the old desk in the attic looked even to her like a machine Rosalind Russell might have used in *His Girl Friday*. *This is the day when no man living may 'scape away*, she pecked out. It was the line from *Everyman* she wrote first whenever she tried out a pen or a typewriter or started a new project. The keys were stiff but would loosen as she worked. She'd sent the Facit to the repair shop in Water Mill

for a tune-up, but in the meantime there were letters to be written: it was time for Henrietta Stackpole to catch up on Miss Stafford's correspondence.

Miss Stafford herself wrote several thousand words to Con Edison listing her dinner engagements over a month's time to demonstrate that she hadn't been home enough to use the amount of electricity for which they had billed her; she wrote to Governor Rockefeller to protest her tax bill; she wrote to the *Star* to complain about mistakes in *The New York Times*.

Miss Stackpole replied to those who submitted manuscripts for Miss Stafford's perusal or asked how to get published. The days when Miss Stafford would help out any young author in sight for the sheer joy of it were long past; she had nothing in common with them and felt no sympathy. Miss Stackpole sometimes reported on Miss Stafford's activities to friends. Today she would write to Miss Stafford's doctor, as Miss Stafford was feeling low and couldn't manage it herself.

She rolled a sheet of Four Star Bond into the carriage.

In re: Mrs. A. J. Liebling.

In re this referral, we have had nothing but trouble since the party above named entered the kennel.

A). She periodically appears to be under the impression that she is 14 or 15 yrs. of age and is therefore immune to the Laws of Deportment: thinks she can stay up all night long and dance hulas on table tops to the delight (in fact, hopeless boredom) of the drunken company she keeps . . .

B). Despite massive doses of chloral hydrate, will not sleep. And keeps other inmates awake. Especially Miss Bonacker (Bonnie) whom she tends to hug and kiss all night long.

If she stays away from John Barleycorn she is, in our opinion, an O.K. kid, and to tell you the honest truth, I think

J.B. is basically the root of her problem who, in conjunction with J. Calvin and J. Knox have mucked up this poor woman to a fare-thee-well.

She typed his address on the front of an envelope and sealed it. The fall light was sharp and clear, the salt hay in the meadow opposite her house bent in a stiff breeze. There was a faint sighing of trees and the regular groan of a tree limb that rubbed against the shingles when the wind picked up; then the house seemed like a creaking ship. She covered the machine and carried the mail to the kitchen table, made a Scotch and water, and walked into the parlor, where three cats slept, one curled up like a fur hat, one lying on its back with a paw thrown across its eyes, and a third, which woke as she entered, hunched atop a bookcase.

Thirty years before, she'd walk Manhattan for miles, hoping that the exertion coupled with a string of cocktails would allow her sleep, but it wouldn't come, and she'd finally broken down and checked into Payne Whitney, emerging over the next year just a handful of times, once to be photographed at the Bronx Zoo with a mountain lion for the cover of her second novel. Sleep had never come willingly, and she envied the cats their easy repose.

It was safer in the house than outside. Once, in Grand Central Terminal decades before, she'd heard her name called twice in that loud void, *Jean Stafford*, *Jean Stafford*. She found a booth and phoned Joe Mitchell, who knew his way around the D.T.'s. He fetched her, and after a couple of bourbons in his club she could feel the ground beneath her feet again.

But even the house wasn't safe, if she wasn't careful. The middle of a story used to be the worst time. After she got five pages right, nothing more would come. She'd rise from the typewriter in the late morning with no ideas—no, with no *words*—and the bourbon would open itself, and within a couple of days

the bottle would have company, and then she would find herself telephoning in the half-light of dawn because creatures were darting across the bedroom walls.

Liebling had rescued her. After Cal, after the twenty-minute marriage to Oliver, there was Joe Liebling, steady as a rock, amused, amusing, who knew the exact value of her writing and whose opinion she trusted. When she couldn't work, he'd worry

Jean Stafford in her Springs house (Jean Stafford Collection, Special Collections Department, University of Colorado at Boulder Libraries)

that he was the cause, and he would cajole her and praise her but never judge her. For this she loved him more than anything.

The time came when she found herself growing weary of him and he was more annoyed by her drinking than sympathetic. After a day at the magazine he'd come home to find her in her robe, drinking with a friend from one of her former lives, and it made him angry, and he wondered if he hadn't made a grave mistake again, marrying a woman who would prove to be, finally, just as disturbed as his first two wives, and just as much a burden.

But he died before push came to shove, and she was alone again with the memory of the two good years they'd had before disillusionment set in. There was no way to respond to his death but self-annihilation, and the most efficacious method she knew was to drink, so she drank for two weeks, and then checked into New York Hospital, where the doctors and nurses and attendants were friends of old standing, and she stayed there for a while, discharged with Antabuse, Elavil, chloral hydrate, and Librium, and a couple of months later, while dining at the Cosmopolitan Club, she was gripped by a fist of pain from her lower back to the base of her skull and collapsed with a heart attack. Five weeks later she was out with a bag of cardiac medication and barbiturates, and then she moved to Springs.

The taxi pulled past the big acacia in the front yard and into the narrow, juniper-lined driveway and halted, rumbling alongside the clapboard house. The driver, Mae, honked once and waited. Mrs. Liebling usually took some time to come out.

—Jim, I'm at Liebling's.

—Okay, where you taking her to?

—Didn't she tell you?

—No, she just said to send someone over.

—Okay, I'll let you know soon as I see her.

—Right.

After Mae had used the horn twice, Mrs. Liebling appeared, carrying a basket of wildflowers and wearing a shawl which made her look older than she was, over dark pants and a blouse. She folded herself into the backseat, coughing like a professional smoker.

—Where are we off to, Mrs. Liebling?

—I want to go over to Green River for a little bit, and then you can bring me home.

She'd never driven anyone to the cemetery and wondered who was being interred and why Mrs. Liebling was going alone.

—Are we early for a service, Mrs. Liebling?

—No, no, dear, I'm going to visit my husband's grave. It's around the back; you can let me out just by that tree. I won't be long.

She climbed from the car with her basket, coughing again, and walked about twenty yards farther along the path. She laid the flowers—bittersweet and holly—before a low slate marker, then stood there.

He was in good company here, Bonackers for the most part. Jackson Pollock's boulder faced him; it was set on a knoll above everyone else, its back to the woods, in a posture both grandiose and defensive. The boulder looked like it belonged there, though it was so large it seemed tacky. His paintings did nothing for her, and she suspected that his reputation was wildly inflated, though Saul thought highly enough of him for her to grant that his intentions at least had been serious.

He was from the West, she knew, California, in fact, and from what she'd been told, he sounded unreformed to such a de-

gree that he was doomed to be unhappy in the East; he was a character familiar to her, a fish out of water, and no doubt that had directly contributed to his demise, though it was no excuse for the boorish behavior she'd heard stories of from her neighbors. She wouldn't have wanted to tangle with him.

The stroke had come, as she had feared it would, and she had improved very little since they'd discharged her six months before. She could not bear to have anyone in the house and fired nurses as fast as they were hired. She dreaded telling her sisters, but it had to be done when Mary Lee wrote her a cluelessly chatty letter.

She sat down at the Facit and slowly typed a draft.

Dear Mary Lee,

 I had a seizure at the end of the year—November 9th—and since my speech is gone altogether now I have to write you. My fine labials and lenes are lean, diabled.

 I have been in New York, disabled, at the Rusk clinic, a growth an end: this mean time and I can't and I cannot write.

Love,

Jean

Night fell early in October. Leaves swirled at the edge of the cone the headlights carved in the dark as he drove the narrow roads to Jean's house.

He had spoken to her earlier in the week, and though she was harder to understand on the telephone than in person, they had managed. Her obstinacy made conversation even more difficult. She was reluctant to reorder the sentences she'd formed in her mind. Words came out wrong, or wouldn't come at all, and

then she clenched her teeth and screwed her eyes shut and growled like an angry bear, her raised fists trembling. She'd let out a long rasping sigh and begin again, sounding out syllables. Strangely, the sentences sometimes came easily, in a low, slow voice. Then, when there were blanks, she would allow him to fill them in and would snort appreciatively when he picked the right ones, but if he picked the wrong one, her frustration returned. It was, everyone agreed, the cruelest possible hand that she could have been dealt.

He met her at the back door, and she walked on his arm to the car, slowly, only rolling her eyes when he asked how she was. When they were belted into the front seats, she sighed.

—Old bag out for an airing.

He laughed. She sounded better than he had expected; the words were mumbled but unmistakable. She'd had a few drinks.

He chattered about the weather and the beauty of East Hampton in the autumn; after a silence he asked if she'd found any improvement in her writing. He knew she knew he knew she would never write a story again, but it seemed right to pretend otherwise.

—Perhaps.

—You've made some improvement?

—Not much.

—It will take time, of course. Does it make you angry?
She snorted.

—It's a curse.

The restaurant was a kind of shack with a view of the harbor, set not on stilts but something like that. It seated no more than fifty, and, decorated with dolls and knickknacks, had the effect of an eccentric's parlor. The food was simple and good, the seafood was fresh, and it was reasonable. He and Jean had dined

there successfully before. They could see the shadowy forms of sailboats in their slips and a still expanse of water, whose surface, tonight, shivered with coruscations. A votive candle flickered on the table.

A schoolgirl waitress took their orders—bourbon and ice, a gimlet—and recited the fish of the day. The rest of the menu was on a chalkboard that Jean waved away when the waitress brought it.

—Are you ready, Jean?

—Go ahead.

—I'll have the striped bass.

Jean was silent. He asked the waitress to give them a minute.

—Not sure?

She shook her head.

—I cannot do the striped bass.

—She said that they had striped bass and flounder and bluefish. Broiled. And scallops. Do you want to look at the board? They have other things—

—I'll have the striped bass.

—Are you sure?

She nodded, and he called the girl over and ordered. When the dishes arrived, Jean put out her cigarette and looked her plate over.

—This isn't what I wanted.

—Well, let's send it back and order something else.

—No, no. I'll keep it.

—Are you sure? I don't mind waiting.

She nodded, and moved her drink to the edge of the table, looking for the waitress.

—What I really wanted was the finnan haddie.

Something was wrong. It wasn't the drink; he'd seen her drink more and handle it. Perhaps the drink and the medication.

Perhaps the stroke had confused her, something gone wrong in the cognitive faculty. Maybe the stress—

—What do you think of friends?

He paused.

—Friends?

She was looking at her plate, probing the fish with her fork.

—Well, they're essential, aren't they? I mean friends as opposed to lovers, say. They may be the most important people in one's life; I know they have been in mine. A kind of second family.

She pulled a cigarette from a pack of Benson & Hedges and sighed.

—Yes, I must give them up. The doctor says. I must stop smoking.

She seemed not to notice the miscommunication, or was pretending not to. Then he remembered what a mutual friend had said years and years before, that cigarettes were like "twenty little friends in a pack."

The news spread, and soon she had a message from Marjorie on the answering machine, offering to travel from Oregon. She seethed; she couldn't possibly get through a telephone call without misunderstandings. She sat down again at the Facit.

I had your Valestine over the inter-com and I was faiy sick I was away. Don't call me *even* until my marble are back.

My marbles and to are to be back once I devote to a month oftrouble.

I would kill you if you did come to my aid: having had this far attended to my own aid and comfort, so far, I will be cross as a button if you do come.

I can stand for three and have days and more night and a
vamoose then.

Jean

P.S. I am very crass with uinal. Please rest assuring than I'm
not

She'd had Joe's stone cut in Newport, a handsome slate
tablet with a fleur-de-lis cut into it, and now they cut hers to
match, a single snowflake inscribed above her name. Jean, Mrs.
Lowell, Mrs. Jensen, the widow Liebling. Jean Stafford Liebling.

(1973–1975)

ELEVEN

The Holiday Grill was the real gateway to the Hamptons, as he noticed people had begun to call it. Although the Shinnecock Canal, where the highway and the railroad briefly spanned water, might be the true geographical line between the South Fork and the rest of the world, it went by so quickly you hardly noticed unless you knew what to look for. The diner, on the outskirts of Southampton, marked the road's most significant and most obvious turn. It confronted you at a stoplight, and you had to be warned to go left. You didn't tell people, "Watch for the canal"; you said, "Look for the diner!" Its glinting aluminum shell upstaged its neighbor, the other landmark, a Cadillac dealership, through whose broad glass expanse an allegedly drunk but certainly overenthusiastic woman had once hurtled in her own Cadillac. Since then they'd installed a concrete barrier.

When Saul paused there for coffee and sometimes a slice of pneumatic coconut cake, he knew that he was twenty-five minutes from his front door, give or take a turtle crossing or a slow stretch spent behind a potato truck. The people eating there were inescapably natives of the region, though how he knew that he could not pin down: it was something about their bearing, not necessarily their clothes or speech.

In America, unlike in Romania or anywhere in Europe, there

was but one great meal, breakfast, and breakfast was what he ate, no matter what the time of day, on the rare occasions when he had a whole meal there. Breakfast at any hour was an American freedom made available by the diner. Ordering from the big, plastic-coated menu, with its dozens of variations on a handful of themes, was like trying to buy a car. You couldn't just have the car; you needed to select from options packages, color charts, payment plans. You had to guess how much the salesman might reduce the sticker price, and you had to calculate how much to leave the waitress.

Dining in America was about the why, not the what, of eating. Ask an American where to eat and he'll respond with another question: What's the occasion? Business lunch? First date? Anniversary? It was like writing a card in America—you found your category and hunted for the message and illustration appropriate to the emotion to be articulated. The ten-foot drugstore rack was a cafeteria line of sentiment.

The diner was the most democratic of institutions, accepting whoever washed up on its asphalt shore, with large or small hungers. It was a place to eat, but it was an occasion unto itself. He watched the kiddies stick French fries in their noses, the truck drivers staring into their chili, the old man and his chicken soup trembling with icebergs of saltines. There was no dress code, and drunks sat back-to-back with debutantes. Young and old, halt, lame, overdressed and underdressed, birthdays, post-wake coffees, those greeting the dawn on their way to the sea or home to their beds. There was a well-stocked, mirrored bar. The entire menu was available twenty-four hours a day, 365 days a year.

Here was the Formica tabletop printed to resemble a slab of fine-veined marble, the sleek metal caddy with its stubby glass cylinders of salt and pepper ground to gunpowder, a pair of dull plastic squeeze bottles with conical hats that allowed precise

penmanship in ketchup and mustard. Crinkly sugar packets slept in sheaves in a little basket fit for a mouse.

A menu of pop songs on pink cards lived inside a vitrine bolted to your booth; you turned the pages with little chrome rods, and when you dropped a quarter in and pushed the amber buttons, the song played, mostly for you, its tinny melody barely leaking over the back of the banquette where you sat, thinking you were alone until you felt the breath of a child on your neck as he peered over your shoulder at your western omelet.

He asked the pretty waitress for coffee, and as she walked off in her nurse's uniform, her sneakers complained to the bright tiles. A man and a woman in matching blue nylon windbreakers and jeans with rolled cuffs slowly ascended the front steps. His cane was wooden and hers was metal, and both had candy-cane loops for handles. Above their heads, the sky was one unbroken cloud in gently modulated shades from chalk to pewter, like a huge diffusing lens. Cars and trucks in subdued colors were pulled down a drab ribbon of highway as if by a giant magnet. A truck with a rhinoceros snout passed, cartoon puffs of gray smoke bursting on the air from a little spout mounted on its flank. People marveled at his imagination, but all you had to do was open your eyes.

Another couple, also with canes, came up the steps, and he wondered if a gathering of the elderly and mildly disabled was convening until he remembered that it was mid-afternoon on a Monday, when most people were at their jobs and children were still locked in classrooms. The waitress deposited a thick mug and a thin spoon and wrote down his request for scrambled eggs with crisp bacon and whole wheat toast, then squeaked away.

Hillocks of gray snow guarded the two entrances, and the asphalt parking lot was whitened with the ghost of snow that had melted. Everything in the window was pearlescent in the soft

light, absorbed and reflected by the water that lay just over the horizon in every direction, light that bounced around for a while before it reached your retina. It was much the same when it was sunny; even on the brightest days a certain filtering process gave the light a special texture. Bill said it reminded him of Holland. It didn't remind him of anything, but he'd take his word for it, for Bill had caught its transience in paint.

Round mirrors like large portholes rode a track of sleek horizontal chrome rails from one end of the huge, cafeteria-like dining room to the other, and the mirrored ceiling trapped an explosion of chandeliers. He pulled a sketchbook from his pocket and began to draw the lamp fixture over his head with a black felt-tip pen; it was a kind of Art Nouveau Roman soldier's shield, or a hubcap.

He lived in Springs, on its East Side, as the natives called it, closer to Amagansett than to East Hampton, a bit deeper in the woods. Amagansett was a smaller village than East Hampton and he liked that. A winding drive through the woods and across a field, the railroad tracks, and there it was, a short strip of Main Street with everything Americans needed—a few bars, a coffee shop, a delicatessen, a liquor store, a clothier that featured what he thought of as the winter uniform, long, scratchy-looking woolen jackets, puffy vests, blue jeans, and orange work boots. Boys and men who liked to hunt walked the street with numbered cards stuck to their backs; the licenses were fastened with large silver pins, like old-fashioned diapers.

There was a hardware store, too, where he'd once paid several dollars to have a single key made; in the city, this would have cost fifty cents. It was expensive, but because you'd have to drive half an hour or more to find reasonably priced trash cans or gar-

den hoses or vacuum cleaner bags, you spent your money there and were grateful you didn't live in Bucharest.

In the late 1950s he'd driven a new Citroën DS21—one of the first ones most people had seen, an odd and beautiful design—across several countries, and never before had he felt so conspicuous; now he preferred a well-broken-in Ford the color of dishwater, the better to observe and be left alone. He turned south to the Montauk Highway and followed it until it became Main Street, parking there and strolling through the hardware store's bell-rigged front door to buy a mailbox to replace one that rampaging children had destroyed, probably with a bat swung from the open window of a passing car. His, and those of several neighbors, had been decapitated the night before. Two policemen had responded to a neighbor's call and soberly made notations in their pads. The cops in East Hampton were well-paid children in uniforms; you sensed their pleasure in their badges and guns, their cars festooned with lights. They were reserved and polite to their elders and wanted to be helpful. None of them would last a minute in New York.

He bought the plainest box they had, a dollar's worth of stamped aluminum for $15.99. Sleek ribs ran the length of its floor, and its flag was a red enamel semaphore; the bumpy lettering on its little door indicated the gravitas of mail delivery. The odds were that it, too, would soon translate to smashed sculpture. He found large, cheap, not-too-shiny stick-on numbers that you could buy one digit at a time, and carried everything outside in a big white paper bag.

Though the sun was burning white, it was a cool autumn day, and he heard leaves skating in the street, and then there was an awful racket. As he climbed into the car, he saw down the street a cement mixer, of all things, parked up on the sidewalk in front of the liquor store, a brutish gray thing, and a pickup truck with the

insignia of the local government on its door. Repairs on this scale were rare on Main Street, and a few people were watching.

It was Columbus Day or thereabouts, and American flags had been stuck onto storefronts or drooped from poles that pointed to the sky. There were flags, too, on the antennas of several pickup trucks parked along the street. He thought of Columbus and the Indians, turkeys, Uncle Sam and Sacagawea. Americans thought of history as a series of opportunities to buy discounted linen and invite friends to dinner to celebrate the purchases. There were worse ways to observe holidays, and the most benign of them fell in autumn. Even Halloween was for children.

A couple of men in the winter uniform stood smoking, hands in pockets, watching the barrel of the cement mixer turn. Both wore reflective orange caps and neither one spoke. A third man stood at the rear of the mixer, waving traffic past.

Suddenly he noticed the black dogs—at first two, in the beds of parked trucks, then three, the new one standing near one of the orange-capped men, wagging its tail very slowly, a metronome at lento. They were Labradors, solid, self-assured, affable animals content to ride in the back of a truck or stand by while cement was mixed, poured in lumpy batter down a chute, slopped around with a flat trowel. They liked children and barked economically, happily carried shot waterfowl from the bay to shore, slept an innocent sleep. Their intelligence was praised because they mirrored their owners' behavior. He liked their shape and their numerousness.

He pulled a spiral sketch pad from the glove box—the glove box that was destined to be filled with pencil stubs, pennies, packets of Kleenex, and crumpled traffic tickets—propped it against the steering wheel, and began to draw the Futurist clamor of the mixer, then quickly got the perspective of the street in, and the simple storefronts. Then it was the men who stood here and there,

Saul Steinberg, *Amagansett Barricade*, 1987. Collage, colored pencil, crayon, and ink on paper, 13¾ x 10¼ inches (Yale Collection of American Literature, Beinecke Rare Book and Manuscript Library. Originally published in *The New Yorker*, February 23, 1987. © 2005 The Saul Steinberg Foundation/Artists Rights Society [ARS], New York)

and finally the flags and the dogs, and then more flags and dogs that weren't really there, for they were the point of this exercise.

Drawing was writing. You went to your desk and you made marks. Composers sat at desks and made marks, too, though the image that persisted was that of a wild-haired German pounding at a keyboard. And music, of course, was speech, and drawing was music. Once you understood these things you were halfway home.

—You were a cartoonist when you started but you have become accepted as a fine artist.

—I think of myself as a writer who draws. The cartoons were what I found myself doing, and I could make a living at it, early on, in Europe, in Milan.

—You are fascinated by geography, it seems. Is that because you were an immigrant?

—Everyone is interested in the places they came from. Even if you were born and died on the same street, that street will have changed over the course of time. I was born in Romania and lived in several different places before I came to New York.

—So those drawings, the imaginary maps, are representative of personal history?

—Well, they are maps for the sake of drawing maps. They are imaginary in the way that a novel is imaginary; that is, they are my way of organizing the world. They are evocative to me, and maybe to others.

—There's a series of drawings that made you famous, one in particular, of the world as seen from Manhattan, in which all of India takes up about as much space as Kennedy Airport, and Siberia is smaller than Brooklyn.

—Yes. And my drawing table is bigger than Africa. And Long Island is foreshortened so that there's nothing between Brooklyn and a string of towns on its East End.

—So much for Long Island.

—Well, we only have room for so much in a life. The firehouse down the street from me is a lot bigger in my life than Canada is. I'm not drawing at a table in Milano now, I'm in New York.

—So these are autobiographical drawings.

—They are not autobiography, they are drawings. I like to draw buildings, for example; this doesn't mean that something of importance happened to me in every building I draw.

—I understand. But you select certain cities and countries and ignore others when you draw the world.

—Well, you don't ask Manet why he painted certain trees and ignored others, do you? You draw what you are interested in drawing. That's your sensibility as an artist. As a person.

—Places from your youth figure in your geographies, but only as dots and names.

—That's how they continue to exist for me. Those places are gone.

—Except in imagination.

—They don't exist in imagination, they exist in time, and time passes. I am not a time traveler.

—So you draw what's in front of you.

—What else is there?

—Your subjects are diners, people in the street, taxicabs, banks, everyday things that are transformed in your eyes. These are unusual subjects for an artist of your generation.

—They aren't the usual subjects, it's true. I'm not sure why. No, that's disingenuous. Artists don't paint diners, because they don't seem worthy of art, art with a capital *A*. But then look at the Photorealists. There is a man who paints diners to the exclusion of everything else.

—Why were you attracted to these subjects rather than, say, the figure, or more abstract considerations?

—It's what I see in front of me. I don't see Olympia, or the Grand Canyon. When I came here it was fantastic to see how untouched America was as a subject. They were painting all these wonderful things in the landscape, out in the West. This was in the early 1940s. They were painting these things, though, as if they were Monet or Renoir, or they were looking with neoclassical eyes. The Indians were filthy savages that they painted in a neoclassical manner. They didn't really look at what was in front of them; they felt they had to paint in an artificial manner. There was an inferiority complex at work, not just about their own

abilities compared to the European painters, but also they felt that their subject matter was inferior, that Wyoming was less wonderful and less important than Fontainebleau.

—You didn't feel that way.

—Not at all. It was a wonderful, unspoiled place. It wasn't even scratched, really, as far as art went. But they couldn't see it clearly.

—And then there was a reaction to that kind of painting with Abstract Expressionism, later in the '40s.

—Yes. But that was a different matter, really. It happened because the Surrealists came here and turned people's heads. And it wasn't so much that those painters wanted to look clearly at the landscape or paint a truer Indian or mountain range. It was more in the nature of a putsch, or a coup d'état. It was a conscious attempt to create art history, to make a name for yourself. It had to do with careers and reputations.

—With ambition.

—Yes, of course. But abstraction is a meaningless topic, really. I like what Bill said once, in a disingenuous way, he said that he once knew an eccentric man who lived in a room full of old newspapers, I think it was, and he remembered that the man had a very abstract look on his face. That was what abstract meant to Bill.

—You are neighbors out here.

—He lives not too far away. It was a good, cheap place for all of us to go to back then, to get out of the city. It's quiet and pleasant to look at. The bay is right down here, so I can go for a swim when I want.

—You've made drawings here.

—I like to draw the landscape. Pascal said that man and animals, and plants, too, display a horizontal symmetry. But the rest of nature is vertically symmetrical. And the cause of that is

water. Puddles in the street are sudden leaks of vertical symmetry. The oceans, and the bay just down the road. And then there's the sky, with the clouds drifting through it, which is reflected in the water.

The postcard showed the Big Duck crouched by the side of a road, with some summer-green shrubs before it; it was as if it sat on a platter ringed with parsley sprigs. It had a neutral expression, as ducks do: was it hostile or amused? It wasn't at all giddy, like a cartoon duck; it was a calm aberration. He liked its frank stare, gazing out across the road toward the horizon as if it were gliding on a pond, not frozen to a scrubby plot in Flanders, where he had passed it dozens of times driving to or from Amagansett. People bought poultry there—it had a door in its convex plaster breast, and a sales counter within—but he'd never stopped, because the odor of the duck farm behind it nauseated him. It was a monstrosity, an icon looming, almost godlike, over a steady stream of ordinary people in ordinary cars, children staring through the windows.

The duck's dominion over the road before it was interesting. He plumped it up as he drew its outline, making it more like a turkey on a Thanksgiving table, but pure white, with a pert tail. The single eye with its black iris was a doughnut. He placed it on a small hill, the better to assert its divinity. A yellow path like a river of melting fat ran down from the red door he inserted in its breast. Behind the duck's head he made clouds out of French curves, flat lacy shapes with designs that looked cut with a jigsaw. The sky a runny blot of green and blue wash.

The duck was a great silly mother, and its children were busy going this way and that on their chubby black tires trailing little puffs of smoke, each vehicle on an important mission. There was

Saul Steinberg, *Untitled*, 1985. Pencil, crayon, and watercolor on paper, 14 x 10¾ inches. (Yale Collection of American Literature, Beinecke Rare Book and Manuscript Library. © 2005 The Saul Steinberg Foundation /Artists Rights Society [ARS], New York)

a sleek orange carrot, a fish, a mouse, a green bird with a sharp yellow beak, and something that looked like a hippo. The carrot's streamlined elegance set it apart from the others; eyeless, it was meant only for speed. The others gritted their teeth and

stared straight ahead as they puttered to work or home, to the grocery store, to the dentist.

His friend and neighbor Herman sat in the backyard in a white wicker armchair on a warm early-fall afternoon, the scrub oak still full of leaves that filtered the sunlight. Birds called from here and there. They had been talking about nothing in particular. Herman was a painter who liked to put down patches and swaths of high color as if he were laying brick. It was a juggling act of temperatures, and often led to work that seemed insubstantial at first, but improved the more you looked.

He wrote poetry, too, and his paintings were precisely the stuff people thought of as "poetic" because they signified mood. He was a Debussy of paint. Herman's appearance, though, was that of a preoccupied, somewhat sour merchant. He was plumpish, short, pugnacious-looking, with stubby fingers.

They talked and he drew. Herman carried himself with economy. Even a grand gesture was limited by the length of his arms. His center of gravity was low. When he settled himself into the white wicker armchair, the fit was nearly perfect; he was ready to be shipped. His thick torso filled just the right amount of the curved chair back, his feet just met the ground, legs neither too short nor so long that his knees stuck up. Even the cigar he held in his fingers was perfectly proportioned.

Saul was intrigued by Herman's compact perfection. He himself was bony and slight, as were all of the men in his family. And, it now seemed to him, as were all of the men in Romania. Herman was efficiently built; he was not overly fat, but you sensed that he stored much energy.

The curved arms of the chair continued through the slow curve of Herman's solid shoulders. He imagined that if he pressed a fingertip there, it would be like pushing your finger into the padded dashboard that they'd started putting in automo-

biles. Herman's forearms were plump cylinders. The cigar released two little gray clouds of smoke.

Best of all was Herman's head, his close-cropped, woolly brown gray hair. It was neatly clipped around his large, flat, extravagantly whorled ears. He stared dolefully with button eyes. His nose was magnificent, its bridge a long, convex slope, an architectural detail, an Art Deco stair rail. He drew the flaccid sausage of a mustache, an echo of the fingers and cigar.

His expression in repose was distant, resigned. He looked up through the leaves to the sky. Was a bird looking back from a nearby branch? A robin, a jay, a sparrow?

He drew a bird lighting on the nest of Herman's hair, a French curve of a bird with wings uplifted. A plump white parrot with a sloping beak like Herman's. Chatty bird, reticent man. Peaceful, perturbed.

In America, banks and post offices were the architectural equivalents of churches in the Old World, and here they quoted so-called colonial architecture; the First National Bank or Eastern Federal Savings and Loan nodded to its neighbors, the shingled saltbox houses of the settlers. Of course there was a difference: the banks were ugly. Though most of the people who came to the East End now worshipped at clothes stores and real estate brokerages, the banks made it all possible. Everyone came together there on payday.

He stood on line at First National in the heart of East Hampton, a short man in a gray sports jacket, a blue button-down shirt, and khaki pants, withdrawal slip in hand, and watched the people in front of him shifting from foot to foot in the fluorescence. It was Friday noon and he'd just arrived in town. Stepping from his car onto Main Street, he was struck as always by the quiet: though it was midday and cars zinged by, their wake was filled by calm. The hum that seeped through everything

in New York, even in the deepest closet of the most vault-like apartment in the oldest brownstone in the East Seventies, was missing. The molecular activity had slowed, or there were fewer molecules. In the city, everything was part of an endless chain re-action of sounds and motion; there was an immediate conse-quence to the smallest action. There were no consequences here.

One of the great American inventions was the drive-through window. He never remembered that it was there, though, and now he watched the back of a red-haired teller as she turned and strode to take care of a customer seated in his pickup truck on the other side of the big tilted plane of tinted windowpane. When she slid out the little drawer to receive the customer's tribute, it made a noise like an old-fashioned coffee grinder. The little speaker crackled with an exchange of pleasantries. The man was in his thirties perhaps, with a windburned face under a stained khaki cap; he was a plumber, a carpenter, a fisherman; he smiled, for he had gone to high school with the woman, had dated her best friend in senior year, and found it hard to remember her married name, as she'd gotten hitched to a guy he didn't know, from away.

People who were not native to the East End, specifically to East Hampton, were from away. There was a man who lived in a tiny house just down the road who said he hadn't been west of the Shinnecock Canal in thirty-five years, and there was no rea-son to disbelieve him. He was in his sixties, and probably had been sent somewhere during the war, though the subject never came up. He had offered to mow the lawn when he first saw Saul standing in the yard twenty years earlier, and he'd taken him up on it. The man still arrived in the same forest green pickup he'd driven that first day, and the lawn mower was probably the same, too. His name was Donald. He lived alone and kept two window boxes of zinnias. Saul had never been inside his house. Now that he thought of it, Donald had never been inside his house, either.

He drew a pickup truck towing a boat on a trailer, exiting the drive-through lane at the bank, and then a black dog in the bed of the truck. He added some elegant clouds, decorative vapor in the sky's oxygen tent.

Then he poured Scotch and water over ice in a squarish tumbler and took a big sip while looking at de Kooning's *Self-Portrait with Imaginary Brother* on his wall. How beautiful it was. What he now liked best about it was its tentativeness; it was really a drawing of the same figure done twice, one of them looking as if its head had been added to the body after the fact. That awkwardness, which Bill had clearly tried to eliminate here—he could hear him saying "Let's get dis goddam ting right" to himself as he worked—was a quality he would never again avoid. He learned that the tentative figure, the figure in flux, was the only true figure.

He carried the Scotch outside, folded himself into a wicker chair, and stared into the tangled scrubby woods that extended beyond his property and ran nearly uninterrupted to the harbor. It was evening, though it was still light, and the air had cooled significantly. Tomorrow was Saturday, and he would drive to Louse Point early in the morning with a box of watercolors and a few sheets—the first three tries were the only ones that counted—and get the morning sky down the best he could. Then he would come home, unplug the phone, read the *Times* in bed, and then take a nap, maybe stay in bed all day. At some point, Donald would arrive, and the smell of fresh-cut grass would pour through the windows in luxurious waves. He'd get up and give Donald $20, then eat a tuna fish sandwich in the backyard, maybe drink a glass of cold white Burgundy. All was right in the world, for now.

(1978, 1984)

SOURCES

BOOKS

Adams, James Truslow. *History of the Town of Southampton.* Hampton Press, 1918.

Adams, Steven. *The Barbizon School and the Origins of Impressionism.* Phaidon, 1994.

Adelson, Warren, Jay E. Cantor, and William H. Gerdts. *Childe Hassam, Impressionist.* Abbeville Press, 1999.

Ashton, Dore. *The New York School: A Cultural Reckoning.* Viking, 1972.

Baigell, Matthew. *Dictionary of American Art.* Harper and Row, 1982.

Berbrich, Joan D. *Three Voices from Paumanok.* Ira J. Friedman, 1969.

Berkson, Bill, and Joe LeSueur, eds. *Homage to Frank O'Hara.* Creative Arts Book Company, 1980.

Bermingham, Peter. *American Art in the Barbizon Mood.* Smithsonian Institution Press, 1975.

Blodgett, Harold. *Samson Occom.* Dartmouth College Publications, 1935.

Braff, Phyllis. *The Surrealists and Their Friends on Eastern Long Island at Midcentury.* Guild Hall Museum, 1996.

Breen, T. H. *Imagining the Past.* Addison-Wesley, 1989.

Breton, André. *Nadja.* Grove Press, 1976.

Bryant, Keith L., Jr. *William Merritt Chase: A Genteel Bohemian.* University of Missouri Press, 1991.

Burton, Robert. *The Life and Death of Whales.* Universe, 1973.

Cernuschi, Claude. *Jackson Pollock: "Psychoanalytic" Drawings.* Duke University Press, 1992.

Christman, Henry M., ed. *Walt Whitman's New York.* New Amsterdam Books, 1963.

Davis, Myrna. *The Potato Book.* Foreword by Truman Capote. Hampton Day School Press, 1972.

De Antonio, Emile. *Painters Painting.* Videotape. Mystic Fire Video, 1972.

DePietro, Anne Cohen, et al. *Esteban Vicente*. Heckscher Museum of Art, 2001.

East Hampton Town 350th Anniversary Committee. *East Hampton Town from the Ice Age to the Year 1998 A.D.* Videotape. 1998.

Epstein, Jason, and Elizabeth Barlow Rogers. *East Hampton: A History and Guide*. Medway Press, 1975.

Ernst, Jimmy. *A Not-So-Still Life*. St. Martin's/Marek, 1984.

Everdell, William R. *The First Moderns*. University of Chicago Press, 1997.

Fearon, Peter. *Hamptons Babylon*. Birch Lane Press, 1998.

Feldman, Alan. *Frank O'Hara*. Twayne, 1979.

Field, Louise M. *Amagansett Lore and Legend*. Amagansett Village Improvement Society, 1948.

Frank, Elizabeth. *Jackson Pollock*. Abbeville Press, 1983.

Friedman, B. H. *Alfonso Ossorio*. Harry N. Abrams, 1973.

———. *Jackson Pollock: Energy Made Visible*. McGraw-Hill, 1972.

Gaines, Steven. *Philistines at the Hedgerow*. Little, Brown, 1998.

Gallati, Barbara. *William Merritt Chase*. Harry N. Abrams, 1995.

Glackens, Ira. *William Glackens and the Ashcan Group*. Crown, 1957.

Gooch, Brad. *City Poet: The Life and Times of Frank O'Hara*. Knopf, 1993.

Gordon, Alastair. *Weekend Utopia: Modern Living in the Hamptons*. Princeton Architectural Press, 2001.

Griffiths, Teresa, producer, director. *Jackson Pollock: Love and Death on Long Island*. Videotape. Close Up/BBC, 1999.

Gruen, John. *The Party's Over Now*. Viking, 1972.

Hall, Lee. *Elaine and Bill, Portrait of a Marriage: The Lives of Willem and Elaine de Kooning*. HarperCollins, 1993.

Harrison, Helen, ed. *Such Desperate Joy: Imagining Jackson Pollock*. Thunder's Mouth Press, 2000.

Harrison, Helen, and Constance Denny. *Hamptons Bohemia*. Chronicle, 2002.

Hassam, Childe. Unpublished autobiographical essay. Archives, American Academy of Arts and Letters, New York.

Hawes, Charles Boardman. *Whaling*. Doubleday, Page and Company, 1924.

Herd, David. *John Ashbery and American Poetry*. Palgrave, 2000.

Hickey, Dave. *Air Guitar: Essays on Art and Democracy*. Art issues Press, 1997.

Hiesinger, Ulrich W. *Childe Hassam, American Impressionist*. Prestel, 1994.

Hopps, Walter, et al. *James Rosenquist: A Retrospective*. Guggenheim Museum Publications, 2003.

Howell, George Rogers. *The Early History of Southampton, L.I., New York*. Reprint, Heritage Books, 1989.

Hulbert, Ann. *The Interior Castle: The Art and Life of Jean Stafford*. Knopf, 1992.

Iannone, Helen. *Some Indigenous Flora of the Nature Trail*. East Hampton Public Schools, n.d.

Isenberg, Sheila. *A Hero of Our Own: The Story of Varian Fry*. Random House, 2001.

Karmel, Pepe. *Jackson Pollock/Jazz*. Compact disc. Museum of Modern Art, 1999.

Kligman, Ruth. *Love Affair: A Memoir of Jackson Pollock*. Morrow, 1974.

Larkin, Oliver W. *Art and Life in America*. Holt, Rinehart and Winston, 1960.

Larkin, Philip. *Required Writing*. Farrar, Straus and Giroux, 1983.

Larson, Philip, and Peter Schjeldahl. *De Kooning: Drawings/Sculptures*. Dutton, 1974.

Lessard, Suzannah. *The Architect of Desire*. Dial Press, 1996.

LeSueur, Joe. *Digressions on Some Poems by Frank O'Hara*. Farrar, Straus and Giroux, 2003.

Long, Robert, ed. *Long Island Poets*. Permanent Press, 1986.

Morand, Anne, and Nancy Friese. *The Prints of Thomas Moran*. Thomas Gilcrease Museum Association, 1986.

Morris, Willie. *New York Days*. Little, Brown, 1993.

Moss, Howard. *Minor Monuments*. Ecco Press, 1986.

Murphy, Robert Cushman. *A Dead Whale or a Stove Boat*. Houghton Mifflin, 1967.

Myers, John Bernard. *Tracking the Marvelous*. Random House, 1983.

Naifeh, Steven, and Gregory White Smith. *Jackson Pollock: An American Saga*. Clarkson N. Potter, 1989.

National Gallery of Art. *William Merritt Chase at Shinnecock*. Videotape. 1987.

Novak, Barbara. *American Painting of the Nineteenth Century*. Praeger, 1969.

Occom, Samson. "Life Among the Montauketts." Massachusetts Historical Society.

———. Transcript of Samson Occom's Journal. Dartmouth College Library Special Collections.

O'Hara, Frank. *Belgrade, November 19, 1963*. Adventures in Poetry, 1972.

———. *Jackson Pollock*. George Braziller, 1959.

Parini, Jay. *John Steinbeck*. Henry Holt, 1995.

Perloff, Marjorie. *Frank O'Hara: Poet Among Painters*. George Braziller, 1977.

Pisano, Ronald G. *A Leading Spirit in American Art: William Merritt Chase*. Henry Art Gallery, University of Washington, 1983.

Pisano, Ronald G., and Alicia Grant Longwell. *Photographs from the William Merritt Chase Archives at the Parrish Art Museum*. Parrish Art Museum, 1992.

Plimpton, George. *Truman Capote*. Nan A. Talese/Doubleday, 1997.

Polizzotti, Mark. *Revolution of the Mind: The Life of André Breton*. Farrar, Straus and Giroux, 1995.

Pollet, Elizabeth. *Portrait of Delmore*. Farrar, Straus and Giroux, 1986.

Porter, Fairfield. *Art in Its Own Terms*. Zoland Books, 1993.

Potter, Jeffrey. *To a Violent Grave*. G. P. Putnam's Sons, 1985.

Prelinger, Elizabeth. *American Impressionism*. Watson-Guptill Publications, 2000.

Ratcliff, Carter. *The Fate of a Gesture: Jackson Pollock and Postwar American Art*. Farrar, Straus and Giroux, 1996.

Rattray, Everett T. *The South Fork*. Random House, 1979.

Rattray, Jeannette Edwards. *East Hampton History*. Privately printed, 1953.

Reynolds, David S. *Walt Whitman's America*. Knopf, 1995.

Rivers, Larry, with Arnold Weinstein. *What Did I Do? The Unauthorized Autobiography*. HarperCollins, 1992.

Robbins, Ken, and Bill Strachan, eds. *Springs: A Celebration*. Springs Improvement Society, 1984.

Roberts, David. *Jean Stafford*. Little, Brown, 1988.

Rosenberg, Harold. *Saul Steinberg*. Knopf/Whitney Museum of American Art, 1978.

Samuels, Ellen, Robert A. M. Stern, Margaret Stacker, and Enez Whipple. *East Hampton Invents the Culture of Summer*. East Hampton Historical Society, 1994.

Schaffner, Ingrid, et al. *About the Bayberry Bush*. Parrish Art Museum, 2001.

Schulberg, Budd. *Writers in America*. Stein and Day, 1983.

Schuyler, James. *Selected Art Writings*. Black Sparrow Press, 1998.

"Shinnecock Summer School of Art for Men and Women, 1897." Brochure. William Merritt Chase Archives, Parrish Art Museum, Southampton, N.Y.

Simpson, Eileen. *Poets in Their Youth*. Random House, 1982.

Sleight, Harry D. *Sag Harbor in Earlier Days*. Hampton Press, 1930.

Snyder, Robert. *Willem de Kooning: Artist*. Videotape. Mystic Fire Video, 1994.

Sokolov, Raymond. *Wayward Reporter: The Life of A. J. Liebling*. Harper and Row, 1980.

Spears, John R. *The Story of the New England Whalers*. Macmillan, 1908.

Spring, Justin. *Fairfield Porter: A Life in Art*. Yale University Press, 2000.

Stafford, Jean. *The Collected Stories of Jean Stafford*. Farrar, Straus and Giroux, 1969.

———. *The Mountain Lion*. Farrar, Straus and Giroux, 1972.

Steinberg, Saul. *The Discovery of America*. Essay by Arthur C. Danto. Knopf, 1992.

Steinberg, Saul, and Aldo Buzzi. *Reflections and Shadows*. Random House, 2002.

Strong, John A. *The Montaukett Indians of Eastern Long Island*. Syracuse University Press, 2001.

Talmage, Ferris G. *The Springs in the Old Days*. Starchand Press, 1983.

Tomkins, Calvin. *Living Well Is the Best Revenge*. Viking, 1971.

Twomey, Tom, ed. *Awakening the Past: The East Hampton 350th Anniversary Lecture Series*. Newmarket Press, 1999.

Vaill, Amanda. *Everybody Was So Young: Gerald and Sara Murphy, a Lost Generation Love Story.* Houghton Mifflin, 1998.

Venezia, Mike. *Jackson Pollock.* Children's Press, 1994.

Wilkins, Thurman. *Thomas Moran: Artist of the Mountains.* University of Oklahoma Press, 1966.

Zilczer, Judith. *Willem de Kooning from the Hirshhorn Museum Collection.* Hirshhorn Museum, Smithsonian Institution/Rizzoli, 1993.

ARCHIVAL MATERIAL

Chase, William Merritt. Archives. Parrish Art Museum, Southampton, N.Y.

Freilicher, Jane. Interview. Archives of American Art, Smithsonian Institution.

Hassam, Childe. Papers. Archives. American Academy of Arts and Letters, New York.

Moran, Thomas. Collection. East Hampton Library, East Hampton, N.Y.

Porter, Fairfield. Papers. Archives of American Art, Smithsonian Institution (Porter interview by Paul Cummings).

Steinberg, Saul. Interviews. Archives of American Art, Smithsonian Institution.

NEWSPAPER ARTICLES

Long, Robert. "Plots Thicken at Green River." *East Hampton Star*, Feb. 11, 1999.

———. "Seventeen Years of de Kooning." *East Hampton Star*, Feb. 28, 2002.

INTERVIEWS

Ferren, Rae. Interview by author. Tape recording. East Hampton, N.Y., Nov. 7, 2001.

Ferriss, Donald. Telephone conversation with author. Notes. Sept. 4, 2001.

Harmon, James J., and Ann Harmon. Interview by author. Notes. Southampton, N.Y., Feb. 2002.

Harrison, Helen. Interview by author. Pollock-Krasner House and Study Center, East Hampton, N.Y., April 2002.

Palmer, Florence Wilcox. Interview by author. East Hampton, N.Y., Sept. 2002.

ACKNOWLEDGMENTS

I owe thanks to many friends and colleagues who helped me to think about my subjects more clearly and provided encouragement. Among them are Helen A. Harrison, the director of the Pollock-Krasner House and Study Center; Alicia Longwell, curator of the Parrish Art Museum; Dorothy King and Diana Dayton of the Long Island Collection at the East Hampton Library; Christina Mossaides Strassfield, curator of Guild Hall; Helen S. Rattray, David E. Rattray, Virginia Garrison, Sheridan Sansegundo, and Irene Silverman of *The East Hampton Star* and its archivist, Alice Ragusa; Andrew Botsford of *The Southampton Press*; Ann and James J. Harmon; Rae Ferren; Mary Abbott; Mike Solomon; Athos Zacharias; Joe Stefanelli; Donald Ferriss; B. H. Friedman; Ken Robbins; John Gruen; Nicholas Grimshaw; Maryann Calendrille, Kathryn Szoka; Mary Long; Josh Dayton; the late Florence Wilcox Palmer; and the late Howard Moss. A small part of Chapter Ten was loosely adapted from Mr. Moss's essay "Jean: Some Fragments." John Esten's thoughtfulness set into motion a sequence of events that led to my writing this book, and I thank him for his kindness.

There would have been no book without the encouragement

and patient instruction of my agent, Patricia Van der Leun; the understated criticism of my brilliant editor, Lorin Stein; and the precise eyes and ears of Annie Wedekind, Kabir Dandona, and Kevin Doughten. I am grateful to them all.